# The Artful Home™

## Art for the Wall

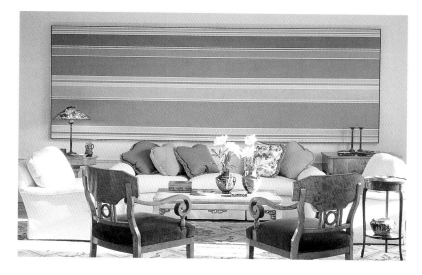

A Source & Guide for Living with Art

# The Artful Home ™
## Art for the Wall

## A Source & Guide for Living with Art

Louis Sagar, Executive Editor

GUILD Publishing
Madison, Wisconsin

# The Artful Home™
## Art for the Wall

A Source & Guide for Living with Art

Louis Sagar, Executive Editor

**PUBLISHER**
GUILD Sourcebooks
An imprint of GUILD, LLC
931 E. Main Street
Madison, Wisconsin 53703
TEL 608-257-2590 • TEL 877-284-8453

**ADMINISTRATION**
Toni Sikes, CEO and Founder
Reed McMillan, Vice President of Sales
Jeanne Gohlke, Administrative Assistant

**DESIGN, PRODUCTION AND EDITORIAL**
Georgene Pomplun, Art Director
Sue Englund, Production Artist
Katie Kazan, Chief Editorial Officer
Jill Schaefer, Editorial/Production Coordinator
Jori Finkel, Michael Monroe, Jill Schaefer and Susan Troller, Writers (Artist Profiles)

**ARTIST CONSULTANTS**
Nicole Carroll • Carla Dillman • Lori Dumm
Amy Lambright • Laura Marth • Mike Mitchell

Copyright © 2003 GUILD, LLC
ISBN 1-880140-49-7

Printed in China

Cover art: Interior design by Mary Drysdale. Photograph: Andrew Lautman.
Page 1: Interior design by Barbara Hauben Ross. See page 173.
Pages 2 and 3: Interior design by Mary Drysdale; painting by Sam Gilliam. Photograph: Andrew Lautman.
Opposite: Interior design by Mary Drysdale. Photograph: Andrew Lautman.

GUILD.com is the Internet's leading retailer of original art and fine craft. Visit www.guild.com.

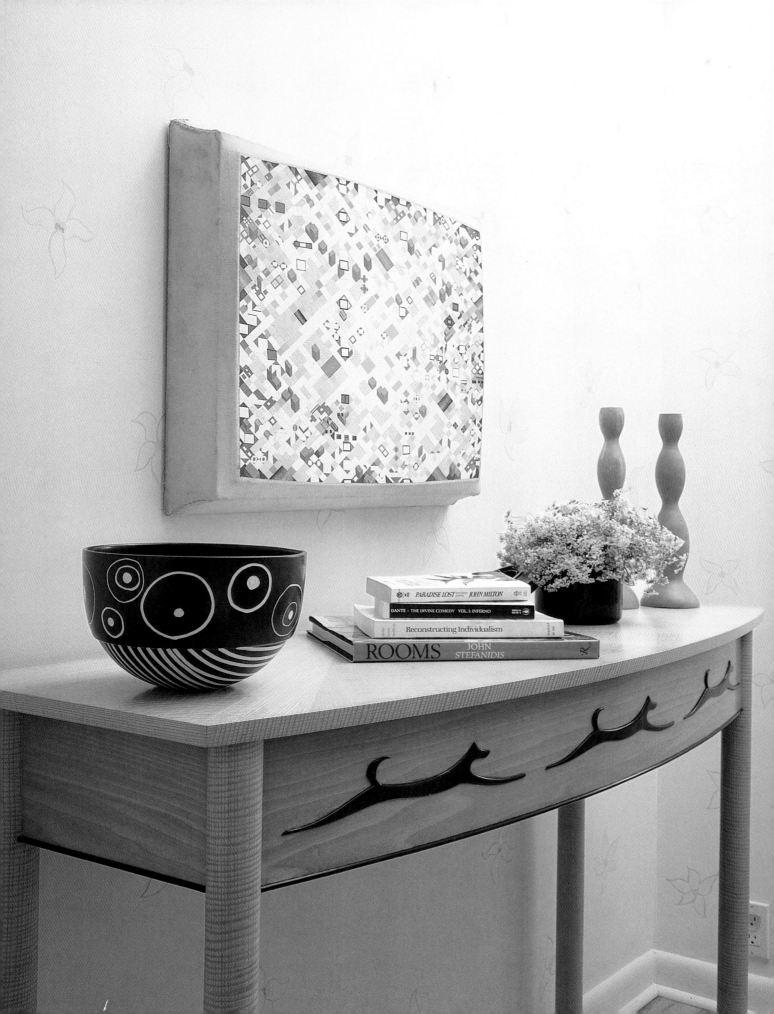

# TABLE OF CONTENTS

## Introduction

## Articles and Tips

### THE ROOMS OF YOUR HOME

### TIPS FOR AN ARTFUL HOME

Left: Michele Hardy, *Colorfields: Jade* (detail). Photograph: Jackson Hill. See page 207.

# TABLE OF CONTENTS

## Artist Display Pages

Representative work from *Artful Home* artists, organized by discipline and complete with addresses and phone numbers so you can contact artists directly for special projects and purchases.

## Artists Profiles

## Resources

❧

*The Artful Home* shows artwork of enduring value; we think you'll refer to it for years to come. If, at any time, you're not able to reach an artist through contact information included in this book, call GUILD at 1-877-284-8453. We keep track of updated phone numbers and the like, and are glad to share our most current information.

# WELCOME TO THE ARTFUL HOME

When GUILD asked me to become the executive editor for a series of books titled *The Artful Home,* I turned to my friends. What did they think about the proposed series? How did they feel about buying art? Owning art? Living with art?

These questions elicited interesting responses. As I'd suspected, many people feel intimidated by art and by artists. The idea of going to a museum or gallery and looking at art makes some of my friends feel insecure. Some feel a sense of exclusion, or say that galleries are cold and uninviting. Another common complaint: people think there's an elusive "right" way to look at art, but they aren't sure what it is. Several of my close friends feel it's all a big mystery, as if enjoying art requires membership in an elite club, a club they have not been invited to join.

Even those who consider themselves art collectors mentioned that the buying process is sometimes confusing. How are values established? Why are some pieces so expensive and others so modest in cost?

It didn't take long for me to realize how common these feelings and questions are. In fact, there is no right or wrong way to look at art. The goal is to follow your own instincts, make your own choices and learn how to live with art that you love. And although many factors influence price and value, our most important goal should be to develop, and then refine, an individual approach to looking at and enjoying the art we acquire and display in our homes. From there, all other considerations, including value and pricing, will fall easily into place.

This book offers insights and strategies for achieving that goal. It also answers questions that have surfaced over the course of researching this book—questions about commissioning custom-designed artwork, about caring for art of various mediums and about displaying art in your home. The book you're holding now, *Art for the Wall,* is one of two volumes in the *Artful Home* series. The companion volume, *Furniture, Sculpture & Objects,* includes artworks for the home created from wood, metal, glass, ceramic and fiber. Both volumes are available through bookstores or directly from GUILD Publishing (1-877-344-8453 or www.guild.com).

Appreciating original art and finding ways to bring art into your home are both central to the journey and the focus of this book. It's one thing to realize that a particular work of art is inspiring and pleasurable to you. It's another to determine whether a photograph you've taken a fancy to will actually fit in with everything else going on in your living room, or whether a hanging tapestry will coexist happily with the paintings and prints already hanging on your dining room wall.

Our homes provide a wonderful context in which to display art and nurture our own creativity. *The Artful Home* volumes, filled as they are with suggestions, information and practical tips, are designed to help demystify artists and their work. Each volume includes artist profiles; tips about selecting, caring for and living with art; photographs of homes enriched by art; a glossary of terms and definitions; and a list of terrific galleries.

Gold gilding and cream fabrics connect traditional with contemporary in these two chairs, which complement the light walls and hearth while contrasting elegantly with the rich black of the wall piece and table. A Mary Drysdale design. Photograph: Andrew Lautman.

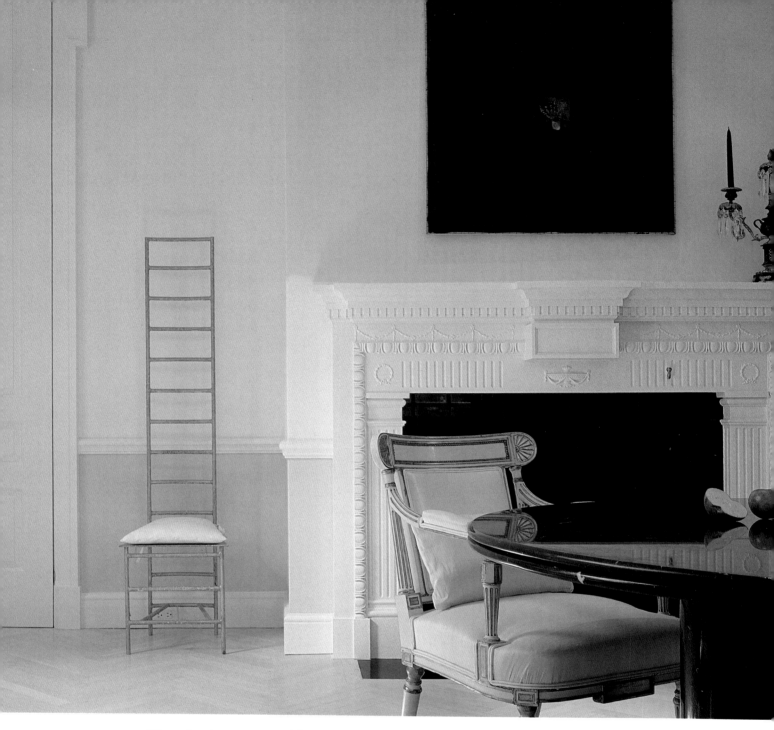

These books are part guide and part sourcebook. The artists included in each volume have works available for purchase from their studios. They are also available for custom projects—commissioned works of art that fit, hand-to-glove, into the styles, spaces and colors of your home. Whether by phone or e-mail, these artists want to hear from you.

One of my most important goals as editor and guide for this series of books is to suggest a point of view about creating an artful home. It begins with a philosophy of sorts; turn to page 12 to see what I mean. Once understood, this philosophy will empower you to learn about art and artists at your own pace and in your own way. As you'll see, there is pure pleasure to be gained when we immerse ourselves in the process.

Let's get started.

— Louis Sagar, Executive Editor

# HOW TO USE *THE ARTFUL HOME*
## Your Direct Connection to Artists' Studios

The decision to live with art is a decision to live with things of enduring value. The paintings, prints and photographs you place in your home—like the works of art in clay, fiber, metal, glass and wood—enrich your life with a silent and strengthening presence, and with the joy of beauty and imagination.

Because original art can be costly compared to manufactured goods, and because each artwork is unique, shopping for art calls for research and initiative. Hence *The Artful Home*. Two companion volumes invite you to browse, buy and commission works of art directly from the studios of exceptional contemporary artists.

- *Art for the Wall* features paintings, photographs, prints, art quilts, tapestries and works for the wall in fiber, paper, ceramics, glass, metal and mixed media.

- *Furniture, Sculpture & Objects* features furniture, lighting, floor coverings, architectural details and art objects in all media, as well as sculpture for pedestals and gardens.

Full-color photographs make it easy to find the artists whose style appeals to you most, while complete contact information allows you to get in touch with those artists directly to purchase existing pieces or commission custom-designed works.

You need not be an art collector to purchase works from artists included in *The Artful Home*. In fact, the only qualifications you really need are a sincere appreciation for the artists you call and a genuine interest in owning their work.

## FINDING WHAT YOU NEED
### *A Roadmap to* The Artful Home

Want to contact an artist featured in *The Artful Home?* Look for addresses, phone numbers and other contact information at the tops of artists' display pages. Additional information about each artist can be found in the Artist Information section in the back of the book; listings are in alphabetical order by the heading on each artist's page. This is where you'll find information about the artists' mediums and techniques, their range of products and their notable awards or commissions.

If you know what type of artwork you want to purchase or commission, a search by section will help you find results quickly. You'll find a list of sections in the Table of Contents. Likewise, if you know the name of the artist you want to work with, you can easily search using the Index of Artists and Companies, found in the back of the book. If you would like to work with an artist in your area, check the Geographic Index, which lists artists by location.

Curious to know more about an artist's work? Don't hesitate to contact them directly; they'll be delighted to hear from you. And for more information about these and other artists who create works for home environments, visit the GUILD Custom Design Center, a featured service of GUILD.com.

Opposite: Sheryl VanderPol, wall mural. Photograph: Greg Page/Page Photography. See page 144.

## PUTTING THE BOOK TO WORK

We welcome you to browse *The Artful Home*, enjoying the artwork, the artist profiles and the many suggestions for building a home rich in beauty and creative energy. But there's more to this book than that. Every one of our featured artists invites you to call or e-mail to purchase pieces from their studio or to arrange a commission for a custom work of art.

Your call to an *Artful Home* artist can take you in many directions.

- The same artworks shown on these pages may be available for immediate purchase. Some of these works are from an artist's production line or created in limited editions; others are one-of-a-kind pieces.

- The artist may have other available works on hand. If you live near the artist (see the Geographic Index), consider visiting the studio. If a studio visit isn't feasible, ask to see images; these can often be e-mailed for quick review.

- Alternately, you could hire the artist to create a unique work that reflects your home, your aesthetic and, perhaps, some landmark event in your life or the life of someone you love. For help in commissioning artworks, consider the services of GUILD's Custom Design Center. You can reach the CDC from GUILD's home page (www.guild.com), or call CDC staff at 1-877-344-8453.

When viewing an artist's page, keep in mind that while the projects shown are representative of the artist's work, they don't demonstrate the full extent of the artist's capabilities. If you like a certain style but want something other than the works pictured here, call the artist and talk it over. He or she may be intrigued at the prospect of exploring new forms.

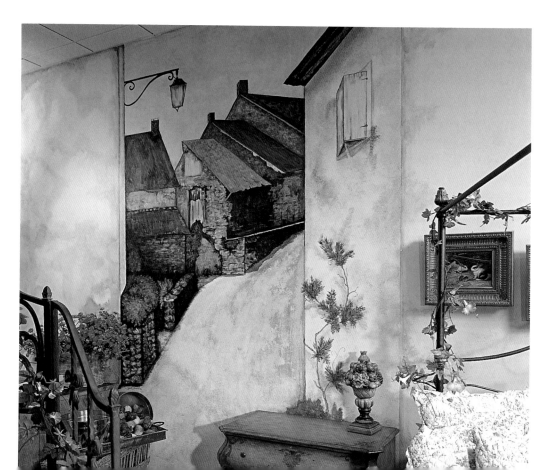

# HOME AS SANCTUARY

Home is the one place in our lives that is uniquely ours. It is a space that reflects where we come from, who we are and how we got here.

I often think of my home as a white canvas; the rooms are empty and the spaces are filled with natural light. I do this mental exercise because, in reality, my home is like yours: not perfect. Kids, cats, too much clutter, stuff to throw away. Just dreaming about empty space and soft lighting puts me in a better mood.

Like an artist, I use a set of tools to create within my white canvas. My tools include a favorite set of markers, a scrapbook for clippings and a diary for recording flashes of insight. I have a big imagination and like to change my mind a lot, and these tools help me develop my aesthetic on paper, where it's easy to try different options. They help me know what I like.

A personal aesthetic develops from building a point of view about space, proportions and texture. I find that I can identify and refine that point of view by using the markers, scrapbook and diary to identify colors, patterns and types of art that are meaningful to me. This exercise takes practice and matures over time, but once I find the aesthetic values that are meaningful to me—and develop those values in the design and content of my home—I have something wonderful to share with family and friends. The process of sharing feels comforting, and comfort is one of my key goals. Over the years, I've found that home is the sanctuary where I can accomplish that goal.

From a historical perspective, we've only recently had the time to look at our homes as more than shelter from nature and the elements. The daily activities of cleaning, maintaining and repairing are an essential part of homemaking. Shopping for furnishings and decorating are other parts of the rhythm. Arranging flowers, playing music and lighting candles all combine to create an atmosphere that stimulates the senses and sets the mood.

I like to think of the entire homemaking process as a journey, one without beginning or end, limited only by my time and imagination.

As you become more artful in your approach to your home, slow down and enjoy the process of getting there. In a world where so much is result-driven, projects at home need not be rushed. Take time to visualize home spaces that are new and refreshing. Take time to look at art and to think about the kinds of artworks you want to live with. Learn about the artists whose work speaks to you, about their inspirations and their techniques. This knowledge enables you to train your eyes and enriches your personal aesthetic. It helps strengthen your point of view and it helps you define who you are.

So when you think about your home, think like an artist.

—L.S.

## ART FOR YOUR HOME'S DISTINCTIVE SPACES

Rooms are the energy centers of your home. They vibrate with an ebb and flow that change with the time of day and time of year.

In creating an artful home, your goal is to establish a thematic point of view for each room in your house. Your challenge is to balance the functional needs of the room with a story that expresses something about you—your tastes, your values, your heritage. The color palette, the style and arrangement of your furnishings, the art that you live with—all help to tell your story.

Few rooms in a home function solely in the traditional roles suggested by their names. Most serve multiple functions, and this flexibility presents opportunities for a personalized and creative approach to decorating. Once again, art can play an important role. The selection and placement of the art you own is a powerful way to communicate something about your soul, about who you are at the core of your being.

14

Glass, metal and wood are wonderfully interwoven and well-balanced in this utilitarian interior design by Mary Drysdale. Notice how the arrangement of the artwork and the soft lighting immediately invite the viewer's eye up the stairs and into the home. Photograph: Andrew Lautman. Photograph of Mary Drysdale, opposite page: Mary Noble Ours.

# A CONVERSATION WITH
# MARY DOUGLAS DRYSDALE

Mary Douglas Drysdale is one of the premier interior designers in North America today. Examples of her designs appear throughout this book and on the book's cover. These interior spaces resonate with taste and style, each one a distinctive integration of her three passions: art, architecture and decoration.

A Mary Drysdale design is strongly anchored in classical themes; at the same time, it intimately reveals the interests and personalities of her clients. This kind of synthesis is made possible by her keen capacity to listen and interpret.

"After all," she says, "designing is a collaborative process. I think of my role largely as that of guide and teacher; I make sure the client is involved in the process. By contrast, the conventional role of the client is simply to delegate, leaving the decisions to the designer. In these instances, more often than not, you end up with a house—not a home.

"When I begin a project, I focus on helping clients get in touch with styles they like and styles they don't. I encourage them to express themselves and make special note of their passions. In every project, I'm challenged to integrate the personal imprint of the client with a harmonious and balanced interior.

"We all have an inherent talent to express ourselves in the sanctuary of our own homes. It is the role of the designer to facilitate that expression, so that the home becomes a reflection of self and can evolve over time."

## MARY DRYSDALE'S KEYS TO AN ARTFUL HOME

- Interior designing is like art directing. Create a visual composition in each room and establish points of continuity between rooms. Think of your furnishings, objects and framed artworks as elements in an ever-changing still life.

- Evaluate the open spaces in each room. These literal and visual pathways need space to breathe; don't let them suffocate from too much stuff! Put it away, give it away or throw it away.

- In the end, good interior design tells a story. Great interior design tells a story about you.

# COMMISSIONING A WORK OF ART

There's something exhilarating about engaging an artist to create a unique work of art for your home. Custom-designed (or "commissioned") works of art reflect your personal taste and vision more deeply than "off-the-shelf" artworks. At the same time, they can significantly enhance the value of your home.

Commissioned works of art may or may not be expensive, depending upon the scope of the project, but they will always require your personal involvement. If you enjoy that involvement, art commissions are the ultimate way to buy original art. Custom-designed artworks—whether movable, as with a painted portrait, or permanently attached to the structure of your home, as with a tile fireplace surround—can become instant family treasures, adding deeply to the heritage of who you are.

## CHOOSING AN ARTIST

The most important step you'll take when planning a commission is the choice of artist. Who is the right choice? Someone whose previous art projects appeal to you. Whose previous clients are enthusiastic. Who has undertaken similar projects in the past and delivered completed work within the agreed-upon budget and schedule.

And how do you find this individual?

*The Artful Home* is a wonderful place to start. Every one of our featured artists accepts commissions for custom-designed artwork, and the contact information included with their individual display pages will put you in touch with them directly. You may also want to talk with friends who have hired artists for commissions similar to yours, or visit artists' studios and art fairs to talk with possible candidates in person.

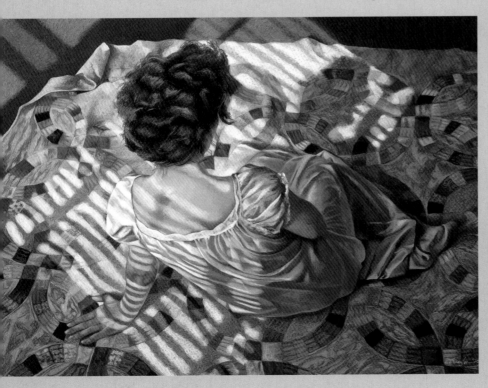

Once your A-list is narrowed down to two or three names, it's time to schedule meetings to discuss the project, either face-to-face (for local artists) or by phone. As you talk, try to determine the artist's interest in your project, and pay attention to your own comfort level with the artist. Try to find out whether the chemistry is right—whether you have the basis to build a working relationship—and confirm that the artist has the necessary skills to undertake your project. Be thorough and specific when asking questions. Is the artist excited about the project? What does he or she see as the most important issues or considerations? Will your needs be a major or minor concern? Evaluate the artist's style, approach and personality.

If it feels like you might have trouble working together, take heed. But if all goes well and it feels like a good fit, ask for a list of references. These are important testimonials, so don't neglect to make the calls. Ask about the artist's work habits and communication style, and—of course—about the success of the artwork. You should also ask whether the project was delivered on time and within budget. If you like what you hear, you'll be one important step closer to hiring your artist.

### Expect Professionalism

Once you've selected the artist, careful planning and communication can help ensure a great outcome. If this is an expensive or complicated project, you may want to request preliminary designs at this time. Since most artists charge a design fee whether or not they're ultimately hired for the project, start by asking for sketches from your top candidate. If you're unhappy with the designs submitted, you can go to your second choice. If, on the other hand, the design is what you'd hoped for, it's time to finalize your working agreement with this artist.

17

 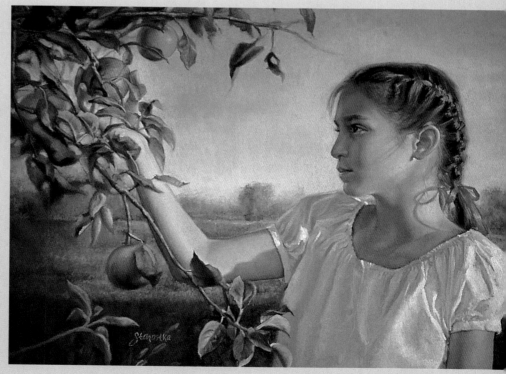

Left: Helen Vaughn, *Woman Seated on a Quilt*. Photograph: Doug Brewster. See page 33.
Center: Debra Nicholas, *Sweet Peas*. Photograph: Xystus Studio. See page 57. Right: Ardith Starostka, *Late Summer Apples*. See page 59.

    As you discuss contract details, be resolved that silence is not golden and ignorance is not bliss! Be frank. Discuss the budget and timetable, and be sure that these and other important details are spelled out in the contract. Now is the time for possible misunderstandings to be brought up and resolved—not later, when the work is half done and deadlines loom.

## THE CONTRACT: PUTTING IT IN WRITING

It's a truism in any kind of business that it's always cheaper to get the lawyers involved at the beginning of a process than after something goes wrong. In the case of custom-made works of art, a signed contract or letter of agreement commits the artist to completing his or her work on time and to specifications. It also assures the artist that he or she will get paid the right amount at the right time. That just about eliminates the biggest conflicts that can arise.

    Contracts should be specific to the job. If your commission is for a photograph of a beloved country home, a sales slip noting down payment and delivery date should do the trick. If, on the other hand, you've hired a muralist to paint an *Alice in Wonderland* scene in the kids' playroom, a more detailed document will be needed.

    Customarily, artists are responsible for design, production, shipping and installation. If someone else is to be responsible for installation, be sure you specify who will coordinate and pay for it. With a large project, it's helpful to identify the tasks that, if delayed for any reason, would set back completion of the project. These should be discussed up front to assure that both parties agree on requirements and expectations.

Above: Thomas Masaryk, dining room trompe l'oeil. Photograph: John Dessarzin. See page 138.

*Payment Schedule*

The more skill you need and the more complex the project, the more you should budget for the artist's work and services. With larger projects, payments are usually tied to specific milestones; these serve as checkpoints and assure that work is progressing in a satisfactory manner, on time and on budget. Payment is customarily made in three stages, although—again—this will depend on the circumstances, scope and complexity of the project.

The first payment for a large-scale commission is usually made when the contract is signed. It covers the artist's time and creativity in developing a detailed design specific to your needs. For larger projects, you can expect to go through several rounds of trial and error in the design process, but at the end of this stage you'll have detailed drawings and, for three-dimensional work, an approved maquette (model). The cost of the maquette and the design time are usually factored into the artist's fee.

The second payment is generally set for a point midway through the project and is for work completed to date. If the materials are expensive, the artist may also ask that you advance money at this stage to cover their costs. If the commission is canceled during this period, the artist keeps the money already paid for work performed.

Final payment is usually due when the work is finished or, if so arranged, installed. Sometimes the artwork is finished on time but the building is delayed (as so often happens with new construction); in this case, the artist should be paid upon completion but still has the obligation to oversee installation.

## WHERE TO FIND HELP

If your project is large and expensive, or if it needs to be carefully coordinated with other aesthetic and functional aspects of your home, consider hiring an art consultant. The consultant can help with complicated contract arrangements and make certain that communication between the artist and professionals such as architects, interior designers and engineers is clear and complete.

Another terrific service is available online through GUILD, the publisher of *The Artful Home*. The GUILD Custom Design Center lets you describe special projects by filling out an online form. Your information is shared with qualified artists over the Internet; GUILD then forwards their proposals to you. This is a great way to find artists when you're celebrating a family milestone, solving a design problem or looking for ways to make everyday objects artful.

One thing to keep in mind: some people may feel that the process of commissioning a work of art for the home involves a degree of involvement that they just don't want to take on. If that describes you, rest assured—you may still find that treasured work of art! Most artists have a wide selection of completed works on hand in their studios, giving you the option to purchase something that's ready-made. If you find something great among the artist's inventory, don't hesitate to buy it. The piece you choose will still be unique, and it will still reflect your personal aesthetic sense. Your goal should be to develop an individual approach to enjoying art … and that includes your comfort level with how you purchase it.

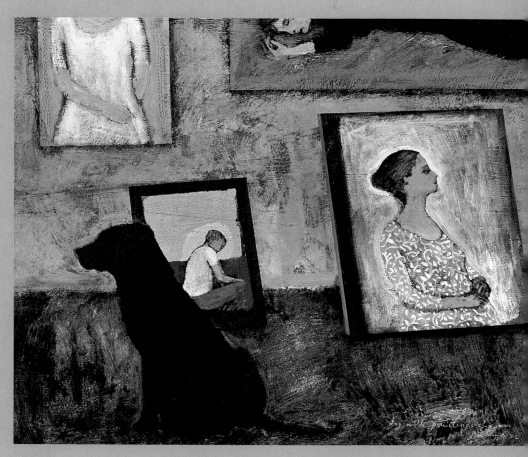

PAINTINGS

# BOB BROWN

BOB BROWN STUDIO ■ 2725 TERRY LAKE ROAD ■ FORT COLLINS, CO 80524
TEL/FAX 970-224-5473 ■ E-MAIL BOBBROWN-ARTIST@ATT.NET

22

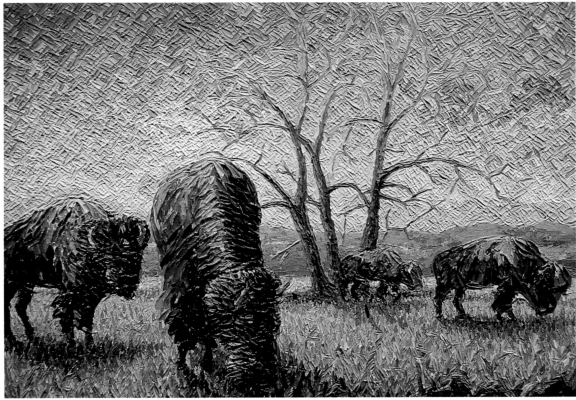

Top: *Cottonwood in Fall,* 36" x 48". Bottom: *Bison Range,* 36" x 48".

# MICHELLE T. COURIER

326 SOUTH LINCOLN ROAD ■ BAY CITY, MI 48708 ■ TEL 989-895-6219

Top: *Lead the Way*, 2001, acrylic, 48" × 66". Bottom: *Laying Long Shadows*, 2001, acrylic, 48" × 66".

# EDWARD SPAULDING DeVOE

219 MAIN STREET SOUTH ▪ BRIDGEWATER, CT 06752 ▪ TEL 860-354-5072 ▪ E-MAIL EDWARDSDEVOE@EARTHLINK.NET

24

Top: *Mackeral Dawn*, 2000, oil on canvas, 48" × 72". Bottom: *Genesis*, 1997, oil on panel, 24" × 35".

# CLAIRE EVANS

2810 WILDERNESS PLACE SUITE E ■ BOULDER, CO 80301 ■ TEL/FAX 303-444-3839
E-MAIL MCLAIREEVANS@EARTHLINK.NET ■ WWW.ARTISTSREGISTER.COM

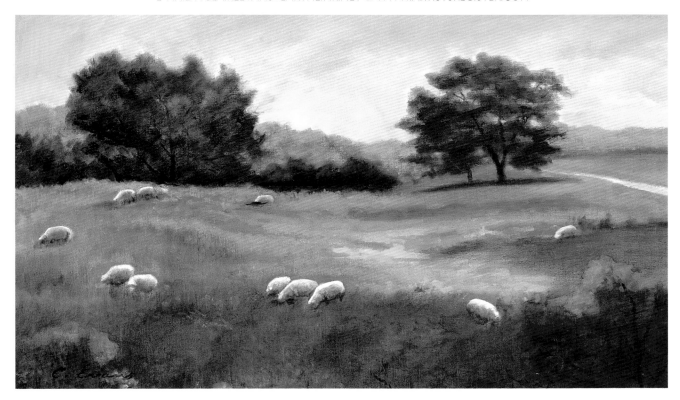

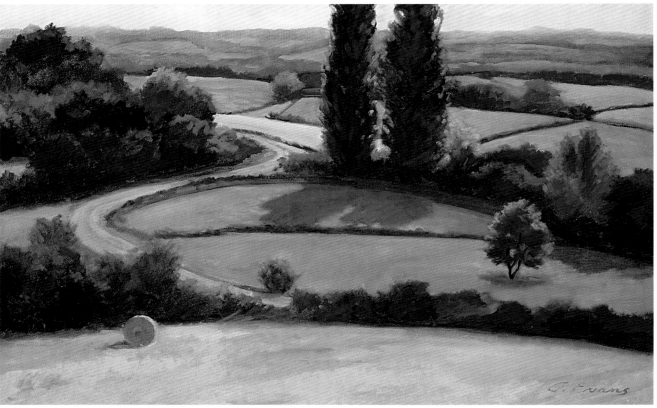

Top: *Hill Country Sheep*, 1999, 14" × 22".
Bottom: *From the Hilltop*, 2002, oil on linen, 24" × 36". Photograph: Ken Sanville.

# KARL DEMPWOLF STUDIO/GALLERY

KARL DEMPWOLF ■ 3962 WITZEL DRIVE ■ SHERMAN OAKS, CA 91423 ■ TEL 818-788-0173
E-MAIL DEMPWOLF@PACBELL.NET ■ WWW.NETMONET.COM

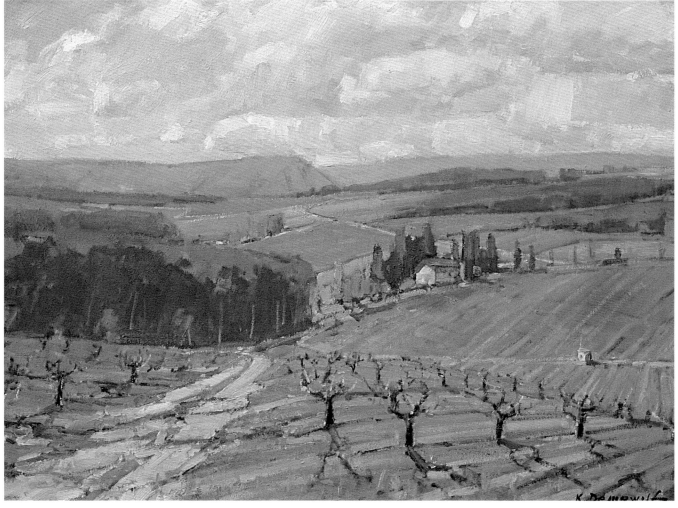

Top: *Dusk at the Huntington*, 2001, San Marino, CA, oil on canvas, 11" × 28".
Bottom: *Dormant Vines*, 2000, San Luis Obispo County, CA, oil on canvas, 24" × 36". Photographs: Karl Dempwolf.

# JUDY GRIFFITHS

ARTS OF THE WILD ▦ 2349 AUSTINTOWN-WARREN ROAD ▦ WARREN, OH 44481 ▦ TEL 330-652-0170
E-MAIL JGRIFFI978@AOL.COM ▦ WWW.ARTSOFTHEWILD.COM

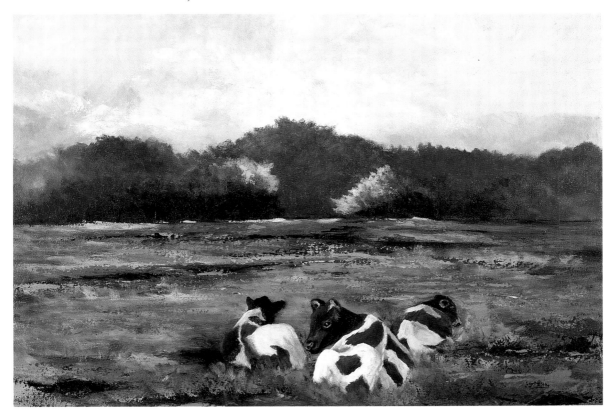

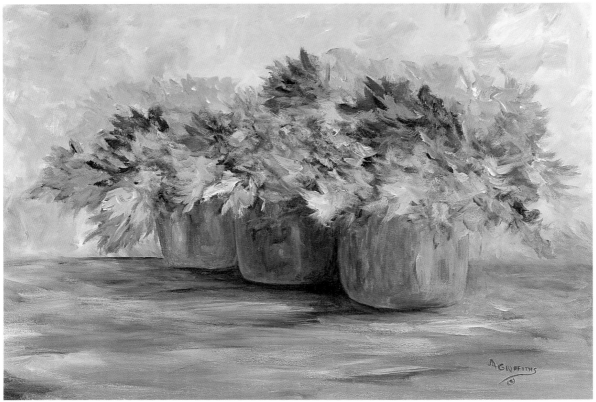

Top: *Cows at Rest*, acrylic, 18"x 24". Bottom: *Three Pots*, acrylic, 16" x 30". Photographs: Rudinec & Associates.

# MIKE FERGUSON

MIKE FERGUSON STUDIO ◼ 18424 120 AVENUE SE ◼ RENTON, WA 98058 ◼ TEL 425-228-1893
E-MAIL MIFERG@JUNO.COM

28

Top: *Rampart Lakes*, acrylic on wood, 38" x 46" (unframed). Bottom: *Reed Lakes*, acrylic on canvas, 40" x 75" (unframed). Photographs: Ivey Seright.

29

Top: *Evening by the River*, 2001, Italy, oil on Lana paper, 20.5" x 30.5". Photograph: Robert Puglesi.
Bottom: *Sunset Valley*, 2001, Italy, oil on Fabriano paper, 20" x 28". Photograph: Adam Reich.

# A WORD ABOUT FENG SHUI

Feng shui (pronounced *fung shwey*) is an ancient Chinese discipline dedicated to the study of energy, or *chi,* as it relates to movement and pattern in physical environments. Feng shui provides insight into how our environments affect our physical, emotional and spiritual well-being. The principles of classical feng shui were closely guarded in ancient China. The keepers of this secret knowledge were the feng shui masters, highly respected scientists and astronomers who were responsible for sustaining the good health, prosperity and power of the imperial dynasties.

The practice of feng shui enlightens, harmonizes and improves lives by identifying the natural rhythms of energy that affect us daily. A basic understanding of feng shui can help you promote positive energy flow in each room of your home and throughout your household. This understanding can influence your selection and placement of artworks.

A host of books about feng shui are available. Here are some favorites: *A Master Course in Feng Shui* by Eva Wong (Shambhala Publications); *The Feng Shui Journal: A Guided Workbook to Bring Harmony Into Your Life* by Teresa Polanco and Chris Paschke (Peter Pauper Press); *Feng Shui in 10 Simple Lessons* by Jane Butler-Biggs (Watson-Guptill Press).

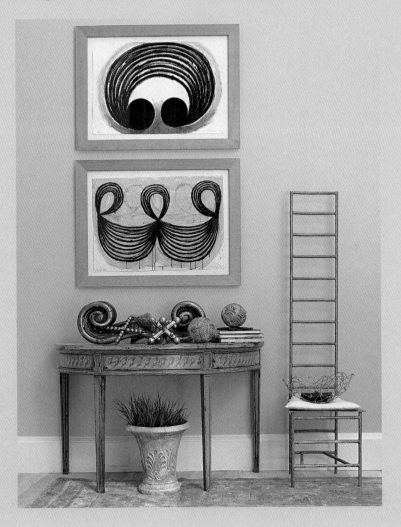

Vertical plays against horizontal in this wonderful arrangement by Mary Drysdale. Notice how the pattern created in the back of the chair echoes the placement of the two wall pieces over the table. Photograph: Jeannie O'Donnel.

# YOSHI HAYASHI

255 KANSAS STREET ▪ SAN FRANCISCO, CA 94103 ▪ TEL/FAX 415-552-0755
E-MAIL YOSHIHAYASHI@ATT.NET ▪ WWW.YOSHIHAYASHI.COM

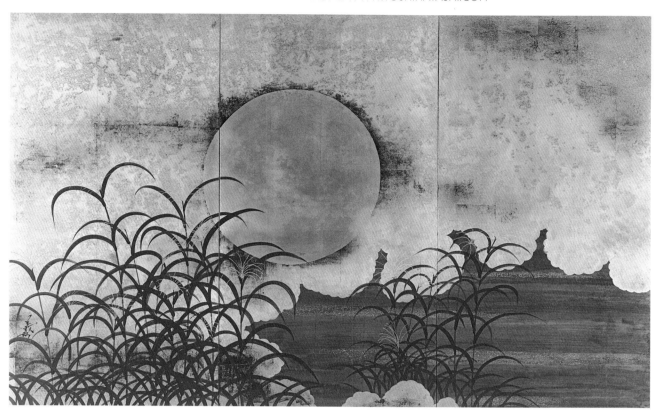

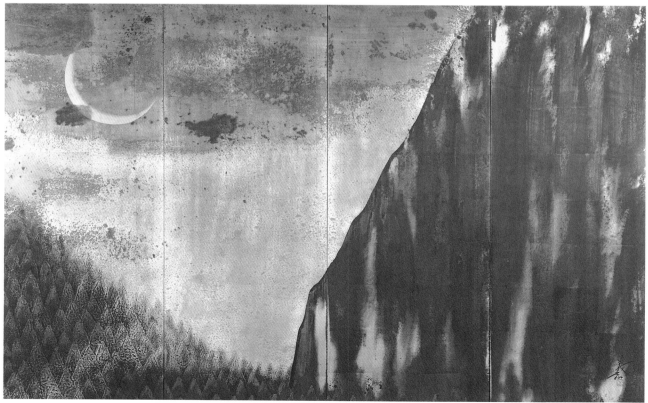

Top: *Full Moon with Wild Grass*, 2000, gold, silver leaf and oil paint, 42" x 64". Bottom: *New Moon*, 2000, silver leaf and oil paint, 42" x 64". Photographs: Ira D. Schrank.

# ALLAN STEPHENSON

3820 SE CLINTON STREET ▨ PORTLAND, OR 97202 ▨ TEL 503-239-6825
E-MAIL ASIS@TELEPORT.COM ▨ WWW.ALLANSTEPHENSON.COM

Top: *Tuscan Poppies*, pastel, 14" × 24". Bottom: *The Shadowlands*, oil, 40" × 60".

# HELEN VAUGHN

VAUGHNART STUDIO ■ 313 FRANKLIN STREET ■ HUNTSVILLE, AL 35801 ■ TEL 256-534-4202 ■ FAX 256-534-0956
E-MAIL VAUGHNART@ATTGLOBAL.NET ■ WWW.HELENVAUGHN.COM

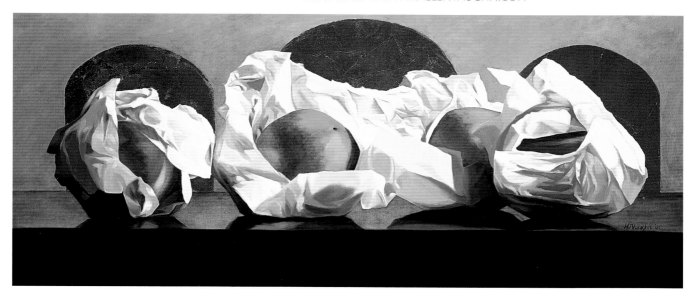

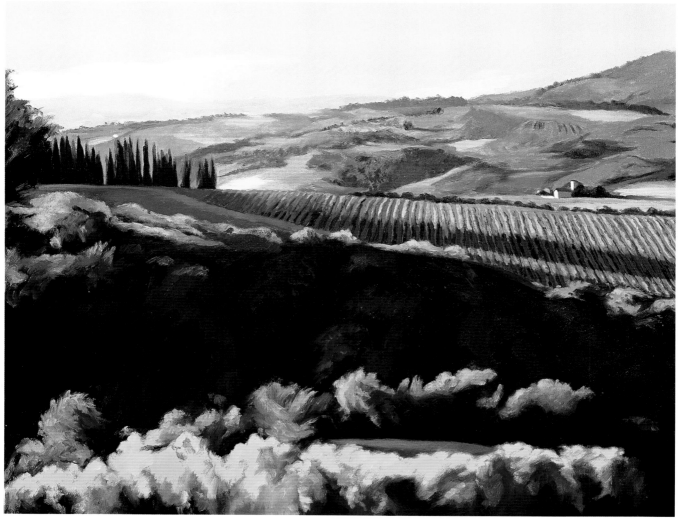

Top: *Wrapped Oranges on a Sideboard*, 2001, oil and gold leaf on canvas, 24" x 48". Bottom: *Midday in Tuscany*, 2002, oil on canvas, 22" x 28". Photographs: Doug Brewster.

# MARLENE LENKER

28 NORTHVIEW TERRACE ■ CEDAR GROVE, NJ 07009 ■ TEL 973-239-8671
LENKER FINE ARTS ■ 13 CROSSTREES HILL ■ ROAD ESSEX, CT 06426 ■ TEL 860-767-2098 ■ E-MAIL LENKERART@PRODIGY.NET

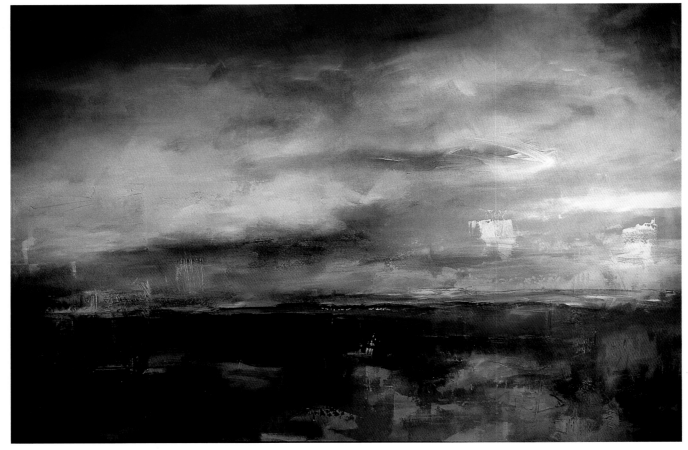

Top left: *Mesa*, 2001, 20" x 20". Top right: *Sunset Vista*, 2001, 20" x 20". Bottom: *Desert Vista*, 2001, 48" x 72".

# BRIDGET BUSUTIL

BUSUTIL IMPRESSIONS, LLC ■ 490 ROCKSPRINGS ROAD NE ■ ATLANTA, GA 30324 ■ TEL 404-875-9155
E-MAIL BMBART@ATTGLOBAL.NET ■ WWW.BRIDGETBUSUTIL.COM

*Fire Sky*, oil glaze on canvas, 36" x 40". Photograph: Parallax Studio, Atlanta, GA.

# EDY PICKENS

1422 SEVENTH STREET #505 ▪ SANTA MONICA, CA 90401 ▪ TEL 310-394-8130
E-MAIL EPICKENS@PRODIGY.NET ▪ WWW.EDYPICKENS.COM

36

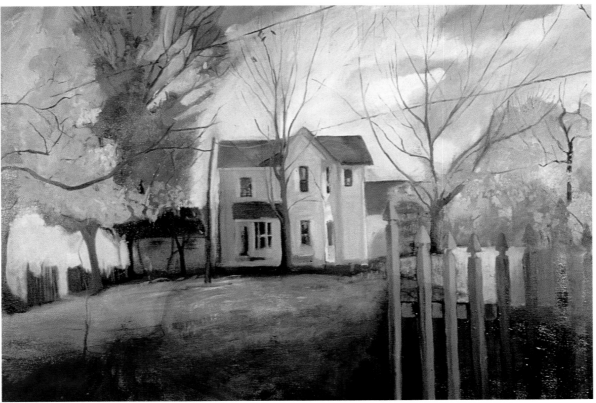

Top: *By the Arno*, 1999, pastel, 19.5" x 25.5". Bottom: *Daisy's Place*, 1999, oil on canvas, 34.5" x 59".

# SUSAN SCULLEY

4546 NORTH HERMITAGE #2 ■ CHICAGO, IL 60640 ■ TEL 773-728-6109 ■ FAX 773-728-9305
E-MAIL SCULLEY@IX.NETCOM.COM

Top left: *October/November*, 1995, oil on canvas, 36" × 36". Photograph: Cynthia Howe. Top right: *Red Gold Path*, 1996, oil on canvas, 28" × 28". Photograph: Dan Kuruna.
Bottom: *Limelight*, 2001, oil stick on paper, 28" × 39". Photograph: Steve Perry.

# THE ANATOMY OF A FRAME

While works on canvas are seldom displayed under glass, other kinds of framed artworks are. These include prints, paintings, drawings, delicate fiber pieces and fragile three-dimensional works in box frames. Typically, four components are used in framing these kinds of works: the frame itself, the glass, the mat and the backing.

Frames are usually sold at a certain price per foot based on the measurement around the outer perimeter of the work. When calculating costs, remember that the mat will add to the work's dimensions. Keep in mind, too, that framing is a customized process built around each individual work of art; costs reflect this unique attention.

Although most of your focus when choosing a frame will be on its appearance, there are some important practical concerns to be considered as well. Obviously, you will need to be sure the frame you choose is strong enough to support the weight of your artwork; if there's any question, select a different style. And be certain that the framing elements are separated from the surface of the artwork, since any rubbing of the frame on the artwork will cause damage. Spacing materials placed between the artwork and the frame will prevent this problem.

## GLASS

There are two choices when it comes to glass for framed artwork: standard glass and conservation glass. Standard glass is rarely specified for framing these days, since it provides minimal protection against ultraviolet light—which causes fading—and offers only fractional savings over conservation glass. A third option, plexiglass, is an excellent choice under some circumstances.

Conservation glass, which is coated to shield the framed work against the most harmful rays in the ultraviolet spectrum, is available in various qualities and thicknesses. An optional anti-reflective coating minimizes the visual distractions caused by reflections. Most standard and conservation glass has a slight or noticeable greenish tint, depending on how much iron is contained in the glass. "Water-white" conservation glass eliminates the green tint altogether, making for a very clear glass.

Use a soft, clean brush to dust the glass periodically, along with the other components of the frame. When needed, apply a glass cleaner on a soft, clean cloth rather than by spraying; sprayed cleaner can find its way under the glass and damage the artwork.

### Plexiglass

The term "Plexiglas" is trademarked by Rohm and Haas, the largest specialty chemicals company in the United States. However, a number of manufacturers produce the clear plastic sheeting used to frame art, and the terms "plexiglass" and "plexi" are now used universally.

Plexiglass became popular initially for use with lower-priced artworks like posters. However, continued advances have improved the quality of the material so that it's now an attractive alternative to conservation glass. It's also lighter than glass and does not break easily, making it the preferred choice for very large framed artwork and for framed artworks hanging in children's rooms. Plexi is available with optional ultraviolet protection and anti-reflective glazing. Since plexiglass tends to flex and bow, reflecting light

from its surface, an anti-reflective coating is a particularly desirable feature.

A few notes regarding plexiglass. The material's slight grayish tint is so pale that it's generally not a concern. Likewise, its resistance to abrasion has improved substantially in recent years, solving one of the traditional concerns regarding older forms of plexiglass: its tendency to scratch. However, it is important that plexiglass not be used for framing artworks made with a loose medium like pastels or charcoal. Plexi creates substantial amounts of static, which can actually pull pastel or charcoal particles off a sheet of paper.

When it comes to cleaning, be sure to use special plexiglass cleaners available from art supply, hardware and home improvement stores. Used as directed, these products clean and protect the plexi without clouding its surface. Do *not* use glass cleaners on plexi, as they will visibly damage the surface.

## MATS

Mats are made of heavy paper stock (called "board") or fabric, and are used to separate the artwork from the frame and glass both physically and visually. Mats come in a variety of finishes, including smooth, textured and linen. Conservators recommend using four-ply, 100 percent rag board or acid-free fabric. Matting materials of a lesser quality contain acid and will damage artwork.

Mats have an important functional purpose in that they create a protective space between the glass and the art. They can also dramatically enhance the presentation of two-dimensional artwork. A wide mat adds presence to any size painting, print or photograph, while double mats lend a refined quality to a framed work. Although mats are available in many colors, most artworks look best against neutral grays, blacks and off-whites; these colors are unobtrusive and they wear well over time. In any case, your eye should never be drawn to the mat; instead, the mat should help to focus attention on the art.

Always be sure there is enough matting around the artwork to enable the work to breathe. Three to four inches is standard, but discuss this with your framer, as his or her experience is invaluable.

A "floating mount" is an interesting alternative to a typical mat—especially when the perimeter of the artwork is asymmetrical. Instead of cutting the mat as a rectangular "window" frame around the artwork, the framer uses cushioning strips to attach the work to the top of a solid mat, so that the art appears to float. This technique is most often used with small pieces. "Close framing," another option, eliminates the mat completely, so that the artwork extends to the frame; this treatment can make an image feel clean and fresh. Professional framers will introduce you to a range of matting techniques to suit a particular piece of work.

## BACKING

The last structural layer in a framed artwork is the backing, which is usually made of pH-neutral foam core. Tyvek, which is waterproof as well as tear- and puncture-resistant, is also used as a backing material; the extra expense is worth considering for important artwork purchases. A sheet of nonacid paper adhered to the back of the frame seals the framing components against dust.

# ROB EVANS

ROB EVANS STUDIO ■ 7152 ROUNDTOP LANE ■ WRIGHTSVILLE, PA 17368 ■ TEL 717-252-1956 ■ FAX 717-252-3526
WWW.ROBEVANSART.COM

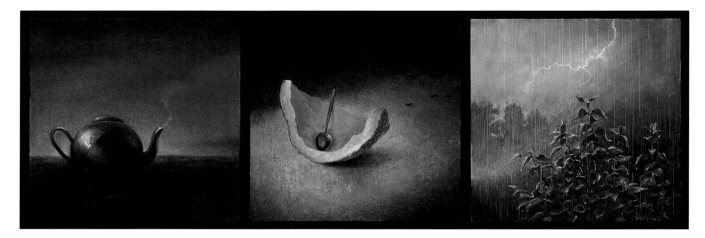

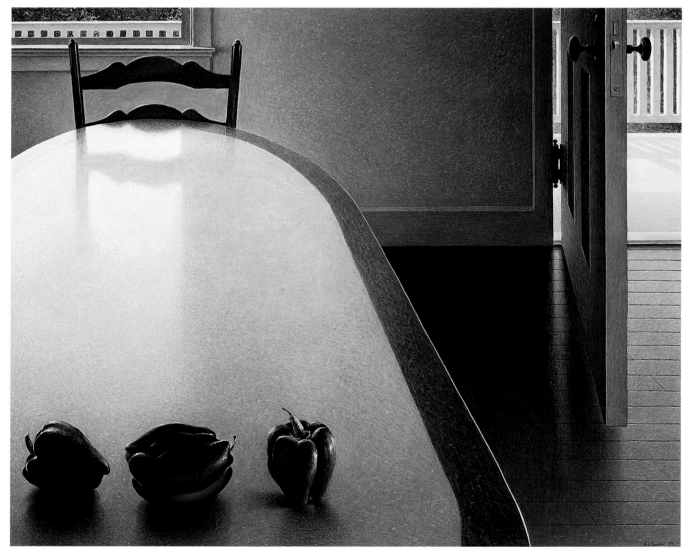

Top: *States of Mind*, oil, 11" × 32", private collection, giclee reproduction available, image size: 11" × 32".
Bottom: *Peppers*, mixed media on paper, 21" × 25", private collection, giclee reproduction available, image size: 21" × 25".

# ROB EVANS

ROB EVANS STUDIO ▪ 7152 ROUNDTOP LANE ▪ WRIGHTSVILLE, PA 17368 ▪ TEL 717-252-1956 ▪ FAX 717-252-3526
WWW.ROBEVANSART.COM

*Refuge,* oil on panel, 48" × 48", collection of Southern Alleghenies Museum of Art, Loretto, PA, giclee reproduction available, image size: 31" × 31".

# STEVE HEIMANN

196 STEFANIC AVENUE ▦ ELMWOOD PARK, NJ 07407 ▦ TEL 201-797-5434
E-MAIL STEVE@STEVEHEIMANN.COM ▦ WWW.STEVEHEIMANN.COM

Top: *Intolerant Society*, 2001, oil on canvas, 24" × 36".  Bottom: *Genome I*, 2001, oil on canvas, 40" × 32".

# GREGORI MAIOFIS

WILLIAMS, BELL AND ASSOCIATES, INC. ▦ 707 18TH AVENUE SOUTH ▦ NASHVILLE, TN 37203
TEL 615-327-8008 EXT. 1126 ▦ FAX 615-329-1689 ▦ E-MAIL INFO@WILLIAMS-BELL.COM ▦ WWW.MAIOFIS-WBA.COM

43

Top: *Tomb of the Wrestlers* (detail), 2000, acrylic on canvas, 63" x 116".  Bottom: *Curious*, 2001, hand-colored gelatin silver print, 16" x 15.75".  Photographs: Andrej Mushtavinsky.

# TALKING TO THE ARTIST
## Charles Munch

Are Charles Munch's enigmatic paintings contemporary icons for a Nature religion? Or are they a kind of Pop-style exploration of an artistic territory somewhere between Van Gogh and comic books? Munch describes himself as an artist in search of the meaning of the term "semi-abstract."

"My first college art course was in calligraphy and historic lettering. I also worked as a professional sign painter. I still find something mysterious about letters—how we create such depth and meaning out of these linear shapes." After graduating, Munch spent three years in New York studying to be a painting conservator. Today he restores artwork for museums and private collectors in Wisconsin and elsewhere.

Although Munch says he has no conscious sense of the source of his images, his work in general—and his large-scale landscapes in particular—are an ongoing exploration of our relationship with the land, and the often uneasy tension between humanity and the rest of nature. "I enjoy turning natural forces—growth, weather and light—into compositional forces in my paintings. When human figures appear, they usually raise questions for the viewer: 'What are the figures doing?' 'What is their place in the environment?' 'Are they fearful or reflective, peaceful or dominating?'"

Although Munch's design vocabulary emphasizes the tremendous power of the simplified line and the strong emotion provided by intense color, he downplays the influences of Postimpressionism, Pop and much of modern art on his work. Instead, he cites fifteenth-century Italian painters like

Ted Haglund

Piero della Francesca and Giovanni Bellini as his primary models.

"What I share with the older painters is a determination to create something beautiful, to present a complex subject—perhaps even a narrative—in a profound way," he explains. "In a sense, I do want my work to function as a kind of icon, as an object of meditation. The similarity between religious icons and signs brings me back to my beginning. I am still a sign painter, but of a different kind."

—Susan Troller

# CHARLES MUNCH

S10093 BEAR VALLEY ROAD ▪ LONE ROCK, WI 53556 ▪ TEL 608-583-2431 ▪ E-MAIL CHARLES_MUNCH@YAHOO.COM

Top left: *Resurrection*, 1993, collection of Robert Brink, New York, NY, oil on canvas, 48" x 32".
Top right: *Man Bear*, 2001, oil on canvas, 36.5" x 44", courtesy of the Tory Folliard Gallery, Milwaukee, WI.
Bottom: *Finding the Sword*, 2002, oil on canvas, 22" x 44" , courtesy of the Grace Chosy Gallery, Madison, WI. Photograph: Harper Fritsch Studios.

# PHYLLIS RAY

SUNNY ARMS ARTIST'S CO-OPERATIVE ■ 707 SOUTH SNOQUALMIE STREET #1-B ■ SEATTLE, WA 98108
TEL 206-682-3991 ■ FAX 206-682-0701 ■ E-MAIL PHYLLISART@W-LINK.NET ■ WWW.SUNNYARMS.COM

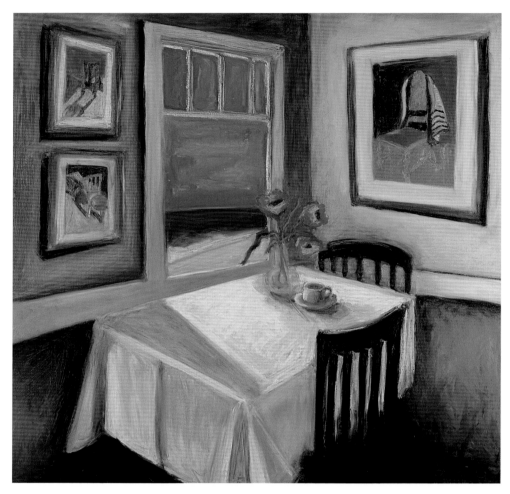

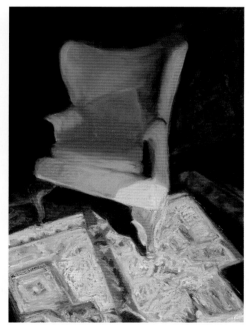

Top: *Ocean Window*, 2002, oil bar, 36" x 36". Photograph: Lynn Thompson.
Bottom left: *Chair in Gold Light*, 2001, oil bar, 21" x 17". Photograph: Craig Sherburne. Bottom right: *Yellow Chair and Rug*, 2001, oil bar, 27" x 19". Photograph: Craig Sherburne.

# ANTHONY ROSS

ANTHONY ROSS STUDIO AND GALLERY ■ 207 NORTH BROADWAY SUITE L ■ SANTA ANA, CA 92701
TEL 714-547-7778 ■ FAX 714-547-7765 ■ E-MAIL ANTHONY@ROSS-ART.COM ■ WWW.ROSS-ART.COM

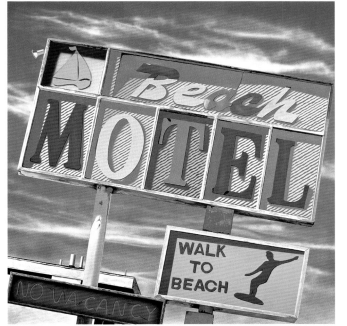

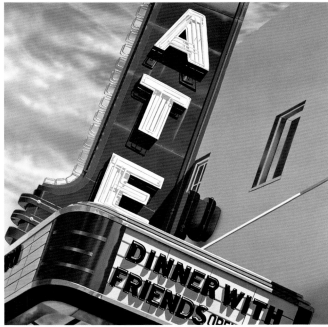

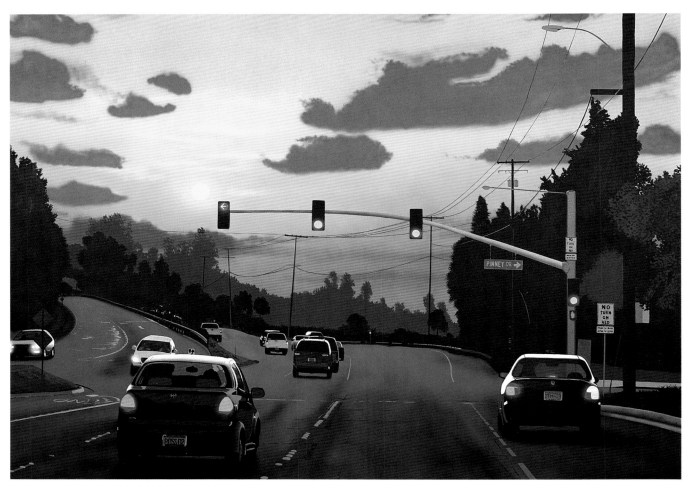

Top left: *Beach Motel,* 2002, acrylic on canvas, 48" × 48". Top right: *Dinner with Friends,* 2002, acrylic on canvas, 36" × 36". Bottom: *No Turn on Red,* 2002, acrylic on canvas, 48" × 60".

# GARY D. GRAY

10 HIGHLAND DRIVE ■ PENFIELD, NY 14526 ■ TEL 585-586-1357 ■ FAX 585-383-6055

48

Top: *Dory Yard*, watercolor, 34" x 27". Bottom: *Fir Point*, watercolor, 37" x 27". Photographs: Richard Margolis.

# PATRICIA GEORGE

ART STUDIO OF PATRICIA GEORGE ▪ 4025 SELKIRK COURT ▪ CYPRESS, CA 90630 ▪ TEL 714-826-7945 ▪ FAX 714-995-5149
E-MAIL PATRICIAARTIST@AOL.COM ▪ WWW.WORLDSBESTART.COM

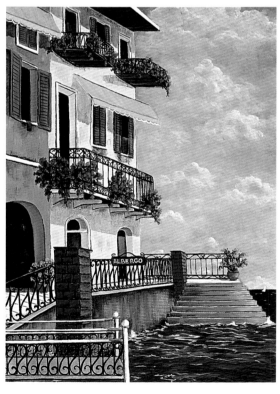

Top: *Piazza Vespucci, Italy*, oil on canvas, 40" × 30".
Bottom right: *Lake Como, Italy*, oil on canvas, 36" × 24". Bottom left: *Walkway in Estonia*, oil on canvas, 40" × 30".

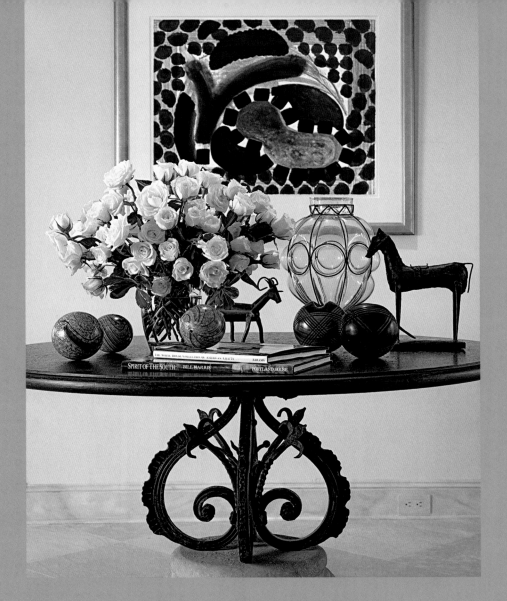

# THE ROOMS OF YOUR HOME
## The Entryway

The map of your home begins at its threshold. Doors and openings anchor the main thoroughfares and connect the outside world to your sanctuary within. Your entry also provides an excellent starting point for the practice of balancing function and comfort; it sets the stage for the style and mood that unfold as you move into your home. Lighting should be warm and easily adjustable, helping those who enter transition from outdoor light to the composed lighting within.

The artwork you place in the entryway creates the first impression guests receive of your home. Entryways are perfect spaces for small, framed artworks. The confined space encourages an intimate interaction between the viewer and the art. Small sculptures and objects can also be intriguing introductions to the story of your home.

Do your best to keep your entryway free of clutter and obstructions. Be sure that you have sufficient shelves, racks and hooks to store coats, hats, shoes and the like. Let the energy flow through this important channel, and don't hesitate to change the art on display, letting it evolve over time.

Above: The dark shapes in this wall piece are reminiscent of the curves of the table's base in this lush interior arrangement by Mary Drysdale. Photograph: Andrew Lautman.

# HELEN KLEBESADEL

2017 JENIFER STREET ■ MADISON, WI 53704 ■ TEL 608-241-3078 ■ E-MAIL KLEBESADEL@TDS.NET

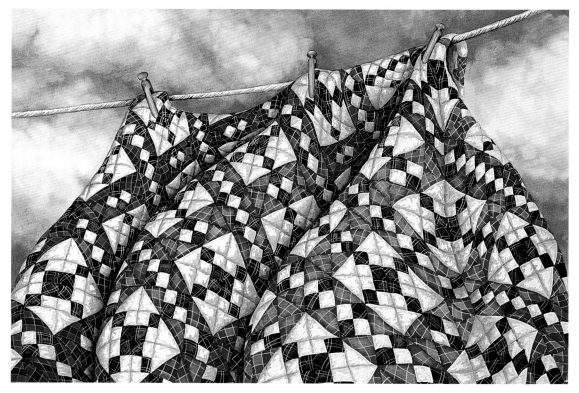

Top left: *Victorian Crazy*, watercolor, 30" × 22", giclee print: 20" × 16". Top right: *Orientation Quilt*, watercolor, 30" × 22", giclee print: 20" × 16".
Bottom: *Freedom Quilt*, watercolor, 30" × 40", giclee print: 16" × 20".

# PAT CASHIN

PAT CASHIN STUDIO ▦ 191 SW 12TH STREET ▦ LOVELAND, CO 80537 ▦ TEL/FAX 970-278-0802
E-MAIL IAM@PATCASHIN.COM ▦ WWW.THEPAINTINGCENTER.COM/ARTFILE/CASHIN ▦ WWW.ARTISTSREGISTER.COM/ARTISTS/CO1212

52

Top: *Oval Gold #20-6*, 2000, acrylic on canvas, 52"W × 52"H.  Photograph: Terry Schank Photo.
Bottom: *Sense of Place #21-4*, 2001, acrylic on wood, 54"W × 48"H.  Photograph: Pat Cashin.

# PAUL VINCENT

609 FOREST HILL DRIVE ■ SHELBY, NC 28150 ■ TEL 704-482-3710
E-MAIL DDVVINCENT@YAHOO.COM ■ WWW.GUILD.COM

*April*, watercolor paper weaving, 46" x 63".

# MIRANDA MOSS

252 FIRST AVENUE NORTH ■ MINNEAPOLIS, MN 55401 ■ TEL 612-375-0180 ■ FAX 612-342-2424
E-MAIL MMOSS@YAMAMOTO-MOSS.COM ■ WWW.YAMAMOTO-MOSS.COM

54

Top: *Springtime,* from the *Four Seasons* series, 2001, oil on canvas, 9' × 6'.  Bottom: *Gateways,* from the *Origins* series, 2001, oil on canvas, 9' × 6'.  Photographs: Paul Najus.

# JERRI CHRISTIAN

2317 ROUTH STREET ◼ DALLAS, TX 75201 ◼ TEL 214-336-1963 ◼ E-MAIL GUMBALLCHICKEN@YAHOO.COM

Left: *Esmeralda*, acrylic and collage on canvas, 60" × 24". Top right: *Crimson Spirit*, acrylic on paper, 27" × 20".
Bottom right: *The Observer*, acrylic on paper, 30'' × 22". Photographs: Expert Imaging, Inc.

# KATHARINA SHORT

PERENNIAL VISIONS STUDIO ■ 314 MORRISSEY BOULEVARD ■ SANTA CRUZ, CA 95062
E-MAIL KATHARTS@PACBELL.NET ■ WWW.TINASHORT.COM

Top left: *Home Again*, 2002, acrylic on birch panel, 24" × 36". Right: *In the Garden*, 2002, acrylic on masonite, 24" × 48".
Bottom left: *Dreamy Waitress*, 2002, acrylic on canvas, 30" × 36". Photographs: Paul Titangos.

# DEBRA NICHOLAS

DEBRA NICHOLAS STUDIO ■ TEL 202-244-4166
E-MAIL STUDIO@DEBRANICHOLAS.NET ■ WWW.DEBRANICHOLAS.NET

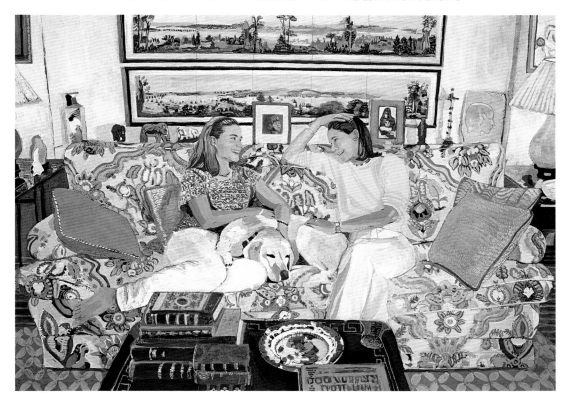

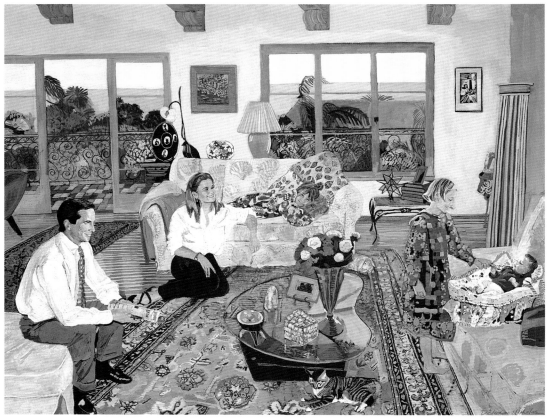

Top: *Sweet Peas*, gouache, 27" × 37". Bottom: *Bel' Aqua*, gouache, 34" × 45". Photographs: Xystus Studio.

# THE ROOMS OF YOUR HOME
## Kids' Rooms

If you have young children, your home will often feel overrun with their playthings. Between Barbie and Barney and all the other kid gear, there may be moments when your home feels more like a sanitarium than a sanctuary.

Children change quickly as they grow up, and their surroundings need to reflect this fact. Keep this in mind when decorating and furnishing their rooms. Children's rooms should be simple and cozy—and flexible enough to allow changes as the kids grow and mature. Involve them in the design of their rooms and share the decision-making process. Include them when choosing colors and engage them in the painting and furnishing experience.

Use your kids' rooms to stimulate creativity and to introduce them to art. If you can, consider commissioning an artist to do a custom mural on the walls or ceilings of your child's room. If your budget won't stretch that far, consider artist-made, child-size furniture or bright, cheerful prints framed with unbreakable plexiglass. The artworks we see when we're children are vividly fixed in our memories, so these are important choices.

Above: Golds, pinks and greens harmonize in the playful furniture and wall pieces of this inviting children's space. Interior design by Mary Drysdale. Photograph: Andrew Lautman.

# ARDITH STAROSTKA

STAR STUDIO ARTS ■ #31 CLEAR LAKE ■ COLUMBUS, NE 68601
TEL 402-562-6686 ■ FAX 402-564-9844 ■ WWW.STARSTUDIOARTS.COM

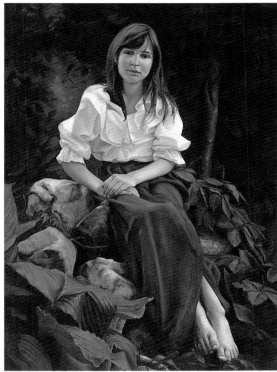

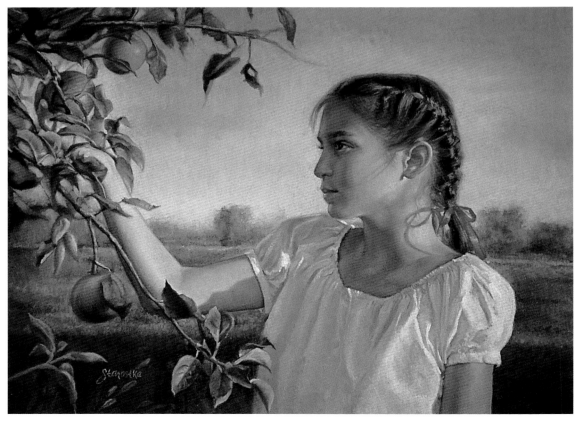

Top left: *Lacey,* oil on canvas, 24" × 36". Top right: *Upon the Rocks,* oil on canvas, 24" × 36".
Bottom: *Late Summer Apples,* pastel, 18" × 24".

# JOAN SKOGSBERG SANDERS

3156 STEVELY STREET ■ LONG BEACH, CA 90808 ■ TEL 562-421-5369 ■ FAX 562-435-2209
E-MAIL SKOGSBERG@AOL.COM ■ WWW.GUILD.COM

Top left: *Hadith*, 1999, mixed media on paper, 22" × 18". Top right: *Rabat*, 1999, mixed media on paper, 24" × 18".
Bottom: *Moussem*, 2001, mixed media on paper, 18" × 24".

# TALKING TO THE ARTIST
## Brian T. Kershisnik

By the age of 18, Brian Kershisnik had lived in four different countries. His father, a petroleum geologist, relocated the family from Oklahoma to Angola; from Angola to Thailand; from Thailand to Texas; and from Texas to Pakistan.

"I've always felt somewhat out of place, but I think that being a stranger may be more of a universal experience than belonging," says Kershisnik, who ultimately settled in the small Mormon town of Kanosh, Utah. "I believe that humanity is largely motivated by a sense of belonging to something we haven't quite seen yet but can *almost* remember. Being awkward is a part of life."

And, he realizes, a part of art. The people in his paintings—drawn in bold, charcoal outlines, but often left with unfinished features—are often out of place themselves. In *Father and Son Dancing*, a man holds his infant son on his shoulder. It could have been painted as a pure expression of joy, but this father is clumsy, heavy-footed. In *Flight Practice with Instruction*, a man tries to fly, but is tethered to the ground like a kite on a string. He is not flying as much as *practicing flight*, a crucial theme for the artist.

"Several summers ago, I saw a man in his front yard practicing his cast with a new fly rod. My comment to my wife was quite accidental. 'Look. That man is practicing flying.' She is quite used to my making such mistakes and rather than

correcting me suggested it was a good idea for a painting. As I began sketching, I realized how vital the issue of 'practice' has been in my work, though I had never before named it. How splendidly human it is to practice. Everything we do can be seen as practice, as long as we believe that the failure of our current task will sooner or later—and probably gradually—give way to something lovely, even beautiful."

—Jori Finkel

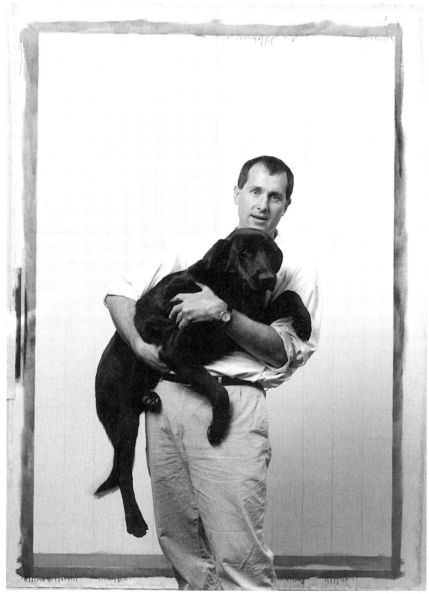

John Snyder

See following pages for paintings and prints by Brian Kershisnik.

# BRIAN T. KERSHISNIK

PO BOX 89 ■ KANOSH, UT 84637 ■ TEL 435-759-2649 ■ FAX 435-759-2570
E-MAIL ART@KERSHISNIK.COM ■ WWW.KERSHISNIK.COM

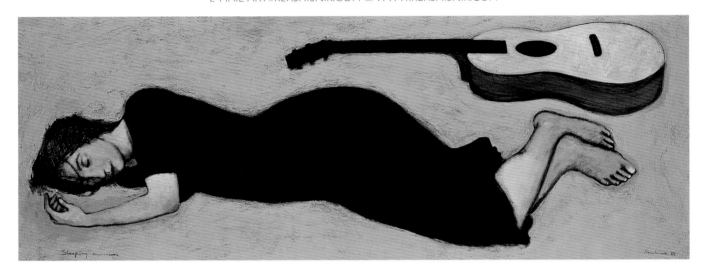

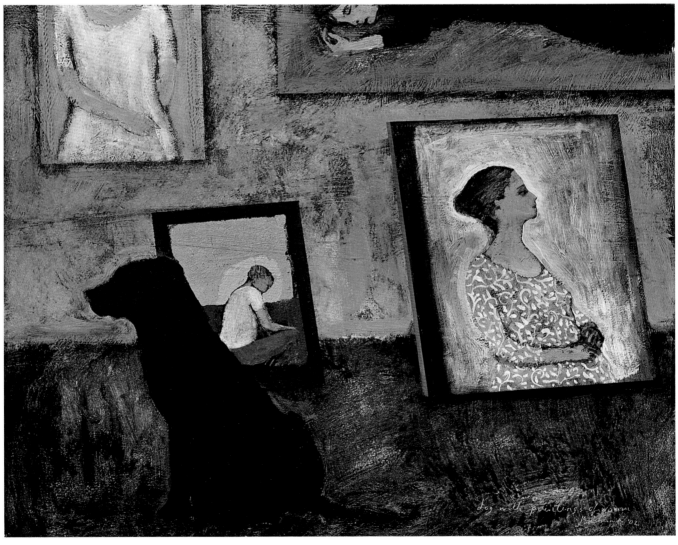

62

Top: *Sleeping Musician*, 2001, oil on panel, 32" x 85". Bottom: *Dog with Paintings of Women*, 2002, oil on panel, 20" x 24". Photographs: David Hawkinson.

# BRIAN T. KERSHISNIK

PO BOX 89 ■ KANOSH, UT 84637 ■ TEL 435-759-2649 ■ FAX 435-759-2570
E-MAIL ART@KERSHISNIK.COM ■ WWW.KERSHISNIK.COM

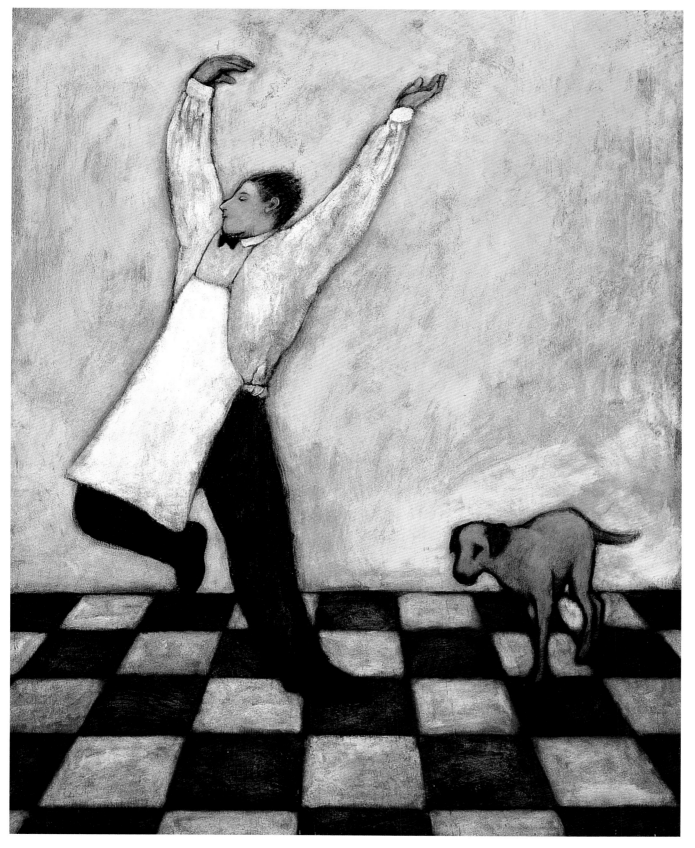

*Dog and Dancing Servant*, 1996, oil on panel, 54" x 42", limited edition, giclees available through GUILD.com. Photograph: Leon Woodward.

# HEATHER BAUSE

STELLAWERKS ■ 425 HEIGHTS BOULEVARD #1 ■ HOUSTON, TX 77007 ■ TEL 713-863-1909
E-MAIL HEATHER@STELLAWERKS.COM ■ WWW.STELLAWERKS.COM

Top: *Cinemexico*, 2002, oil on canvas, 60" × 72".   Bottom: *Sunbather*, 2002, oil on canvas, 24" × 36".

# AMOS MILLER

5741 SW 84TH STREET ▪ MIAMI, FL 33143 ▪ TEL 305-668-3536
E-MAIL AMILLER1307@EARTHLINK.NET

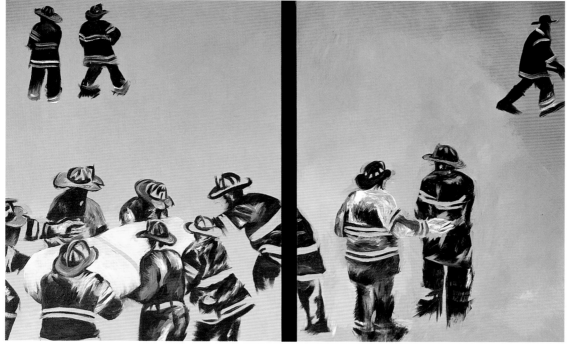

Top: *Ordained*, 2002, acrylic on canvas, 26" x 34".  Bottom: *Firefighters*, 2002, acrylic on canvas, diptych, each panel: 52" x 40"; total size: 52" x 84".  Photographs: Daniel Portnoy.

# RITA BLITT

RITA BLITT, INC. ■ 8900 STATE LINE SUITE 333 ■ LEAWOOD, KS 66206 ■ TEL 800-627-7689 ■ FAX 913-381-5624
E-MAIL RITA@RITABLITT.COM ■ WWW.RITABLITT.COM

66

Top: *Dancing Waters II*, 2001, acrylic and oil on canvas, 48" × 60".  Bottom: *Udow Percussion II*, 2001, acrylic on canvas, 48" × 60".

# RITA BLITT

RITA BLITT, INC. ■ 8900 STATE LINE SUITE 333 ■ LEAWOOD, KS 66206 ■ TEL 800-627-7689 ■ FAX 913-381-5624
E-MAIL RITA@RITABLITT.COM ■ WWW.RITABLITT.COM

*August, 2001*, acrylic and oil on canvas, 48" × 36". Photograph: Stuart Huck.

# TIPS FOR AN ARTFUL HOME
## Balance and Symmetry

The introduction of artwork often has a dramatic influence on the balance of a room. Although a symmetrical arrangement, such as a rectangular painting over a sofa or similar-sized pieces on either side of a mirror, is the most conventional way to display art, some works lend themselves to asymmetrical placement. Try any new piece in several settings before settling on a location—and take your time. Once you find the right fit, the artwork will resonate, and the room will feel more complete and composed.

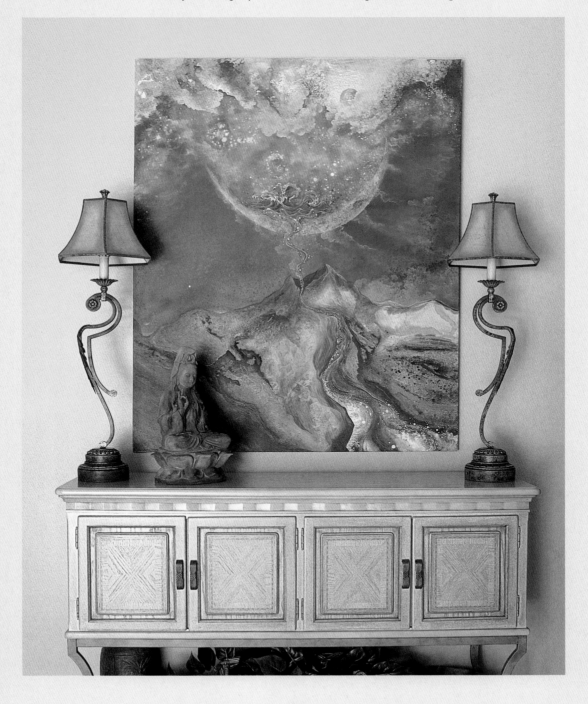

Dana Lynne Anderson, *Mystic River*, acrylic and pastel painting. Photograph: Rosalie Wardell Photography. See page 85.

# MICHELLE LINDBLOM

MICKART STUDIO ▪ 3316 HACKBERRY STREET ▪ BISMARCK, ND 58503 ▪ TEL/FAX 701-258-2992
E-MAIL MICKART@BIS.MIDCO.NET ▪ WWW.MICK-ART.COM

Top left: *Thrust*, 2001, monotype, 24" x 15". Top right: *Evolving Essence*, 2000, acrylic on canvas, 50" x 40".
Bottom right: *Resurrection from Pain*, 1999, monotype, 24" x 15". Bottom left: *Spiritual Revelation*, 2000, acrylic on paper, 30" x 22".

# BEATRICIA SAGAR

810 LINCOLN ROAD. #109 ■ MIAMI BEACH, FL 33139 ■ TEL 305-609-7996
E-MAIL BEASAGAR@AOL.COM ■ WWW.BEATRICIASAGAR.COM

Top: *Totem Paintings*, 2002, mixed media, 14" × 60".
Bottom right: *Time Moving Through the Orchard*, 2002, mixed media, 30" × 30".
Bottom left: *Landscape of Sunshine Through the Twilight*, 2002, mixed media, 48" × 48".

# KAREN SCHARER

SCHARER FINE ART, INC. ■ 1150 SOUTH PEAKVIEW DRIVE ■ CASTLE ROCK, CO 80109 ■ TEL 303-660-9037 ■ FAX 303-688-0367
E-MAIL KAREN@SCHARERFINEART.COM ■ WWW.SCHARERFINEART.COM

Top left: *Improvisation*, 2001, acrylic, 29" x 21". Top right: *Creative Spirit 1*, 2002, acrylic, 29" x 21". Bottom: *Soul Mates*, 2002, acrylic, 30" x 38". Photographs: Reed Photo-Imaging.

# DAVID MILTON

4750 DEGOVIA AVENUE ■ WOODLAND HILLS, CA 91364 ■ TEL 818-224-2164 ■ FAX 818-224-2163
E-MAIL DAVID@DAVIDMILTON.COM ■ WWW.DAVIDMILTON.COM

Top: *Lunar Wisdom*, 2001, oil bar on canvas, 108" × 47". Bottom left: *Portal*, 2001, oil pastel and oil bar on paper, 30" × 42".
Bottom right: *Nurturing Observed*, 2001, mixed media on canvas, 36" × 48". Photographs: Gregg Podolski.

# WILLIAM HARSH

WILLIAM HARSH STUDIO ■ 701 EAST H STREET ■ BENICIA, CA 94510 ■ TEL 707-745-8501 ■ FAX 707-746-6522
E-MAIL BILL@WILLIAMHARSH.COM ■ WWW.WILLIAMHARSH.COM

Top: *Thirst*, 2001, oil on canvas, 32" × 42". Bottom: *Odds and Ends*, 2001, oil on canvas, 44" × 52". Photographs: Hedi Desuyo.

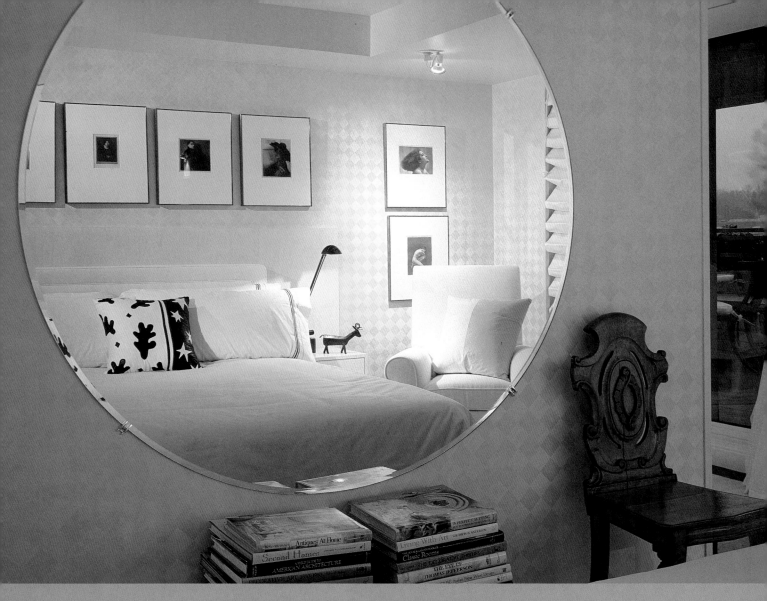

# THE ROOMS OF YOUR HOME
## The Bedroom

A bedroom should be a quiet haven for intimacy and reflection. It's also the perfect set-ting for creating mood and atmosphere. The color palette should be calm and soothing, with sources of light and sound dimmed and softened at the end of the day. Since the bedroom is a private space, it invites experimentation and expressiveness.

As you think about artworks for the bedroom, begin by considering the bed itself. Furniture makers will be happy to show you photographs of bed frames made for pre-vious clients or discuss a unique design specifically for you. Bedside tables, lamps and wall sconces are also special when made by an artist. Like wood, fiber is very much at home in a bedroom. Tapestries or art quilts can create a strong visual impact and pro-vide a practical benefit by softening sounds.

The bedroom is particularly well suited for art that has strong personal meaning. Many collectors place favorite paintings or objects in the bedroom so they can enjoy them first thing in the morning and last thing at night. Others like to use bedroom walls for black-and-white photographs that invite the eye to relax and encourage contemplative thoughts.

Above: Interior design by Mary Drysdale. Photograph: Andrew Lautman.

# STEVE WALKER

6122 CROSSLAND BOULEVARD ▪ GURNEE, IL 60031 ▪ TEL 847-549-7462
E-MAIL STEVE@ILIVEFORART.COM ▪ WWW.ILIVEFORART.COM

Top: *Reclining Nude,* oil on canvas, 5' × 15'.  Bottom: *Electric Slam,* oil on canvas, 45" × 64".

# CALLAHAN McDONOUGH

RUBY SLIPPERS STUDIO ■ 512 HAROLD AVENUE ■ ATLANTA, GA 30307 ■ TEL 404-373-7370
E-MAIL RUBYSLIPPERSSTUDIO@MINDSPRING.COM ■ WWW.RUBYSLIPPERSSTUDIO.COM

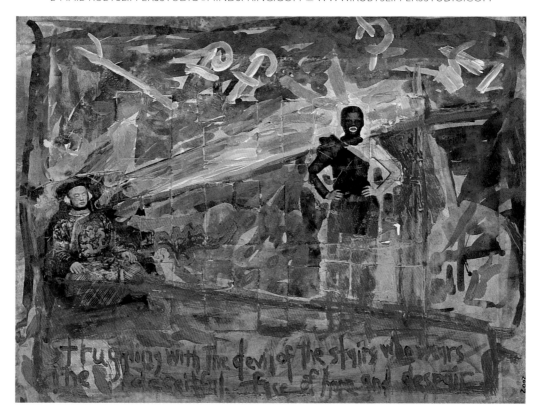

76

Top: *Devil of the Stairs*, 2002, mixed media on canvas, 40" x 32".
Bottom: *Baubo*, from the *Goddess* series, 2002, mixed media on canvas, 5.5' x 7'.

# CALLAHAN McDONOUGH

RUBY SLIPPERS STUDIO ■ 512 HAROLD AVENUE ■ ATLANTA, GA 30307 ■ TEL 404-373-7370
E-MAIL RUBYSLIPPERSSTUDIO@MINDSPRING.COM ■ WWW.RUBYSLIPPERSSTUDIO.COM

Top: *Rose of Love*, 2002, mixed media on paper, 40" × 32".
Bottom: *High Clear Notes*, 2002, acrylic on canvas, 39.5" × 32.5".

# TERESA COX

308 PRINCE STREET STUDIO 510 ■ ST. PAUL, MN 55101 ■ TEL 651-290-9158 ■ FAX 651-228-0843
E-MAIL TERESACOX@EARTHLINK.NET ■ WWW.TERESACOX.COM

Top: *Night Pods*, 2001, acrylic on canvas, 5' × 4.2', or giclee print, 26" × 22". Bottom: *Hill Pod*, 2002, acrylic on canvas, 5' × 4.2'. Photographs: Don Pitlik.

78

# JUDITH ANTON

ANTON ART GALLERY ▓ 26 McCLINTOCK COURT ▓ IRVINE, CA 92612 ▓ TEL 949-509-9088 ▓ FAX 949-509-9029
E-MAIL ART@ANTONARTGALLERY.COM ▓ WWW.ANTONARTGALLERY.COM

Top: *Seaside Stroll*, 2002, original dye painting: 31" × 42", giclee print: 28" × 22". Bottom right: *Spring Flowers on the Round Table*, giclee print of original dye painting: 22" × 22".
Bottom left: *Copernicus*, 2002, original dye painting, 37" × 48", giclee print, 22" × 27". Photographs: Joseph D'Alessio.

# CHOOSING FRAMES

The framing of art is an art in itself. In fact, before the twentieth century, most frames were designed and crafted as part of the artwork. Walk through any museum of historical paintings, and you'll marvel at the extraordinary craftsmanship revealed in those antique frames.

Today, attitudes toward framing have changed dramatically, allowing for frames that complement artworks in imaginative and varied ways. Some collectors like to use ornate gilded frames to contrast the look and feel of abstract contemporary paintings. Others find vintage frames at flea markets and recycle them to beautifully enhance modern photographs. But in general, spare, minimal framing styles are most popular today. These styles keep the eye focused on the work, not the frame.

When choosing a frame for a two-dimensional work of art, you'll need to consider issues such as protection of the artwork, aesthetic enhancement and cost. Acid-free mats and backings provide critical protection for the artwork. Likewise, conservation glass, which filters ultraviolet light, protects against fading. In this important respect, protection is linked to cost.

Local frame shops offer outstanding resources for the consumer. They keep an extensive inventory of frame styles on hand, and display prints and photographs in various combinations of mats and frames. Professional framers will take the time to answer your questions and help you understand the craft of framing.

## AN APPROACH TO FRAMING

Your approach to framing should begin with a focus on the artwork itself. Stay in touch with the work's emotive qualities, and be sure your choice of frame doesn't distract from the art but is, instead, in service to it. Think about why the work is important to you, and determine how the addition of a frame might best convey that message.

### Materials and Surfaces

Painted aluminum and wood are affordable and versatile choices for frames; finished in antique gold or aged platinum, they're elegant and enduring; painted in bright colors, they're amusing and festive. Natural wood is usually my surface of choice; it's tasteful, classic and appropriate for most home settings. Vintage frames can be an economical way to add distinct character to an artwork.

As you choose mats and frames, remember that you may want to move the picture at some point in the future. For that reason, it's usually unwise to coordinate frames with specific furnishings.

### Placement

When choosing a frame, consider the environment in which the work will be placed—the room as a whole, as well as the specific wall where the work will hang. Will the piece be a unique focal point or will it co-exist with other artworks? Do you want the frame to simply outline the work or add proportionately to its size and scale?

Before pounding nails into your wall, take these steps to determine the best possible placement. Cut paper to the size of the proposed framed picture, then tape it in posi-

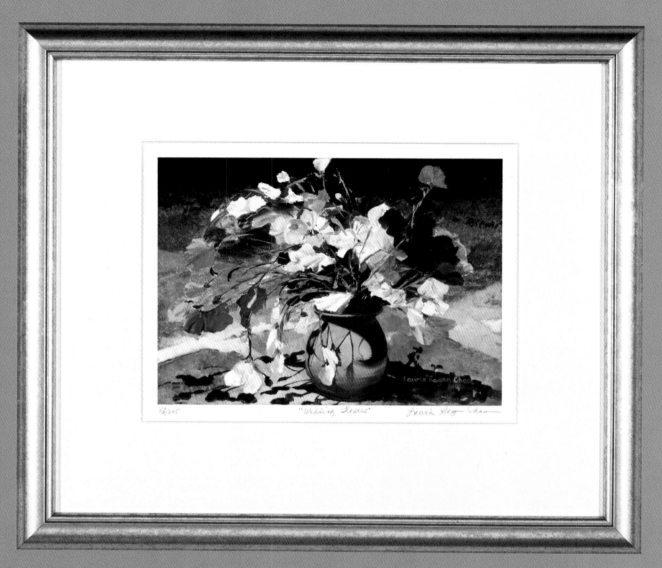

tion on the wall. Step back, get a sense of the impact and adjust the placement as necessary until it feels right. Keep the focus on complementing everything else that's going on in the space. The key is balance.

### Consult the Artist

When commissioning paintings from *Artful Home* artists, be sure to discuss framing. Some artists include frames routinely with their paintings; others don't. If the artwork is sold with a frame, be sure to ask for a description or photograph. If you're not crazy about the proposed frame, don't hesitate to ask about alternatives.

### Gallery Framing

Galleries can provide valuable advice about framing choices. If you're purchasing unframed artwork through a gallery, consider having the framing done there too; it's usually the most efficient alternative. Galleries are aware of the best aesthetic choices for the artists they represent; they're also careful to use archival materials.

Above: Laurie Chase, *Wedding Flowers*, framed giclee print.

# CARING FOR FRAMED ART

Direct sun, heat extremes and moist air all pose threats to framed works of art. Avoid hanging framed artwork in direct sunlight or in unventilated bathrooms or other spaces prone to fluctuating heat and humidity.

## WORKS ON CANVAS

Works on canvas are usually framed without glass. In the case of oil paintings, glass can actually cause damage. Oil paints emit fumes for years; the ventilation afforded by an exposed surface keeps the fumes from harming the painting.

Paintings in oil and acrylic—the mediums most commonly used on canvas—have durable surfaces that can be cleaned directly, with care. Use a soft, clean brush and a gentle motion to dust your paintings (including painted frames), working your way down from the top. At the same time, check for cracks, punctures and fading. If you notice a problem, consult your local picture framer for advice on what action to take. Be careful not to touch the painted surface, as oils from your skin can actually cause it to deteriorate.

## WORKS ON PAPER

Watercolors, prints and other works on paper are generally more delicate than works on canvas, and should be framed under glass. Store unframed works on paper flat (horizontally), in large, acid-free folders cushioned with acid-free tissue. Avoid storing works on paper in cardboard tubes for any length of time. Although sturdy tubes are often a good choice for shipping works on paper, the acid in the cardboard—as well as the curved surface of the tube—can harm the artwork within a matter of weeks.

## PHOTOGRAPHY

The general guidelines outlined above are particularly important in the case of photographs. Avoiding direct sunlight and extreme heat is absolutely necessary with the light-sensitive paper and chemical emulsions used in photography.

## GLASS AND PLEXIGLASS

It's worth the small additional cost to protect photographs and works on paper from fading by using glass and plexiglass with ultraviolet protection. Conservation glass is the best option for most works, but consider plexiglass—which is both lighter and less fragile—for large framed works.

See The Anatomy of a Frame, starting on page 38, for information about cleaning glass and plexiglass.

## STORAGE

When not on display, framed artwork should be stored in a cool, dry area. Avoid stacking pieces on top of one another. Instead, stand them on end separated with sheets of acid-free board, available through art supply stores or frame shops. Don't use standard cardboard, which is highly acidic and can ruin artwork.

# RHONA L.K. SCHONWALD

HISTORIC SAVAGE MILL ▩ 8600 FOUNDRY STREET ▩ CARDING BUILDING #205 ▩ SAVAGE, MD 20763
TEL 410-880-4118 ▩ E-MAIL ICRE8ART2@AOL.COM ▩ WWW.RHONALKSCHONWALD.COM

*Australia – Great Barrier Reef,* (1 of 3), 36" x 36", oil on canvas, limited-edition prints available.

# KERRI LAWNSBY

PROLIFIC MUSE STUDIOS ▧ 59 WASHINGTON STREET SUITE 242 ▧ SANTA CLARA, CA 95050
TEL 408-280-6960 ▧ FAX 408-904-5592 ▧ E-MAIL KERRI@PROLIFICMUSE.COM ▧ WWW.PROLIFICMUSE.COM

84

Top left: *Crazy Dahlias*, 2001, pastel on paper, 18" × 12". Photograph: Dave Monley. Top right: *Rose Daisies in a Vase*, 2001, oil on canvas, 36" × 24". Photograph: Wilson P. Graham Jr. Bottom: *Iris*, 2001, pastel on paper, 12" × 18". Photograph: Dave Monley.

# DANA LYNNE ANDERSEN

AWAKENING ARTS STUDIO ■ TEL 877-463-7443 (TOLL FREE)/707-523-9231
E-MAIL DANA@AWAKENINGARTS.COM ■ WWW. AWAKENINGARTS.COM

*Crown Chakra Blossoming*, acrylic on canvas, 4' × 5'. Photograph: Larry Heirman.

# KRYSTALL BARNES

RURAL ROUTE 1, BOX 55B ■ UNION DALE, PA 18470 ■ TEL 570-222-2324 ■ FAX 570-222-3480
E-MAIL GRAY_ARIES@HOTMAIL.COM ■ WWW.KRYSTALLBARNES.COM

Top: *New Life*, 2002, watercolor, 22" × 30". Bottom: *The Equality of All Things*, 2000, watercolor, 22" × 30".

# CAROLYN HARTMAN

SUNDANCE STUDIO ▓ 14492 TRIADELPHIA MILL ROAD ▓ DAYTON, MD 21036
TEL 301-596-9615 ▓ E-MAIL HARTMANCS2@AOL.COM ▓ WWW.MDARTPLACE.ORG

Top: *Sundance on Stepping Stones*, 2001, multi-image giclee original, paper size: 22" × 31.5", image size: 18" × 27", edition of 275.
Bottom: *Waterflower Reflections*, 2002, multi-image giclee original on canvas, 30" × 40" and 18" × 24", edition of 90.

# TIPS FOR AN ARTFUL HOME
## Combining Old and New

Because we acquire our furnishings and art-works over the course of many years, we are consistently confronted with the challenge of integrating the old with the new. Our most treasured heirlooms may not be fashionable or stylish, but they are always emotive and rich in meaning. Notice how the bright, playful patterns of this contemporary paint-ing invigorate the classic elements of the carefully furnished dining room. By selec-tively combining dissimilar elements, the homeowner has prompted a pleasing sense of surprise and discovery.

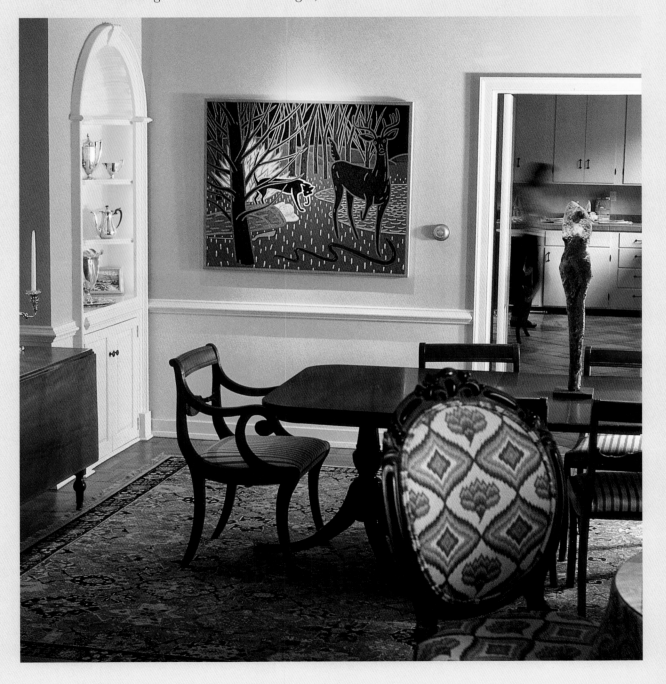

Charles Munch, *The Lake in the Woods,* oil painting. Photograph compliments of the Tory Folliard Gallery. See pages 44-45.

# COLETTE ODYA SMITH

HOLLOW REED ARTS ■ 2471 NORTH 81ST STREET ■ WAUWATOSA, WI 53213-1012
TEL 414-476-7367 ■ E-MAIL COLETTEODYA@SMITH.NET ■ WWW.COLETTEODYA.SMITH.NET

Top: *The Midmost Heart of Creation*, 2000, pastel over watercolor, 20" x 20".
Bottom: *In Good Company*, 2000, pastel over watercolor, 20" x 20".

Top: *Lemon Orbs*, 2002, oil on linen, 40" x 45". Bottom: *Iris Moon*, 2001, oil on linen, 40" x 50".

# GLORIA MATUSZEWSKI

1521 FIFTH STREET ▪ OAKLAND, CA 94607 ▪ TEL 510-444-6340 ▪ FAX 510-832-2610
E-MAIL GLORIAM13@EARTHLINK.NET ▪ WWW.ARTMECCA.COM

Top left: *Three Roses*, oil, 30" × 24", giclee available. Top right: *The White Rose*, oil, 30" × 22", giclee available.
Bottom: *The Lily and the Rose* (detail), oil, 48" × 48", giclee available. Photographs: Black Cat Photo.

# JULIANN JONES

THE FLAT SPACE ▪ 124 NORTH MAIN STREET ▪ LIVINGSTON, MT 59047 ▪ TEL 406-220-1351 ▪ FAX 406-222-8899
E-MAIL JULIANN@JULIANNJONES.COM ▪ WWW.JULIANNJONES.COM

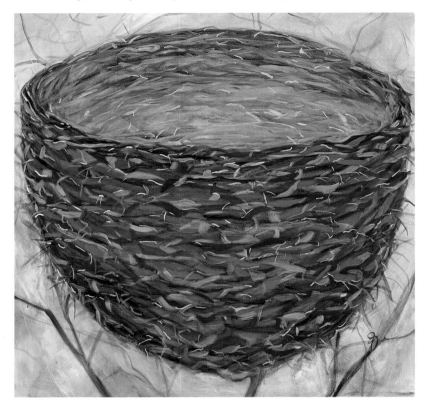

92

Top: *Nest #10*, 2001, casein on canvas, 36" × 36".  Bottom: *Field of Sunflowers*, 2001, casein on canvas, 36" × 36".  Photographs: WMC Photography.

# PAGE SAMIS-HILL

PIGEON STUDIO ▓ 3131-3115 CAPILANO CRESCENT ▓ NORTH VANCOUVER, BC V7R 4H4 ▓ CANADA
TEL 604-990-4571 ▓ E-MAIL PAGESAMIS@SHAW.CA ▓ WWW.ARTBYPAGE.COM

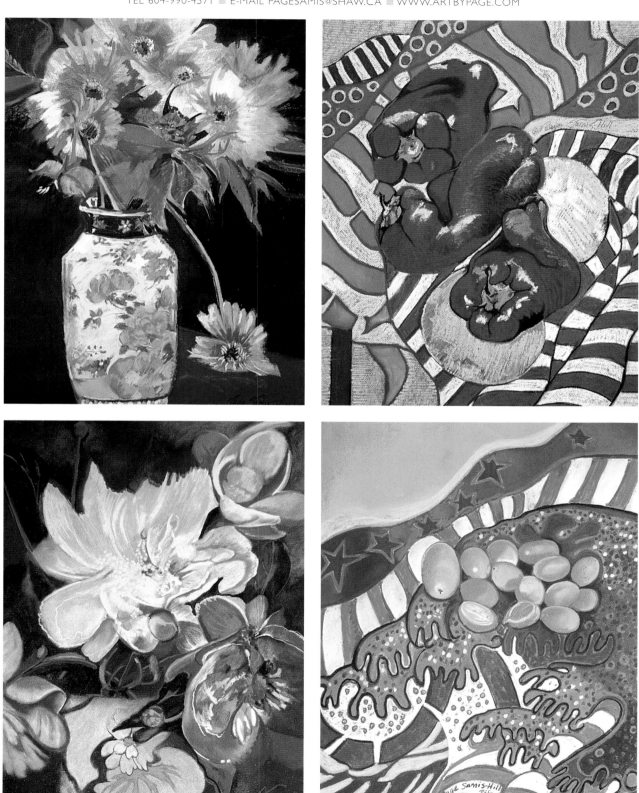

Top left: *Gerbers in Granny's Vase*, 2002, pastel, 22" × 30". Top right: *Red Peppers on a Handpainted Platter*, 2000, pastel, 19" × 24".
Bottom left: *Joy of Peonies*, 2002, pastel, 22" × 30". Bottom right: *Lagniappe on a Platter*, 2002, pastel, 22" × 30". Photographs: Warren Goodman.

# LESTER C. PANCOAST

PANCOASTAL PALMS ■ 3351 POINCIANA AVENUE ■ MIAMI, FL 33133 ■ TEL/FAX 305-448-3724
E-MAIL LPAN@JUNO.COM ■ WWW.PANCOASTAL.COM

94

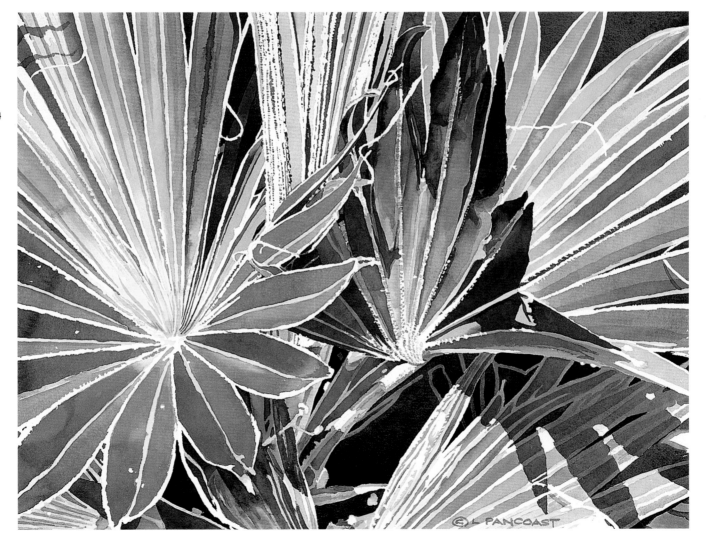

Top left: *Fan Dance*, watercolor, 20" × 27". Photograph: Tom Burk. Top right: *Wake*, watercolor, 16" × 22". Photograph: Tom Burk.
Bottom: *Thrust*, watercolor, 20.25" × 27". Photograph: John Lawrence.

# JUDITH VANACORE

5591 BEACH ELDER WAY ▪ MELBOURNE BEACH, FL 32951 ▪ TEL 321-768-8489
E-MAIL JUDYVANACORE@WEBTV.NET

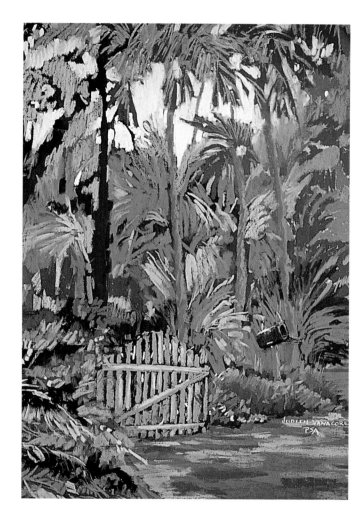 

Left: *Eau Gallie Gateway,* 2000, Florida, pastel, 13" x 18.5". Right: *Cycling the Island,* 2000, Florida, pastel, 15" x 19.5". Photographs: John Andreozzi.

# CHERYL WARRICK

260 ARBORWAY ■ JAMAICA PLAIN, MA 02130 ■ TEL 617-350-0244 ■ FAX 617-524-4387
E-MAIL CEWBR@EARTHLINK.NET

Top left: *Gentle Breeze*, 2001, acrylic mixed media on panel, 22" x 18". Top right: *On Land and Water*, 2001, acrylic mixed media on panel, 22" x 18".
Bottom: *One Kindness*, 2000, acrylic mixed media on panel, 22" x 30". Photographs: Dana Salvo.

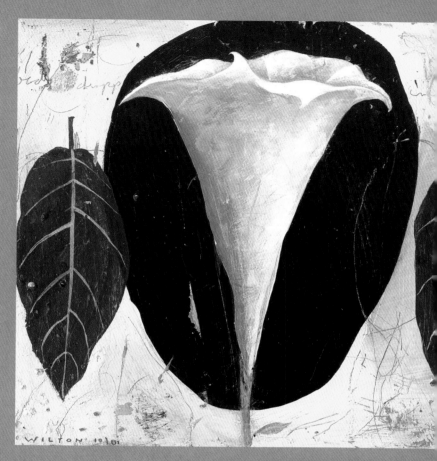

PRINTS

# LORETTA MOSSMAN

LORETTA MOSSMAN STUDIO ■ 290 COLLINS AVENUE #5A ■ MT. VERNON, NY 10552
TEL 914-699-2112 ■ E-MAIL LORETTAMOSSMAN@EARTHLINK.NET

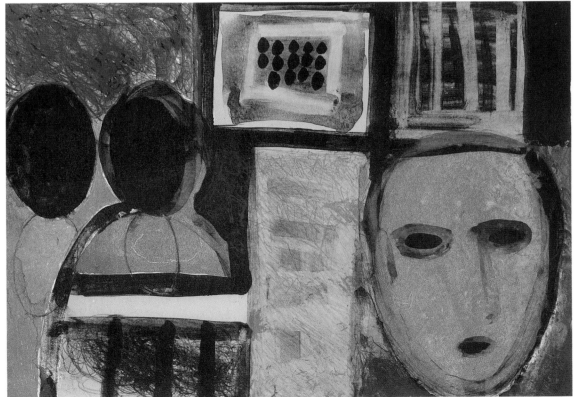

Top: *Rumplestiltsken and the Princess*, 2000, two-color lithograph, 12" x 16". Bottom: *House of Dreams*, 2000, four-color lithograph, 13.5" x 20". Photographs: Jellybean Studios.

# DOUGLAS W. RANDALL

1610 NORTH STREET ■ PHILADELPHIA, PA 19130 ■ TEL 215-235-7898
E-MAIL DWR@DWR2.COM ■ WWW.DWR2.COM

99

Top left: *Reflections #12*, 22" x 19". Top right: *Reflections #23*, 22" x 18.75". Bottom: *Reflections #27*, 22" x 13.75".

# MODESTO PADILLA

DESIGN CONCEPTS UNLIMITED, INC. ■ 881 CAHABA DRIVE ■ AUBURN, AL 36830
TEL 334-826-7728 ■ FAX 630-214-4176 ■ E-MAIL SALES@PHOTOSANDART.COM ■ WWW.PHOTOSANDART.COM

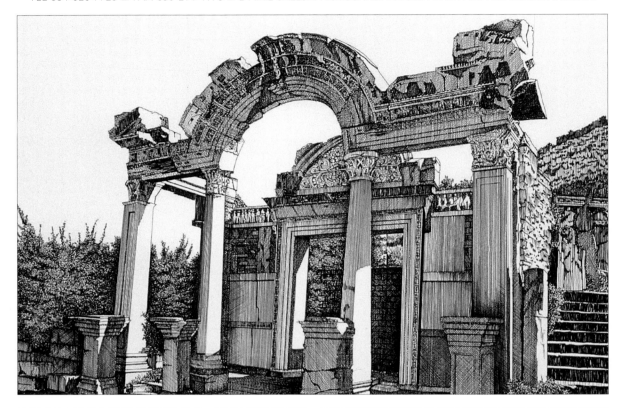

100

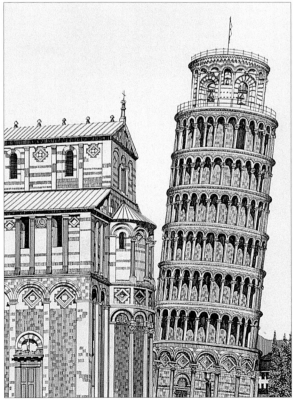

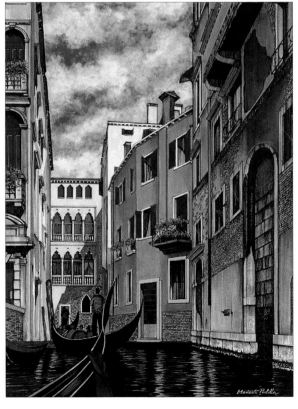

Top: *Hadrian's Temple,* 1999, Ephesus, Turkey, pen-and-ink image, image size: 15"H × 22"W.
Bottom left: *The Leaning Tower of Pisa,* 1999, Pisa, Italy, pen-and-ink image, image size: 20"H × 16"W.
Bottom right: *The Gondola Ride,* 2000, Venice, Italy, pen and ink with liquid acrylic, 30"H × 21"W. Photographs: Donna Corless.

# FRAN BULL

PO BOX 707 ■ CLOSTER, NJ 07624 ■ TEL 201-767-3726 ■ FAX 201-767-7733
E-MAIL FRAN.BULL@VERIZON.NET ■ WWW.FRANBULL.COM

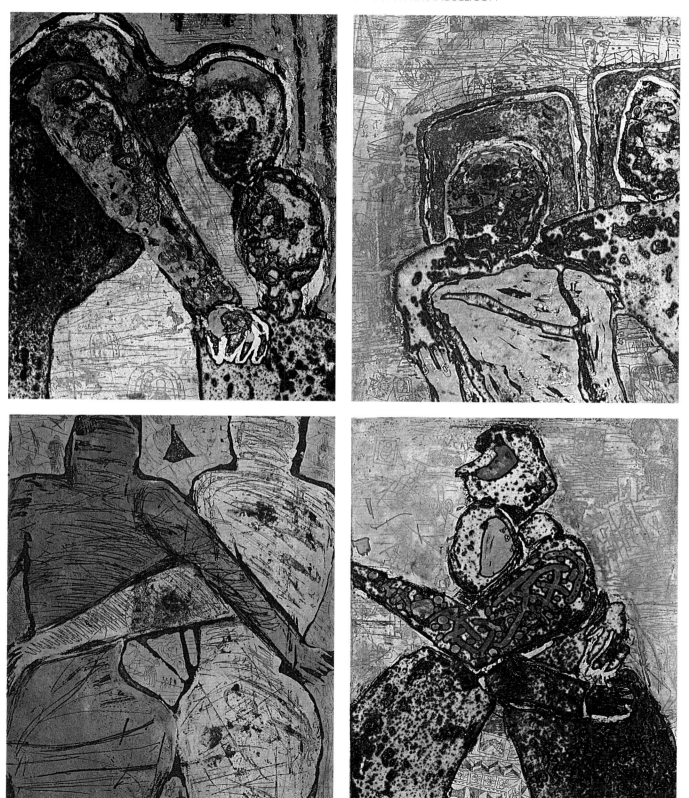

Top left: *Off to School*, 2001, sugar/acid etch on copper, 18" × 14" (plate). Top right: *At the Movies*, 2001, sugar/acid etch on copper, 18" × 14" (plate).
Bottom left: *Street Scene*, 2001, sugar/acid etch on copper, 18" × 14" (plate). Bottom right: *Hug*, 2001, sugar/acid etch on copper, 18" × 14" (plate). Photographs: David Allison.

102

Top: *Datura*, limited-edition print, 12" × 12", artist: Nicholas Wilton. Bottom: *Rebirth*, limited-edition print, 11" × 27", artist: Noah Woods.

Top: *Balance*, limited-edition print, 20" × 15", artist: Nicholas Wilton.
Bottom right: *Teapot*, limited-edition print, 12" × 10", artist: Jennie Oppenheimer. Bottom left: *Woman in Paris*, limited-edition print, 18" × 24", artist: Vivienne Flesher.

# LEARNING TO SEE

To develop a personal aesthetic—the value system that defines our sense of beauty, grace and comfort—we must learn to look with a critical eye at everything that surrounds us. When we study the architecture of our living environment, the array of furnishings we select and the art we acquire, we should be able to recognize how these pieces work together to balance the many elements of design: color, texture, form and proportion. Developing this ability is what we call "learning to see."

An important aspect of creating a personal aesthetic involves cultivating a point of view with regard to material possessions, a point of view based on the goals of your space. Learning to see requires that you look at many objects and absorb what each one has to offer without losing sight of your own circumstances and needs. You can accomplish this by developing a dialogue with an object. No, we don't mean speaking out loud to it, but rather becoming curious about it. Where is it from? How old is it? Was it crafted by hand or by machine? What unusual techniques were used to produce it? Did its creator sign it? Finding the answers to these questions will enrich your understanding and deepen your appreciation of the object you're looking at. This process increases your knowledge, strengthens your personal aesthetic, and prepares your eye to seek beauty in all that it sees.

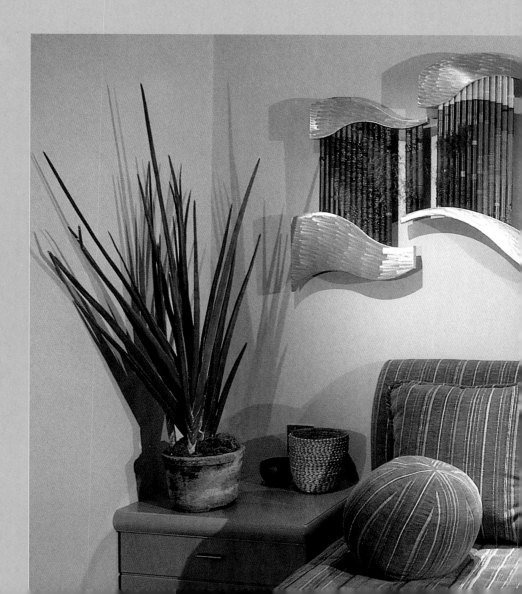

Myra Burg, *From the Deep,* fiber wall hanging.
Photograph: Ron Luxemburg. See page 195.

The art you acquire and objects that you collect each have a story. When brought together in your home, they tell a unique story about you. It's your goal to become a good storyteller.

When you introduce art into your home, you're adding a layer onto a foundation established through the furnishings, lighting and accessories that you've inherited or purchased over time. These possessions were doubtless acquired as much for their function as for taste and style. Creating an artful home is about selecting and placing art that complements your foundation of core furnishings while celebrating beauty and spirit and reflecting something intimate about you and your family.

Looking at art feels very different from looking at other kinds of furnishings. An artist's work can take you by surprise. It can inspire pleasure, confusion or an immediate sense of affinity. You may like what you're looking at, or you may not. Either way, your eye is stimulated, and the piece calls to you for response and reaction.

The wonderful thing about art is that it need not be constrained by anything more than your personal aesthetic: "Wow! I like that! Now, where in my home can I place that for all my friends and family to see?" Suddenly you're engaged. You're thinking about how to share the story. That's the fun and the beauty of learning to see.

# JOHN PETER GLOVER

JP GLOVER FINE ART ■ 5711 FRIENDSHIP AVENUE SUITE #5 ■ PITTSBURGH, PA 15206
TEL 412-363-8315 ■ FAX 412-363-8314 ■ E-MAIL JOHN@JPGLOVERART.COM ■ WWW.JPGLOVERART.COM

106

Top left: *Harlequin Formation*, 2001, pigmented digital output, 32.5" x 32", limited edition of 100. Top right: *Phototrophic Formation*, 2001, pigmented digital output, 36" x 35", limited edition of 100. Bottom: *St. Elmo's Fire*, 2001, pigmented digital output, 30" x 36", limited edition of 100.

# MARY BATES NEUBAUER

#3 NORTH BULLMOOSE CIRCLE ■ CHANDLER, AZ 85224 ■ TEL 480-821-1611 ■ FAX 480-965-7047
E-MAIL MARY.NEUBAUER@ASU.EDU ■ WWW.PUBLIC.ASU.EDU/~MBATES

Top: *Frost Bloom*, 2002, digital iris print, 22" × 30".  Bottom: *Whirlflower*, 2002, digital iris print, 22" × 30".  Photographs: Mouse Graphics, Tempe, AZ.

# BARBARA ZINKEL

BARBARA ZINKEL EDITIONS ▦ 333 PILGRIM ▦ BIRMINGHAM, MI 48009
TEL 248-642-9789 ▦ FAX 248-642-8374

108

Top left: *Sunrise*, silkscreen print, 30" x 30". Center left: *Midday*, silkscreen print, 30" x 30". Bottom left: *Sunset*, silkscreen print 30" x 30".
Top right: *A San Francisco Night*, silkscreen print, 60" x 40", edition of 250. Bottom right: *BZ-R104*, custom wool area rug, available in 7' x 9', 9.6' x 12' and larger custom sizes.

# BJORN SJOGREN

SKANDINAVA ▪ N4946 LEE ROAD ▪ ELROY, WI 53929 ▪ TEL/FAX 608-562-3722
E-MAIL INFO@ART2WEAR.COM ▪ WWW.ART2WEAR.COM

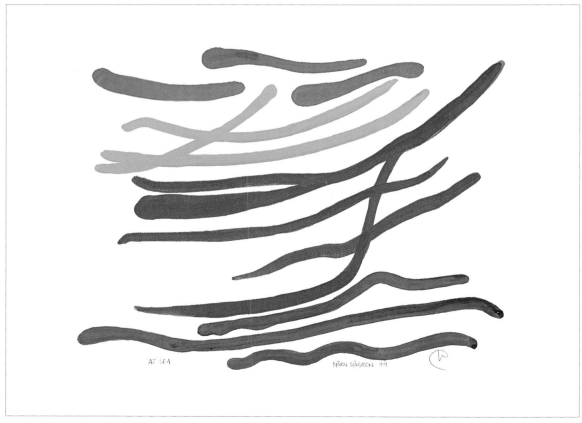

Top left: *The Web.* Top right: *The Egg.* Bottom: *At Sea.*

# THE ORIGINAL PRINT

An original fine art print is a work of art, by an artist, in the print medium. What distinguishes it from printed reproductions is the artist's direct participation in the creation of the image. It differs dramatically from a poster, which is a mechanical reproduction of an original work of art. And although there are examples of posters that can be considered works of art because of the artist's involvement in the reproduction process, most posters are executed without the participation of the artist, or even produced posthumously. This will never be the case with original prints. They are new works created by the artist and, for that reason, they are considered within the larger body of the artist's work.

Because the various printmaking processes have intrinsic visual characteristics, each technique can be identified by a distinct look. Printmaking techniques can be grouped into four basic categories: relief, intaglio, lithography and screenprint.

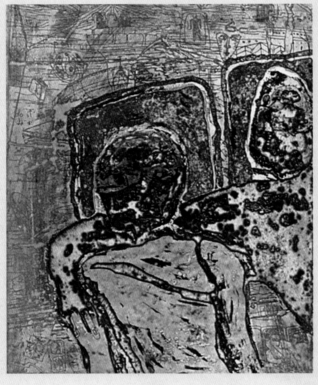

- Relief printing is a process whereby areas are cut away from a flat surface, leaving the raised image to be printed. Included in this category are woodcuts, wood engravings and linocuts.
- Intaglio processes, including aquatint, drypoint, engraving, etching, mezzotint and photogravure, employ the reverse approach: the images are incised or etched into the surface of metal plates.
- Lithography is a process in which the printed and non-printed areas of the plate lie on the same plane. The image is drawn on a smooth surface and the print is created through direct pressure.
- Screenprint images (also referred to as serigraphs and silkscreens) are created as parts of a screen are blocked out so that ink prints only on selected areas of the paper.

A fifth category, known as "giclee" or "Iris" prints, has become popular over the last few years. Giclee technology employs high-resolution ink-jet printers to reproduce scanned images; most giclees are made with archival inks and papers. The resulting images, often achieved after many trial runs, have exceptional texture, clarity and tonal gradation.

Original prints made with the four "fine art" printmaking techniques are pulled by hand and should be thought of not as copies, but as original works existing in multiple impressions. Each print within the edition is signed and numbered by the artist.

Adapted from *The Original Print* by Chris Byrne
Published 2002 by GUILD Publishing

Above: Fran Bull, *At the Movies*, etching. Photograph: David Allison. See page 101.

# KOZAR FINE ART

STEVEN R. KOZAR ■ 10872 CAVE OF THE MOUNDS ROAD ■ BLUE MOUNDS, WI 53517 ■ TEL 608-437-6798
E-MAIL STEVE@STEVENKOZAR.COM ■ WWW.STEVENKOZAR.COM

111

Top: *Farmland Morning in Dane County*, giclee print, image size: 11" × 28", edition of 195.  Bottom: *Winter at the Donald Farm*, giclee print, image size: 16" × 32", edition of 95.

# MADELAINE SHELLABY

26 BLAWENBURG ROAD ■ PO BOX 487 ■ BELLE MEAD, NJ 08502 ■ 908-359-8268
E-MAIL MSHELLABY@EARTHLINK.NET ■ WWW.ARTSPAN.COM

Top: *(Ne)xt Sun To-Die*, 2001, archival digital print, 22" × 25".  Bottom: *Early Morning*, 2001, archival digital print, 16" × 20".

PHOTOGRAPHS

# ERNEST BRAUN

ERNEST BRAUN PHOTOGRAPHY ■ PO BOX 627 ■ SAN ANSELMO, CA 94979 ■ TEL/FAX 415-454-2791
E-MAIL EBB@ERNESTBRAUN.COM ■ WWW.ERNESTBRAUN.COM

114

Top: *Three Cormorants*, Point Lobos State Reserve, California.  Bottom:  *Sparkling Lupine*, Abbott's Lagoon, Point Reyes, California.

# ALLAN BRUCE ZEE FINE ART PHOTOGRAPHY

ALLAN BRUCE ZEE ▪ 2240 SE 24TH AVENUE ▪ PORTLAND, OR 97214 ▪ TEL 503-234-3211 ▪ FAX 503-236-2973
E-MAIL ABZ@SPIRITONE.COM ▪ WWW.ALLANBRUCEZEE.COM

115

Left: *Waiting for the Believers*, St. Amand de Coly, France.  Right: *Forest Cathedral*, Tuscany, Italy.

# TALKING TO THE ARTIST
## Dan Burkholder

A busy photographer, author, teacher and digital imaging expert, Dan Burkholder often seems to be in more than one place at once. So do his photographs, which frequently defy the laws of geography to deliver a greater emotional impact.

Some of his images, like the nine canoes that magically come together like petals of a flower in *Boats at Pokhara, Nepal,* happen to be true to the scene at hand. "The canoes really did take this shape," notes Burkholder, slightly incredulous himself. "I was just there to find the image."

In other cases, though, Burkholder uses Adobe Photoshop software on his Macintosh to create images that never existed in real time. In *School and Trees, Scotland,* the trees come from a photograph taken in Scotland, but the one-room schoolhouse comes from another shot near Johnson City, Texas.

As Burkholder puts it, "The most important photographs are on refrigerators around the world. That emotional connection with people's lives is probably the most vital use of photography." Except in photojournalism, he values a photo's emotional honesty above its factual honesty. "A manipulated photograph can be much more resonant than the straight shot."

Burkholder uses both digital and traditional photographic techniques to achieve emotional effects. After creating a negative from a digital image, Burkholder prints his works in platinum—a highly traditional wet-room technique that involves coating the images by hand.

"It's weird to walk from thousands of dollars of digital equipment into a room with trays or toxic solutions. But we all like doing things with our hands, whether it's gardening, auto repair or sewing. It's a basic human need.

"My most recent work fuses old and new technologies with the application of color pigments to the hand-coated platinum print, creating an altogether new form of photographic expression."

—Jori Finkel

# DAN BURKHOLDER

DAN BURKHOLDER PHOTOGRAPHY ■ 1011 NORTH MARYLAND STREET ■ CARROLLTON, TX 75006
TEL 972-242-9819 ■ FAX 972-242-9651 ■ E-MAIL DANPHOTO@AOL.COM ■ WWW.DANBURKHOLDER.COM

Top: *Abandoned House on Plain, Colorado*, pigment over platinum, 6" × 9". Bottom: *Boats at Pokhara, Nepal*, platinum/palladium, 6" × 9".

# TOM FERDERBAR

1905 HILLSIDE DRIVE ■ DELAFIELD, WI 53018 ■ TEL 262-646-8441 ■ FAX 262-646-8451
E-MAIL TOMFERD@WI.RR.COM

118

Top: *Tree and Warehouse Wall*, 2001, Route 66, Depew, OK.  Bottom left: *Rock, Mirror Lake*, 1958, Yosemite, CA.
Bottom center: *Barley and Boards*, 1958, Mariposa, CA.  Bottom right: *Charred Tree Trunk*, 1958, Yosemite, CA.  All photos © Tom Ferderbar.

# TOM FERDERBAR

1905 HILLSIDE DRIVE ◾ DELAFIELD, WI 53018 ◾ TEL 262-646-8441 ◾ FAX 262-646-8451
E-MAIL TOMFERD@WI.RR.COM

119

*Bridalveil Falls,* 1958, Yosemite, CA. All photos © Tom Ferderbar.

# NATHAN McCREERY

2400 NORTH PRINCE ■ CLOVIS, NM, 88101 ■ TEL 505-762-9856 ■ FAX 505-762-7199
E-MAIL NVMCCREERY@3LEFTIES.COM ■ WWW.NIMBUSART.COM

Top: *Gambel Oaks, Clearing Storm,* Court of the Patriarchs, 2000. Bottom: *The Pinnacle,* Vermilion Cliffs Wilderness Area, 1995.

# WILL CONNOR

WILL CONNOR PHOTOGRAPHY ■ 6925 WILLOW STREET NW ■ BOX 26 ■ WASHINGTON DC 20012
TEL 202-882-8212 ■ FAX 202-244-1573 ■ EMAIL WILL@WILLCONNOR.COM ■ WWW.WILLCONNOR.COM

Top left: *Dune, Melting Snow,* Monument Valley, AZ, photograph. Top right: *Mount Tamalpais,* California, photograph.
Bottom: *Ice Reflections,* Merced River, Yosemite, photograph.

# KELLY FITZGERALD PHOTOGRAPHY

KELLY L. FITZGERALD ▪ 1357 MONUMENT TRAIL DRIVE ▪ CHULA VISTA, CA 91915 ▪ TEL 619-934-6608 ▪ FAX 619-934-6608 *9
E-MAIL KLFPHOTO@AOL.COM ▪ WWW.KLFPHOTO.COM

124

Top: *Gold King Mine, AZ.*  Bottom: *Cliffs of Moher.*

# AMANDA SMITH

SHOOTING STARS PHOTOGRAPHY ▪ 11548 MANZANITA ROAD ▪ LAKESIDE, CA 92040 ▪ TEL 619-390-2916 ▪ FAX 619-390-4134
E-MAIL AMANDA@SHOOTINGPHOTOGRAPHY.COM ▪ WWW.SHOOTINGPHOTOGRAPHY.COM

125

Top left: *Bunk House Window*, available in any size. Top right: *Wild Prayer*, available in any size.
Bottom: *Cattle Chute*, available in any size.

# FINDING ART
## Consider the Source

Your search for a work of art can take many forms. It can be direct and methodical, as when you're looking for a print or painting to highlight the muted colors of your living room, or organic and adventurous, as when you're searching for a special something to mark a landmark anniversary. It can be the focus of a month of weekend outings to galleries, art fairs and artist studios, or an evening's pleasant browsing on the Internet. For more substantial purchases, especially those that involve complex installation, you may want to work with a professional art consultant or with the staff at GUILD's Custom Design Center.

Each of these methods of finding art has unique benefits. Let's begin with a look at buying art on the Internet, using the GUILD.com website as a handy model.

### THE VIRTUAL SEARCH FOR ART

The Internet has revolutionized art buying, just as it has so many other aspects of our lives. A virtual gallery like GUILD.com offers distinctive benefits, especially if you're pressed for time, prefer to shop at night or want to see a very broad selection of quality artworks. By buying art gifts on the Internet, you also avoid having to ship fragile works yourself; at GUILD.com, for example, packing and shipping are handled by the artist—who knows better than anyone how to do it right.

Internet technology also allows you to search for art items meeting precise specifications. Looking through an extensive collection of online art is similar in many respects to visiting a large museum. Visitors to a museum can meander happily from room to room, browsing randomly, broadening their understanding of different art forms, and perhaps kindling new enthusiasms. Alternately, they can use a map of the museum to select and visit the parts of the collection that interest them the most.

So it is with an online collection, except that instead of a map, the visitor uses searches to view the collection strategically. At GUILD.com, search criteria include medium, price range, color, theme and size, and they can be used singly or in any combination to fine-tune your search.

GUILD.com uses Internet technology to offer other services that are both useful and fun. E-postcards, for example, allow you to send images of favorite artworks to friends, with your own notes attached. GUILD's Wish List lets you keep a visual record of items you'd like to own someday, while the Gift Registry lets friends browse and shop from among items you've chosen. Another unique resource, the GUILD Custom Design Center, allows shoppers to have artworks customized to their specifications: a perfect way to celebrate a family milestone, fill an unusual space or make everyday objects artful.

When questions arise, or when you want to place custom orders, you can reach GUILD's knowledgeable staff toll-free. Call 1-877-344-8453 to place an order, or to find out more about individual artists or works of art.

Opposite: Dan Burkholder, *Boats at Pokhara, Nepal.* See page 117.

## GALLERIES

Purchasing from a gallery provides the benefit of consultation; you're tapping into the expertise of the gallery staff and the relative assurance that the work meets high aesthetic and professional standards. The artworks will have been selected by the gallery owner or manager, and will reflect their personal taste. If your own aesthetic is similar, a gallery can be an excellent resource.

Most galleries specialize in specific types of art and are committed to a stable of artists. Much like interior designers or art consultants, galleries act as professional curators; most select 20 to 50 artists to feature from among hundreds seeking representation.

To varying degrees, galleries act as agents for artists and help create a market for their work. It can be fun and interesting to attend gallery openings in your city or town. If the artwork you see appeals to you, introduce yourself to the gallery owner. Talk about your interest in purchasing art and about the kinds of work you're attracted to. Be sure to mention your budget—and don't feel intimidated if you don't want to spend a great deal of money. Galleries are always looking for new clients, and they'll be happy to spend time getting to know you.

## BUYING DIRECTLY FROM THE ARTIST

Every artist whose work is shown in *The Artful Home* will welcome your phone call and your business. Look for their contact information at the top of their display page, as well as basic information about their products and processes in the Artist Information section at the back of the book.

Many artists keep at least a few completed works in the studio and can provide overnight turnaround for last-minute gifts and the like. This is most often true with artists who make small-scale works, but even artists who produce large-scale paintings or tapestries may keep a few available works on hand.

If you're not in a rush to buy, it can be fun to visit the artist's studio (see below). When distance makes that impossible, ask to see photos of available works; photos can often be attached to e-mail if snail mail is too slow. And remember that *Artful Home* artists are available for custom-design projects; see Commissioning a Work of Art, beginning on page 16.

## Studio Visits

When visiting an artist's studio, rules of common courtesy apply. Be sure to call ahead; the artist may have limited visiting hours, especially during crunch times. Once there, don't overstay your welcome. Enjoy your visit, but recognize that the artist will need to get back to work.

Some communities offer organized tours of artists' studios on a particular day or weekend each year. These are terrific opportunities to meet artists and learn about the processes they use.

## Art Fairs

Depending upon the crowds and the weather (if the fair is outdoors), art fairs can be a lot of fun. They're also a great way to see the work of many artists at one time. Most art fairs are juried, so you can expect to see high-quality displays and meet artists who work at a professional level.

## ART CONSULTANTS

Art consultants work with individuals and corporations, helping them select and place art. This is not a service you'll need for most purchases, but an art consultant can be a tremendous help with complex projects (see sidebar). Although art consultants are familiar with the work of hundreds of artists—and may know many artists personally—they are engaged by, and represent the interests of, the art buyer. Normally, an art consultant is not affiliated with specific galleries or institutions.

Finding an art consultant in rural areas of the country can be a challenge. The Internet can be a great help, of course, and local architects and interior designers may recommend art consultants in your area or with whom they've had successful long-distance relationships. In any case, it's wise to talk with several art consultants to get a feel for the services they can offer and to gauge how comfortable you'll be working with them. Be sure to make reference calls as well, just as you would when hiring any service professional.

Art consultants are normally compensated through a percentage of the art-acquisition budget.

128

## WHEN TO USE AN ART CONSULTANT

Art consultants can help with projects of any size and any medium. Their skills and experience are particularly helpful in these circumstances.

- When artwork is integral to the structure of the home, as with custom kitchen tile or a wrought iron balcony railing.

- When coordination is needed between the artist and other professionals, such as architects and engineers.

- When installation is complicated, as with heavy atrium sculpture or custom millwork.

- When art from several sources must coordinate, both functionally and aesthetically.

# MICHAEL A. SMITH

SMITH/CHAMLEE PHOTOGRAPHY ▧ PO BOX 400 ▧ OTTSVILLE, PA 18942 ▧ TEL 610-847-2007 ▧ FAX 610-847-2373
E-MAIL MICHAEL@MICHAELANDPAULA.COM ▧ WWW.MICHAELANDPAULA.COM

129

Top: From the series, *The Bonsai of Longwood Gardens*, 1999-2001, black-and-white photograph, silver chloride contact print, 7.6" × 9.6", in collaboration with Paula Chamlee.
Bottom: *Near Blue River, British Columbia*, 1975, black-and-white photograph, silver chloride contact print, 7.6" × 9.5".

# WOODLAND STUDIOS

GARY WALKER ▦ CINDY LOU ▦ 8807 NORTH CEMETERY ROAD ▦ EVANSVILLE, WI 53536
TEL 608-576-6868 ▦ FAX 608-835-8007 ▦ E-MAIL GWALKER@WOODLANDWEB.COM ▦ WWW.WOODLANDWEB.COM

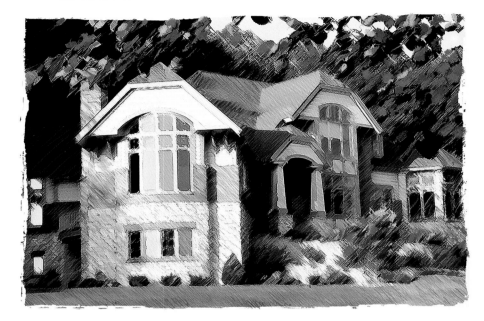

130

Top left: *The Heath's*, mixed media on giclee print. Top right: *Secret Garden*, mixed media on giclee print.
Bottom right: *Sweet Dreams*, mixed media on giclee print. Bottom left: *Patio Blossums*, mixed media on giclee print.

# DONNA CORLESS

DESIGN CONCEPTS UNLIMITED, INC. ■ 881 CAHABA DRIVE ■ AUBURN, AL 36830 ■ TEL 334-826-7728 ■ FAX 630-214-4176
E-MAIL SALES@PHOTOSANDART.COM ■ WWW.PHOTOSANDART.COM

131

Top: *Villa on the Peninsula,* 2001, Nassau, Bahamas, digital watercolor giclee print, 16"H × 35"W, limited edition.
Bottom left: *Boats on the Cay,* 2001, Great Stirrup Cay, Bahamas, digital watercolor giclee print, 30"H × 20"W, limited edition.
Bottom right: *Reflection Canal,* 2001, Venice, Italy, digital watercolor giclee print, 30"H × 20"W, limited edition.

# ROY RITOLA

NEOGRAPHIQUE ■ 100 EBBTIDE AVENUE SUITE #520 ■ SAUSALITO, CA 94965 ■ TEL 415-332-8611 ■ FAX 415-332-8607
E-MAIL INFO@NEOGRAPHIQUE.COM ■ WWW.NEOGRAPHIQUE.COM

132

Top: *Ginger*, giclee.  Bottom: *Haleconia*, giclee, (frames not included).

# DANA MONTLACK

STUDIO MONTLACK ▪ 1204 EMERALD STREET ▪ SAN DIEGO, CA 92109 ▪ TEL 858-274-1822
E-MAIL DANA@STUDIOMONTLACK.COM ▪ WWW.STUDIOMONTLACK.COM

133

Top left: *1-13*, iris print, 37" × 29". Top right: *1-15*, iris print, 37" × 29". Bottom left: *1-2*, iris print, 37" × 29". Bottom right: *1-3*, iris print, 37" × 29".

# MICHAEL BROYLES

BROYLES RENDERINGS ■ 310 DILEGWA WAY ■ LOUDON, TN 37774
TEL 865-458-6741 ■ E-MAIL MBROYLES91@CS.COM

134

Top left: *Crane*, 2002, limited-edition giclee print, 16" × 20". Top right: *Orange Fantasy*, 2002, limited-edition giclee print, 16" × 20".
Bottom left: *Ivy Geranium*, 2002, limited-edition giclee print, 16" × 20". Bottom right: *Pitcher Plant*, 2002, limited-edition giclee print, 16" × 20".

# JAMES F. DICKE II

HAINES GALLERIES ▪ 17 EAST 8TH STREET, 3RD FLOOR ▪ CINCINNATI, OH 45202
TEL 513-559-1405 ▪ FAX 513-651-0860 ▪ E-MAIL HAINESGALLERIES@AOL.COM ▪ WWW.JAMESFDICKE.COM

135

Top: *A Romantic Notion*, iris print, 24" × 18".  Bottom: *Source of Mystery*, iris print, 24" × 18".

# THOMAS MASARYK

99 REEDS LANE ■ STRATFORD, CT 06614 ■ TEL/FAX 203-375-8645

138

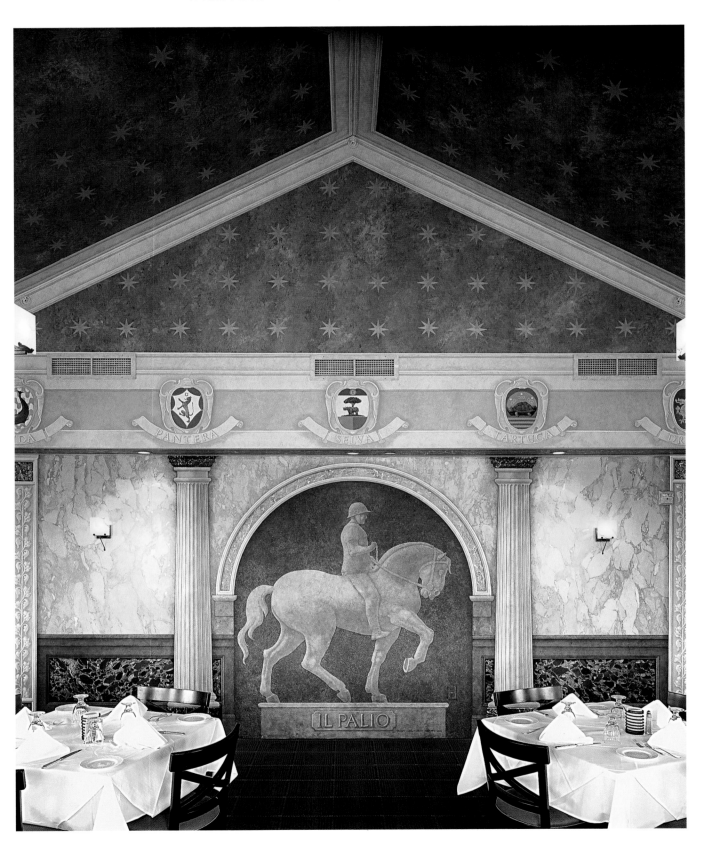

IL Palio Restaurant, Shelton, CT. Photograph: John Dessarzin.

# HOME ART OF ROSEBUD STUDIOS

WENDY GROSSMAN ▪ PO BOX 432 ▪ PHOENICIA, NY 12464 ▪ TEL 845-688-9823
E-MAIL ROSEBUDSTUDIO@AOL.COM ▪ WWW.ROSEBUDSTUDIOS.COM

139

Top left: *Himalayas with Fountains,* acrylic on wall, hand-cut stencils, 5' × 6'.  Center left: *Harlequin Hallway,* acrylic on wall and wood door, gold leaf and hand-cut stencil.
Bottom left: Painted folding screen (double sided), acrylic on wood, gold leaf, each panel: 71" × 20" × 1".  Right: *Yellow Monkey* (detail), acrylic on wall.  Photographs: Steffany Rubin.

# THE ROOMS OF YOUR HOME
## The Living Room

The living room, where you gather with family and friends, is the most theatrical space in your home. Think of it as your gallery, your primary space for displaying and enjoying original works of art.

    Abandon reality for a moment and envision your living room as a clean, empty white space. Now imagine placing favorite framed artworks and objects in their best possible locations, along with handmade, artist-designed furniture and furnishings chosen to complement the artworks. Of course, in reality you're unlikely to buy new furniture and furnishings to enhance each new piece of art you bring into your home. Still, it can be useful to think about how artwork would function in your ideal setting; we recommend you practice this pleasant exercise when considering new art purchases for this most important family space.

    One common focal point in many living rooms is the fireplace, and the mantel and wall above it are perfect locations for framed artworks, small sculptures, family photos

Above: The colorful abstract painting above the fireplace anchors the strong horizontal lines of this room while playing against the asymmetrically arranged floor and tabletop sculptures. Interior design by Mary Drysdale. Photograph: Andrew Lautman.

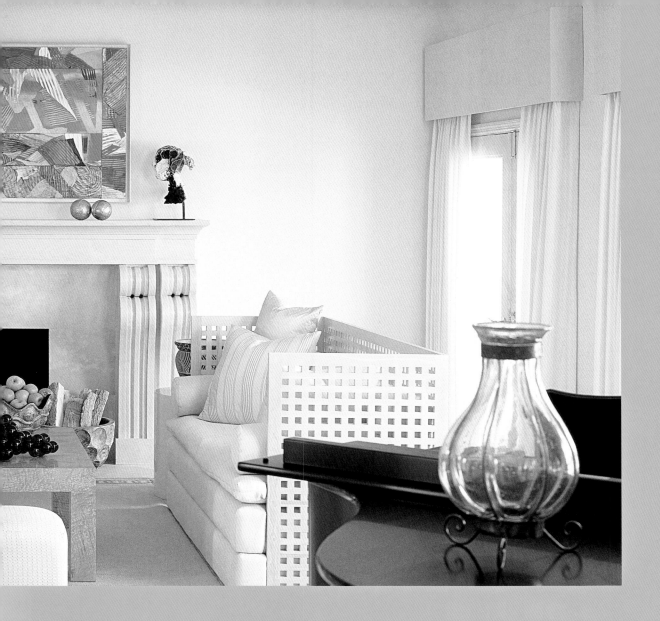

and handcrafted candleholders or other decorative objects. The artworks you place in this area comprise a still life, a vignette celebrating fine craftsmanship. By refreshing this setting periodically—and expanding it to the entire area surrounding the fireplace—you have the opportunity to seek out new works made by artists: forged-iron tools, hand-woven baskets, a rocker, original area rugs. The warmth of this setting is created as much by the artworks as by the fire.

In many homes, the living room is both the most public part of the home and a hub of family activity. Day-to-day, it's the family's gathering place; on special occasions, it's the setting for entertaining guests. It's almost always the largest room in the home and is usually positioned near the entryway. All of these qualities make the living room an ideal location for displaying large works of art, works that make the room inviting, yet dramatic and expressive. Its size also makes it flexible space, allowing for a variety of arrangements and focal points.

# MARY LOU ALBERETTI

ALBERETTI STUDIOS ■ 16 POSSUM DRIVE ■ NEW FAIRFIELD, CT 06812 ■ TEL 203-746-1321
E-MAIL MLALB@AOL.COM ■ WWW.SOUTHERNCT.EDU/~ALBERETT/

146

Top left: *Paravento*, 2001, ceramic relief, 12" x 13" x 1.75". Top right: *Gemelli*, 2001, ceramic relief, 12" x 13" x 2".
Bottom left: *Abbey*, 2001, ceramic relief, 20" x 14" x 2". Bottom right: *Dome*, 2001, ceramic relief, 22" x 18" x 2". Photographs: Bill Quinnell.

# MARCIA JESTAEDT

MARCIA JESTAEDT DESIGNS ▉ 13300 FOREST DRIVE ▉ BOWIE, MD 20715-4391 ▉ TEL 301-464-8513
EMAIL FJESTAEDT@BOO.NET

Top: *Summer Moments*, 2001, raku-fired clay tiles, 18"H × 36"W × .75"D. Bottom left: *Mari's Garden*, 2001, raku-fired clay tiles, 38"H × 28"W × .75"D.
Bottom right: *Waiting for the Breeze*, 2002, raku-fired clay tiles, 38"H × 28"W × .75"D. Photographs: PRS Associates, Inc.

# LISA BAILEY

1001 TRUE STREET APARTMENT 104 ▨ COLUMBIA, SC 29209 ▨ TEL 803-647-0537
E-MAIL LBAILEY303@AOL.COM

150

*Wisdom: Inspired by Athena* (detail), 2002, sand-blasted stoneware, 60" × 42" × 10". Inset: *Wisdom: Inspired by Athena.* Photographs: John Smoak.

# LARRY HALVORSEN

335 NW 51ST STREET ■ SEATTLE, WA 98107 ■ TEL 206-781-1434
E-MAIL LARRY@HALVORSENCLAY.COM ■ WWW.HALVORSENCLAY.COM

151

Top:  *Waves*, 2002, gallery installation, clay, total size:  56" × 96".  Photograph:  Richard Nicol.
Bottom:  *Wall O' Balls*, 2001, gallery installation, clay, total size:  48" × 84".  Photograph:  Lynn Thompson.

# ELIZABETH MacDONALD

PO BOX 186 ■ BRIDGEWATER, CT 06752 ■ TEL 860-354-0594 ■ FAX 860-350-4052
WWW.GARDEN-ART.COM/SCULPTURE/MACDONALD/ELIZABETH.HTML

152

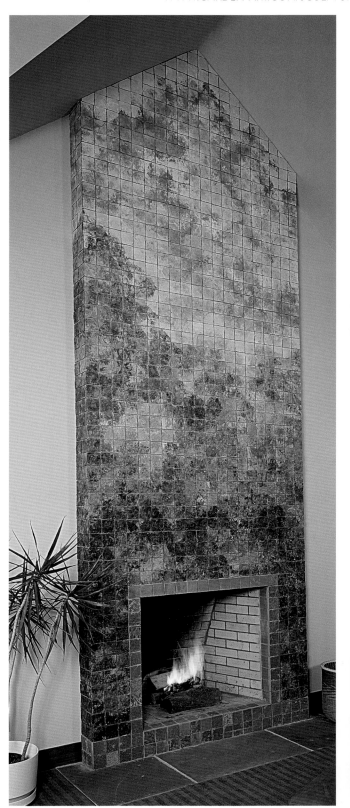

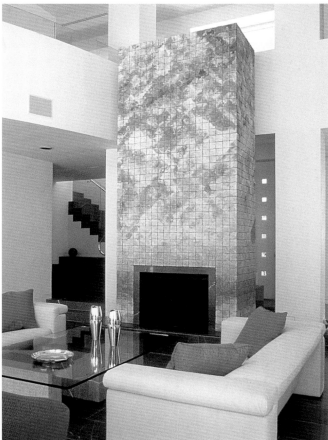

Left: Fireplace, 1989, Sherman, CT, ceramic tile, 16' x 5.5" x 7". Photograph: William Seitz.
Top right: Hubbord fireplace, 2001, Roxbury, CT, ceramic tile, 88" x 84". Photograph: Bob Rush. Bottom right: Hauser fireplace, 1995, Stuart, FL, ceramic tile, 9' x 14'.

# THE ROOMS OF YOUR HOME
## The Kitchen

The kitchen is the heart of the home—and its central nervous system as well. In many modern homes, the family also spends much of its "together time" in the kitchen, and cooking and conversation are the main events. Most families prefer large eat-in kitchens, with quiet dining rooms reserved for holidays and special occasions.

Our kitchens generate the food we eat and represent the bounty of the earth. Food has always been an inspirational subject for painters; they celebrate fruits, grains and vegetables, as well as the spirit of the vine. These kinds of images are very much at home in a kitchen. Since wall space is often limited, small framed pieces are usually best.

The kitchen is also a wonderful place to display objects and tools. Wood, glass and ceramic are the materials of choice for the kitchen: handcrafted wooden bowls, blown glass toasting goblets and glazed stoneware tiles and storage containers complement and enhance the kitchen environment. Handmade tabletop items can be beautifully displayed on open shelves alongside your herbs, dressings and jams. All of these artworks can soothe and calm what is often a hectic pace in these increasingly high-tech spaces.

Above: Elizabeth MacDonald, ceramic tile backsplash. Photograph: William Seitz. See page 152.

# TALKING TO THE ARTIST
## Linda Leviton

Don't expect to see Linda Leviton sitting quietly on her front-porch rocker, stitching one of her wall quilts with a needle and thread. The training for her craft has come from courses in blacksmithing, welding and silversmithing. Her quilts are made from copper, a material she likes for its malleability and amenability to technique and coloration.

It's not surprising that Leviton would gravitate toward a traditionally feminine craft. Quilts have been a source of inspiration since she began her career as a graphic designer more than 18 years ago. Feeling confined by her strictly two-dimensional design work, Leviton began creating quilts out of clothing from the 1940s and 1950s. After a quilt-making class, she found herself adding more unusual elements to her work: found objects, wire, stiffening agent. Anything to give her pieces some dimension and the appearance of metal.

"I finally decided that instead of making my quilts look like metal, I should just switch mediums entirely. I took a welding class, and because I had come from a nontraditional metal background, I was always asking my instructor if I could try unorthodox things. He would say, 'You can't do that.' I would try it anyway, and the instructor would always come back and say, 'I didn't think that was possible.'"

Metal provides an interesting contrast to the type of work Leviton creates. "I work in a traditionally female-oriented craft, but break convention by working in metal, a material associated with the masculine. Through careful color choices, I try to bridge the masculine metal and the feminine form."

Her work also symbolizes a greater kind of configuration. "The quilt is a metaphor for how our world is constructed. It begins with a single unit, whether it's a cell, a grain of sand or a tree in the forest. By multiplying, combining and repeating a simple element, new things are created. Pushing the limit of a simple shape by folding or layering suggests nature in its infinite variations."

—Jill Schaefer

Robert Newman

# LINDA LEVITON

LINDA LEVITON SCULPTURE ■ 1011 COLONY WAY ■ COLUMBUS, OH 43235
E-MAIL GUILD@LINDALEVITON.COM ■ WWW.LINDALEVITON.COM

Top: *Patterns of Nature*, 2001, copper, each three-square unit: 14" × 42" × 3". Photograph: Jerry Anthony. Bottom: *21 Forms*, 1998, copper, 6' × 28" × 7".

# DAVID PAUL BACHARACH

BACHARACH METALSMITHS ■ 1701 BEAVERBROOK LANE ■ COCKEYSVILLE, MD 21030 ■ TEL/FAX 410-252-0546
E-MAIL MAIL@BACHARACHMETALS.COM ■ WWW.BACHARACHMETALS.COM

158

*Variegated Target 1*, 2001, private collection, woven copper and patinas, 26" x 40" x 8".  Photograph:  Norman Watkins.

# DAVID PAUL BACHARACH

BACHARACH METALSMITHS ▪ 1701 BEAVERBROOK LANE ▪ COCKEYSVILLE, MD 21030 ▪ TEL/FAX 410-252-0546
E-MAIL MAIL@BACHARACHMETALS.COM ▪ WWW.BACHARACHMETALS.COM

159

Top: *One Patch Pattern Scrap* Quilt, 2002, private collection, copper and mixed-media panels, 90" x 54". Bottom left: *Compass 1*, 2002, private collection, woven copper and steel, 41" x 41" x 5".
Bottom right: *Yellow Sentinels*, 2002, private collection, woven copper, 40" x 40" x 8". Photographs: Norman Watkins.

# ZACH WEINBERG

FIRE CIRCLE STUDIO ▪ PO BOX 574 ▪ PUTNEY, VT 05346 ▪ TEL 802-387-5061
E-MAIL ZACH@FIRECIRCLESTUDIO.COM ▪ WWW.FIRECIRCLESTUDIO.COM

162

Top: *Forgotten Story*, 1998, private home, steel and stainless steel, 3.5' × 12' × 1"-6". Photograph: Craig Collins.
Bottom: *Take Me There*, 2001, private home, stainless steel, 4' × 5' × 2.5", stainless console with blue pearl granite, 31" × 4.5' × 18". Photograph: Nick Hodsen.

# SUZANNE DONAZETTI

FREEFALL DESIGNS ▪ 912 BEDFORD STREET ▪ CUMBERLAND, MD 21502 ▪ TEL 301-759-3618
E-MAIL SUZ@HEREINTOWN.NET ▪ WWW.FREEFALLDESIGNS.COM

163

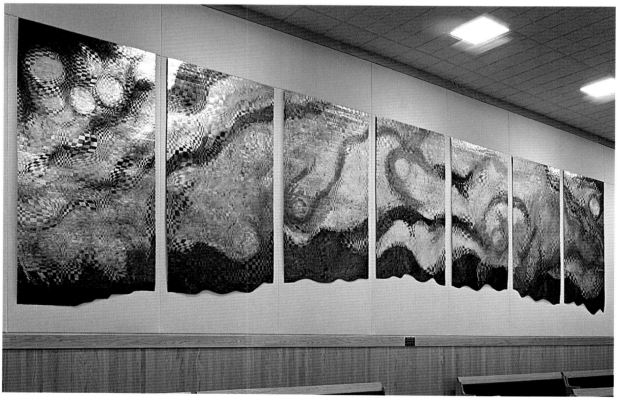

Top: *Blue Flame* (detail), private collection, 48" × 48". Photograph: Randy Adams.
Bottom: *Alaska Skies*, Alaska Court System, Anchorage, 9' × 32'. Photograph: Chris Arend.

# TALKING TO THE ARTIST
## Thomas Mann

Thomas Mann is a visual magician and a poet. His jewelry and sculptural objects convey a delightful voyage through an intriguing world of possibilities. Entering a display of his works is equal to turning backflips into the playground of one's youth.

Perpetually challenging our habitual modes of perception, Mann is fascinated with the flotsam and jetsam of our lives. Entirely or in part, the constituent elements of his art are either manufactured parts or natural objects and fragments not intended as art materials. Intrinsic to "assemblage" (an art form originating in the twentieth century and integral to Surrealism, Dadaism, Constructivism and American Abstract Expressionism) is the evocative, witty and baffling inclusion of objects—simple, real and honest—into compositions. Mann extends this rich tradition into the twenty-first century. His goal is to strike sparks from unrelated, incongruous, contradictory materials and ideas, and thereby lift us out of our humdrum lives; in doing so, he transmutes physical materials and their auras into new amalgams. He poses significant and sophisticated contrasts between folk and fine art, and between pictorial and genuine reality. Mann sees the use of real objects as vehicles for the free exercise of his poetic imagination, and what at first appear to be unexpected and incongruous juxtapositions are, in fact, based upon thematic and formal considerations. He incorporates "reality" into his jewelry without imitating reality. He prefers to work with the raw materials of life, rather than art.

Thomas Mann's quick and direct methods of creating mesh perfectly with our quickened sense of time. He metamorphoses cast-off fragments of daily life into spiritual entities that, because of their associations, reach to the origins of human consciousness and the depth of human possibility.

—Michael W. Monroe

Paula Burch

164

# THOMAS MANN

THOMAS MANN DESIGN ▥ 1810 MAGAZINE STREET ▥ NEW ORLEANS, LA 70130 ▥ TEL 504-581-2111
▥ FAX 504-568-1416 ▥ EMAIL TMD@THOMASMANN.COM ▥ WWW.THOMASMANN.COM

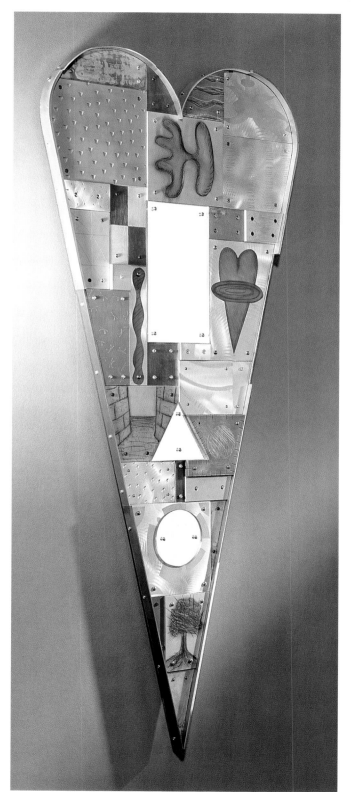

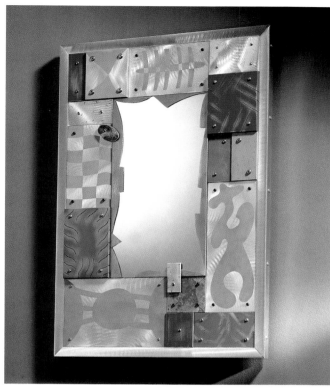

165

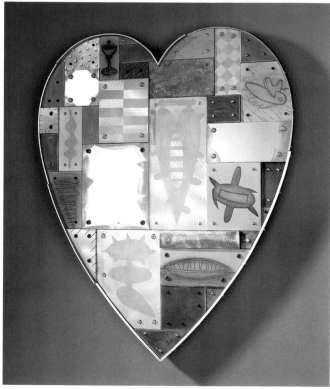

Left: *Elongated Heart*, 2002, aluminum, brass, copper, steel and mirror tiles, paint, graphite and clear lacquer seal, 63" × 27" × 1".
Top right: *Vertical Rectangle*, 2002, aluminum, brass, copper, steel and mirror tiles, paint, graphite and clear lacquer seal, 33" × 23" × 1".
Bottom right: *Heart*, 2002, aluminum, brass, copper, steel and mirror tiles, paint, graphite and clear lacquer seal, 35" × 28" × 1". Photographs: Will Crocker.

# PAM STEELE

STEELE STUDIO ■ 7243 HIGHBRIDGE ROAD ■ FAYETTEVILLE, NY 13066 ■ TEL 315-637-2901
E-MAIL PCSTEELE22@ATT.NET

168

Top: *New Moon Rising,* 2002, copper and fired glass, 27" × 24".
Bottom: *Entry Zone,* 2002, steel and fired glass, 24" × 24".  Photographs: Tony Potter.

JUNO SKY ■ TEL/FAX 419-422-7777 ■ E-MAIL JUNOSKYART@AOL.COM ■ WWW.JUNO-SKY-STUDIO.COM

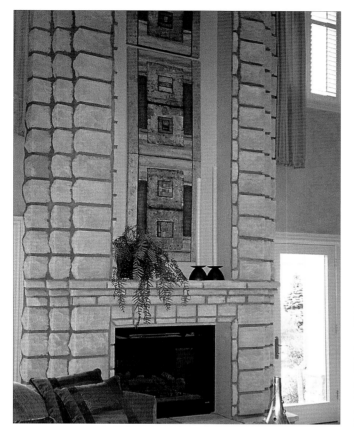

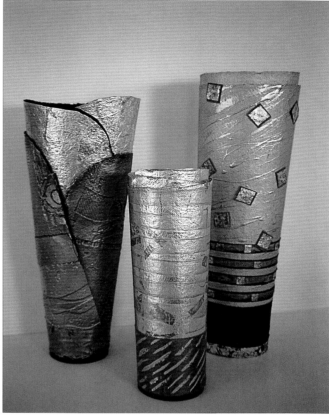

169

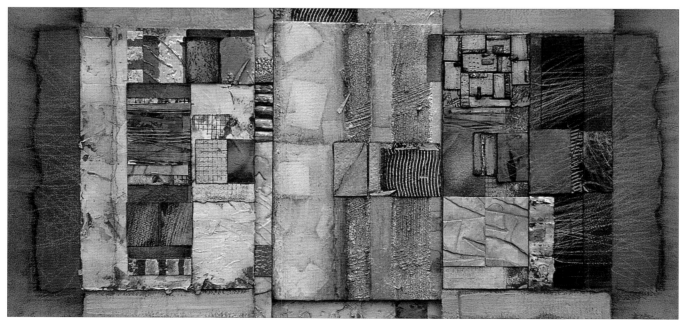

Top left: *New Recordings*, 2002, private collection, mixed media, 40" × 160". Top right: *Spirit Vessels*, 2002, mixed media, 9" × 24".
Bottom: *Continuum*, 2002, mixed media, 30" × 90". Photographs: Adam Fulmer.

# L.P. GREGORY

1025 OAK VALLEY ROAD ▨ SEDALIA, CO 80135 ▨ TEL 303-663-4185 ▨ FAX 303-663-4187
E-MAIL LP@LPGREGORY.COM ▨ WWW.LPGREGORY.COM

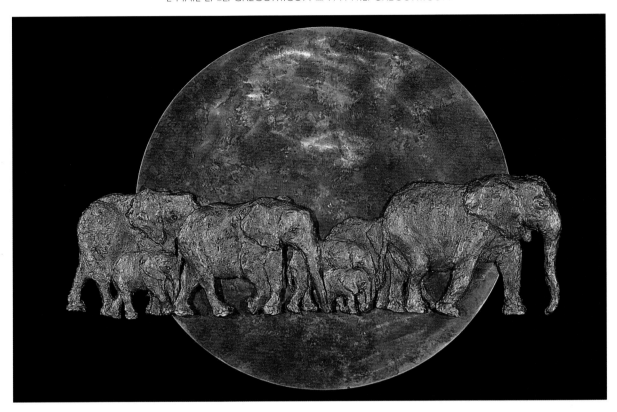

170

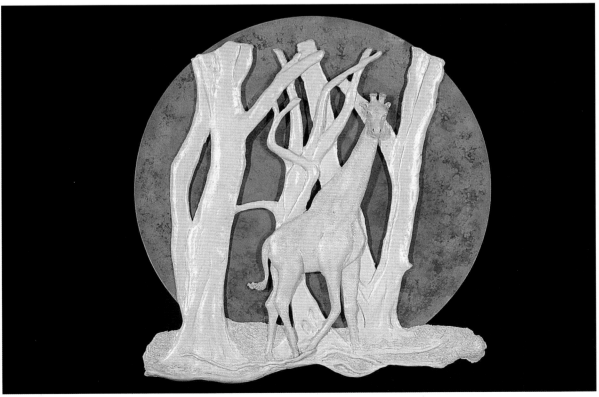

Top: *Elephant Series #1*, 2002, ceramic and copper, 19.5" × 26.5".
Bottom: *Giraffe Series #1*, 2002, ceramic and copper, 23.75" × 23". Photographs: Richard Sosiewicz.

# JEFF EASLEY

PO BOX 502 ■ WELLMAN, IA 52356 ■ TEL 319-646-2521 ■ FAX 319-628-4766
E-MAIL JEASLEY811@AOL.COM

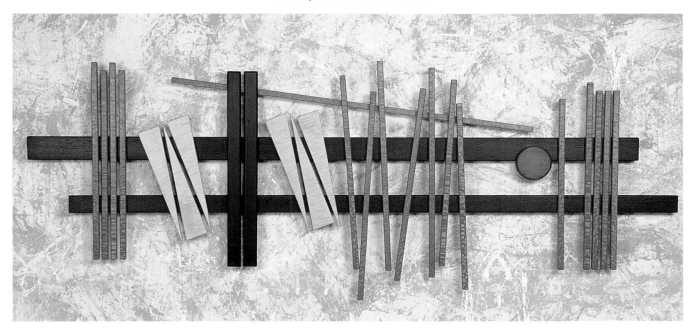

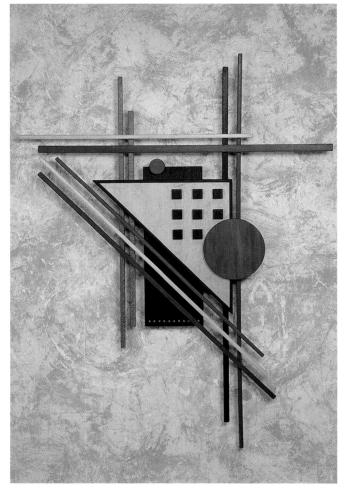

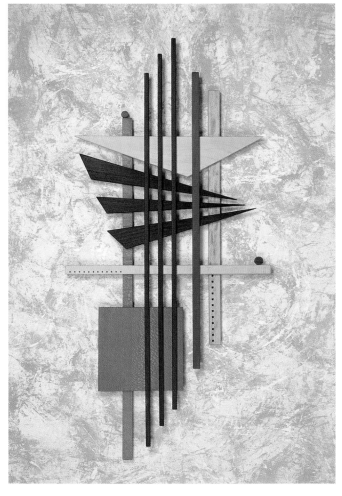

Top: *Music Knows No Boundaries*, 30" × 78" × 2.5". Bottom left: *The Ninth Dimension*, 60" × 48" × 2.5". Bottom right: *Available Space*, 71" × 34" × 2.5". Photographs: Jeff Batterson.

# THE CHARACTER OF COLOR

Color is a manifestation of light and energy; it transforms the world and deeply affects our outlook on life. Hues are altered in different lights and at different times of the day, and the intensity of a color changes when that color is juxtaposed with elements such as wood, stone and metal. Wherever you live—near the ocean or the desert, in midtown Manhattan or rural Idaho—the environment dictates the intensity and path of light and, thereby, the appearance of color. Architects, like artists, are extremely sensitive to geography, climate and the casting of light; regional styles of architecture have developed, over time, in response to this important sensitivity.

As you cultivate your color palette, think about more than simply the colors you like. Think about color in the context of your environment and the architectural style of your home. Think about the intensity and the path of light in each room throughout the day and in each season. It's a balance with nature that you seek.

Color is the least costly way to transform a room and the single most important influence in creating an appealing environment. Good, personalized color choices will strengthen your personal aesthetic and make it easier to invite art into your home.

One of the ways you can enrich your color palette is to tap into the historical wisdom and common associations of different colors. Keep in mind, as you read what follows, that it is the subtle permutations of color that deepen or lessen its influence on the mood and atmosphere of a room.

### White

White represents purity and innocence. Its essence lies in the paradox that its lack of color is its color. This makes it the traditional choice as a background, so that everything around it stands out in contrast. Stark white is cold; it can look almost blue, especially if you live in the mountains where it often snows. Be attentive to the many shades of white; by adding touches of other colors, you can achieve just the right blend to balance the brightness with a feeling of warmth and comfort.

### Black

Black creates a sense of intrigue and depth. If applied sparingly, it can be used as an elegant background to highlight framed works of art and set off other colors. For some, its mystery can be magical and sexy, while for others, it feels somber and uncomfortable.

### Gray

Hovering somewhere between black and white, gray embodies the properties of transition. Gray is a powerful color, and in combination with white, it has become fashionable as a background color. It reflects a contemporary and modern aesthetic, and works well in combination with other colors; in fact, left alone gray can sometimes appear drab and lonely. Pale shades of gray, such as pearl gray, are very effective in setting off bold and colorful framed art.

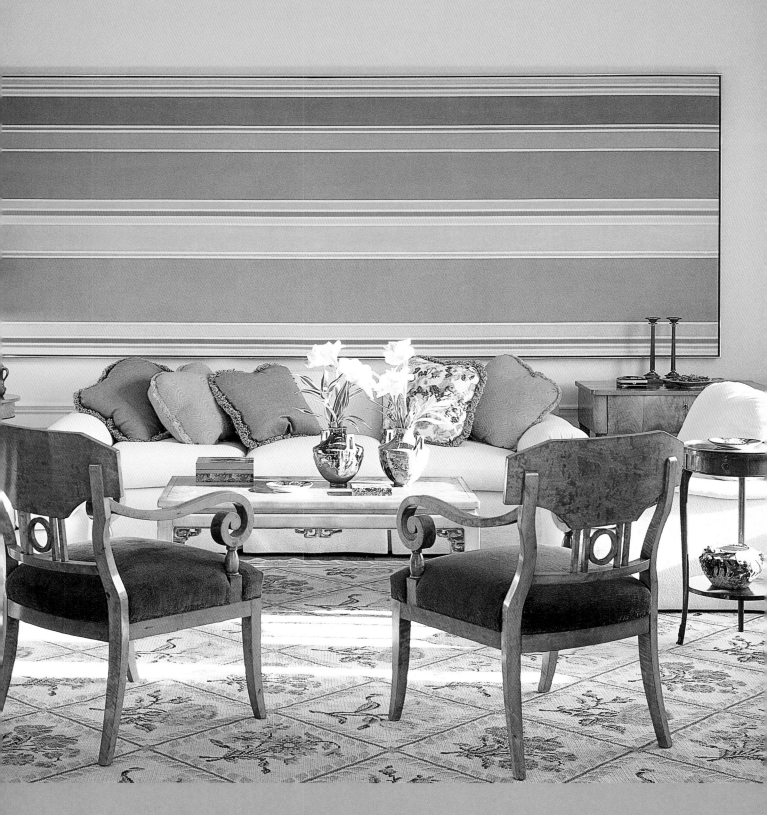

Tabletop vases, candlesticks and circular side tables complement the straight lines of the framed wall piece while playing against its strong horizontal presence in this cozy living space. Interior design by Barbara Hauben Ross.

# JUDY HEIMANN

1906 RAMBLING RIDGE LANE #302 ▧ BALTIMORE, MD 21209
TEL 410-653-3067 ▧ FAX 410-653-1911 ▧ E-MAIL JAZH@WEBTV.COM

Top left: *The Swing*, from the *Fragonard* series, 2001, mixed media and acrylic on wood.  Top right: *Blind Man's Bluff*, from the *Fragonard* series, mixed media and acrylic on wood.
Bottom: *The Bolt*, from the *Fragonard* series, 2001, mixed media and acrylic on wood.  Photographs: Jeff Goldman.

# NAOMI TAGINI

1902 COMSTOCK AVENUE ■ LOS ANGELES, CA 90025 ■ TEL 310-552-1877 ■ FAX 310-552-2679
E-MAIL NAOMI@NAOMITAGINI.COM ■ WWW.NAOMITAGINI.COM

*Belize* (detail), 2001, 2-D painted wood, 87" x 54".

# KOTIKREATIONS

CINDI KOTIK ▦ 2015 TAMPA AVENUE ▦ CLEVELAND, OH 44109 ▦ TEL 216-470-7359 ▦ FAX 216-661-5388
E-MAIL KOTIKDESIGN@EARTHLINK.NET ▦ WWW.KOTIKREATIONS.COM

178

Top: *Autumn*, 2002, Kotikreations Studio, glass and brushed metal, 9'x4'.
Bottom: *Attitude*, 2001, private collector, glass and brushed metal, 12'x4'.

# RICHARD ALTMAN

RA DESIGNS ■ 974 EAST DIVOT DRIVE ■ TEMPE, AZ 85283
TEL 480-831-0201 ■ E-MAIL RA@RICHARDALTMAN.COM ■ WWW.RICHARDALTMAN.COM

Left: *Geometrics #2*, fused glass and metal wall sculpture, 30" × 24".
Right: *Geometrics #3*, fused glass and metal wall sculpture, 32" × 23". Photographs: Greg Mastorakos.

# RENEE HARRIS

RENEE HARRIS STUDIO ■ PO BOX 14300 ■ CINCINNATI, OH 45250
TEL 513-251-9071 ■ E-MAIL RHCW@FUSE.NET

184

Top: *Windshift*, hand-felted wool and embroidery, 30" × 26" × .25".
Bottom: *The Other Hill*, hand-felted wool and embroidery, 30" × 26" × .25". Photographs: C.W. Schauer.

# JULIA MITCHELL

JULIA MITCHELL TAPESTRY ▨ PO BOX 1512 ▨ VINEYARD HAVEN, MA 02568
TEL 508-693-0050 ▨ FAX 508-693-3069 ▨ E-MAIL JMTAPESTRY@HOTMAIL.COM

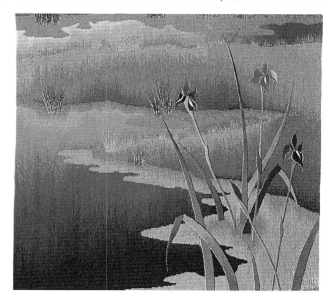
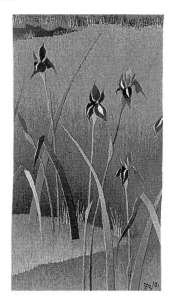

Top: *Siberian Iris Triptych,* 2001, private collection, wool and silk on linen tapestry, total size: 48" × 102".
Bottom: *Tree Trunks,* 2001, private collection, wool on linen tapestry, 60" × 72". Photographs: Ron Hall Photo.

# KAUFMANN STUDIOS

K. SARAH KAUFMANN ▨ 1210 FRANKLIN BOULEVARD ▨ ANN ARBOR, MI 48103 ▨ TEL 734-276-6034
E-MAIL KSKAUFMANN@YAHOO.COM ▨ WWW.SHESHE.COM/KAUFMANN_STUDIOS

188

Left: *Red Portal*, 2001, private collection, hand-painted and handwoven rayon, 32"x 54".
Right: *Core Sample*, 2001, private collection, hand-painted and handwoven rayon, 36" x 62". Photographs: Michael C. Myers.

# PAVLOS MAYAKIS

4015 MATCH POINT AVENUE ■ SANTA ROSA, CA 95407 ■ TEL 707-578-4621 ■ TEL 866-629-2547 (TOLL FREE)
E-MAIL PAVLOSMAYAKIS@YAHOO.COM ■ WWW.PAVLOSMAYAKIS.COM

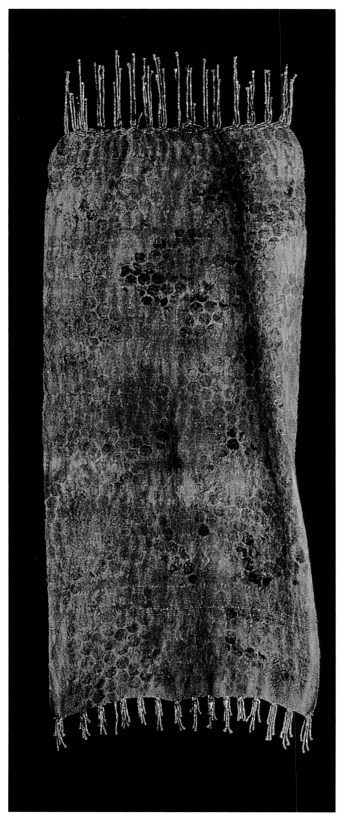 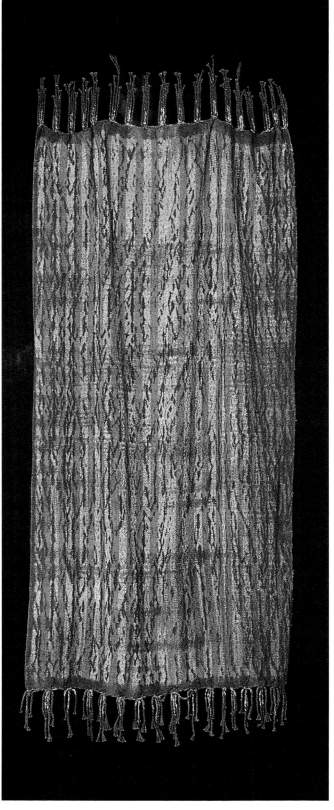

189

Left:  *Shibori Bingo*, 2001, handwoven, dyed and stamped, 28" x 60".  Right:  *Ethno Shibori*, 2002, handwoven, dyed and over-dyed, 28" x 60".  Photographs:  Black Cat Studios.

# BARBARA CADE

262 HIDEAWAY HILLS DRIVE ■ HOT SPRINGS, AR 71901 ■ TEL 501-262-4065 ■ E-MAIL CADE@IPA.NET

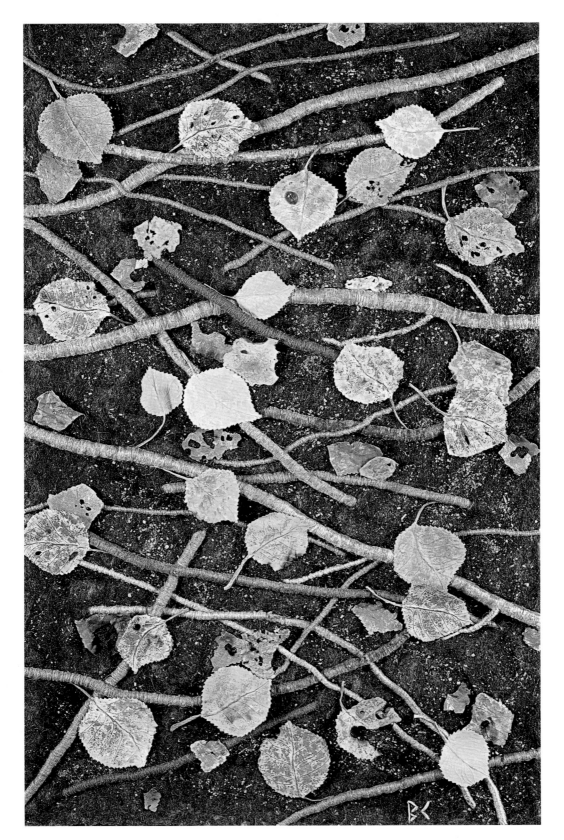

190

*The Last Dance – Alaska Aspen,* 2001, handmade felt and paper, wrapping, wool and linen, 50" × 32" × 2".  Photograph:  Cindy Momchilov.

# LYNN BASA

LYNN BASA STUDIO ■ 2248 NORTH CAMPBELL AVENUE ■ CHICAGO, IL 60647 ■ TEL 773-289-3616
E-MAIL LYNNBASA@LYNNBASA.COM ■ WWW.LYNNBASA.COM

Top: *Checker Doodle*, hand-knotted wool and silk, 42"x 42". Bottom: *Steam Bubbles*, hand-knotted wool and silk, 42" x 42". Photographs: Russell Johnson.

# DETERMINING VALUE

Let's face it. When we find artwork that appeals to us, our reaction is likely to be subjective and immediate. We fall in love with it first—and *then* think about the pragmatic aspects of buying or owning it.

But before you buy that painting or art quilt, it's important to ask some hard-nosed questions. Do I want to live with this work for years to come? If I buy it, where will I place it? And, equally important: is the piece worth the asking price?

Here at GUILD, we help thousands of customers purchase original art each year. We also interact with hundreds of artists. Based on what we've learned, we can suggest some guidelines for assessing the value of a work of art.

## COST AND VALUE

One criterion that all experts and collectors will agree on is this: buy art that you love. If you love it and can afford it, many say, you should buy it; all other considerations are secondary. While we agree with the spirit of this suggestion, we also think you'll make better and more confident purchases if you conduct basic research into the artist's background and stature.

### Pricing

The cost of a work of art is often related to the experience of the artist. Those who have worked in their fields for many years command higher prices than relative newcomers. The same is true for artists whose work is included in museum collections or publications, or who have mounted one-person shows. These are landmark events; they demonstrate respect for the artist on the part of curators, publishers and gallery managers, and they have a cumulative effect on the artist's prices.

Whether or not a work of art seems expensive, it's good to remember that value and price are different qualities. The value of artwork is perceived and subjective, while the price is set and, usually, firm.

### Education

An artist's academic record sheds more light on his technical background and skills than his natural talent. Museums and institutions consider an artist's schooling important, particularly when selecting emerging artists to participate in shows. Your choice of an etching or of tile for a fireplace surround, however, should not be based on which institution granted the artist a master's degree—or even whether the artist holds that degree. Some of our most esteemed artists developed their skills as apprentices or within an artists' community rather than at an institution.

### History of Exhibitions

More than schooling, an artist's credibility is reflected in the number and range of shows that have exhibited his work. This is a very important reference point for value. Young artists compete to participate in group shows at local and regional galleries. Artists who are more advanced in their careers mount one-person shows. Exhibitions give artists an opportunity to obtain exposure and gauge the response to their work.

Opposite: Interior design by Mary Drysdale. Photograph: Andrew Lautman. See page 140.

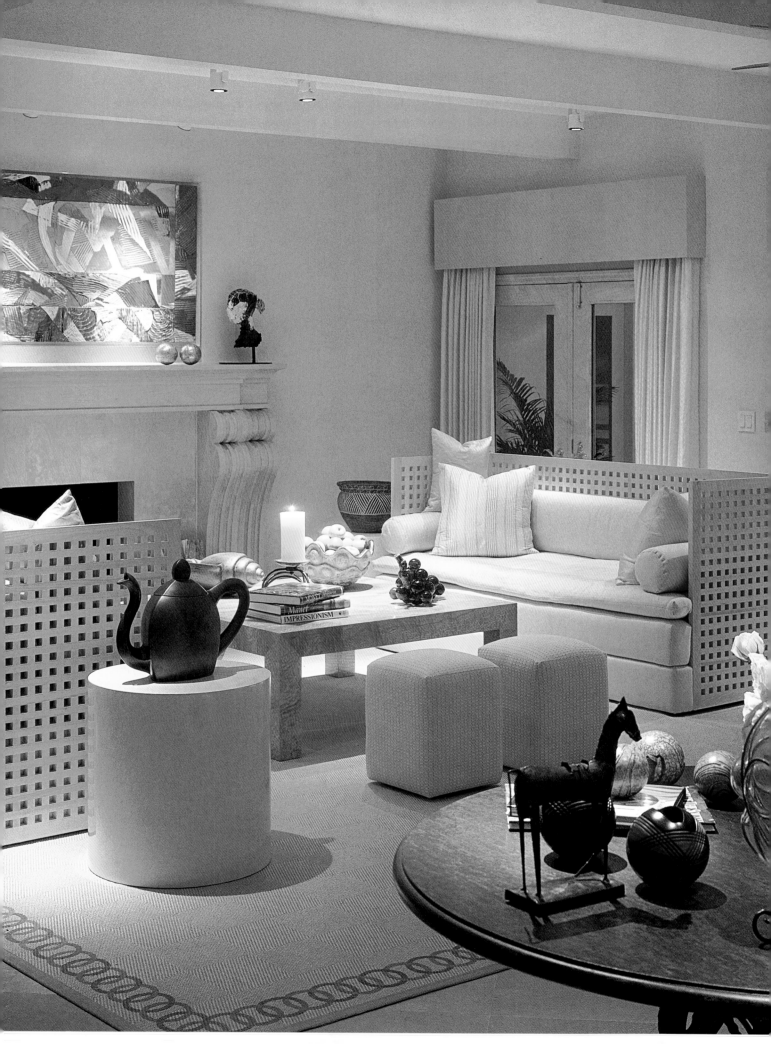

# THE CARE AND MAINTENANCE OF FIBER ART

Handcrafted works in fiber have enriched the lives of both royalty and peasantry since the beginning of recorded history. Persian brocades, Indian *chilkats*, Indonesian ship cloths, Asian *ikats*, Turkish rugs—the artistry and craftsmanship of textiles from centuries past are kept alive in countless museums around the world. And it's a marvel that they exist at all for us to enjoy today. Homage is paid first to the artists who toiled over these works and second to the conservators who have preserved them for safe passage into this century.

Likewise, today's fiber art deserves our thoughtful attention to care and maintenance. Regarding contemporary textiles as the heirlooms of tomorrow is the best way to ensure their preservation for future generations to enjoy.

You don't have to be a museum curator to purchase and display contemporary textiles, but you should remember that they are perishable works of art. Because fiber is somewhat fragile, questions of endurance and care are important. Fiber art that has become shabby or soiled, with its color faded, is an all-too-familiar and disheartening sight.

Successful presentation begins with selecting the right environment—a space, position and illumination that shows off the ultimate quality of a piece. On an artistic level, attention must be given to spatial considerations, proportions, focal points. On a practical level, solutions must be found for showcasing fiber art without risk of damage.

Fiber art has long been recognized as a springboard for explorations in a variety of media; this is a field that continues to evolve through the use of new materials. Peruse the pages of this book and you'll find works in metallic yarns, new lustrous cottons, silk, wools, handmade papers, synthetics, bamboo and wire. Often you'll read in the artists' descriptions assurances that their works are custom-dyed, lightfast, mothproofed, treated with fabric protectant or fireproof. Our contemporary fiber artists have become knowledgeable in areas of durability and maintenance. Conservation gets a good start with their expertise, but there are several things you can do to ensure your fiber artwork will be enjoyed for years to come.

## POSITIONING

Safe placement of fiber art is very important. Ultraviolet rays (sunshine) are the most harmful, but incandescent light can also break down natural fibers. Works in fiber should be placed not only out of direct sunlight, but at a safe distance from artificial light, where heat can destroy the material. Likewise, fiber work needs to be kept at a distance from heat vents and radiators.

Too-close or too-intense lighting not only risks physical harm to fiber art, but also diminishes these works aesthetically. Intense light can distort the colors that have been painstakingly and masterfully chosen for the ultimate effect. Works with subtle transitions in color, and those in which light plays on fibers and in which spatial depth is critical, must also be lit very carefully. Solutions include adding lenses to a fixture to soften bright spots, using up-lights from a floor canister, and lighting the artwork from across the room.

The right light source will enhance, not diminish, the aesthetics and mood of the work. Is the art dramatic, moody, romantic, cheery? Cool colors are enhanced by daylight; incandescent lighting is high on the red, or warm, end of the spectrum; halogen light is visually less blue than daylight, less red than incandescent and has a crisp, almost icy whiteness.

## FRAMING

There are many considerations in framing textiles as well. While glass protects against humidity, dust, insects and touching, it is important to allow an air space around the work and to use conservation glass and acid-free mats and backings to avoid harming the fibers. Many fiber works—especially large pieces—are best displayed unframed.

## INSTALLATION

Many of the works created by artists featured in *The Artful Home* will come ready to hang, and any artist whose work you purchase should have suggestions for hanging his or her artwork safely. One good way to hang fiber involves handstitching a four-inch-wide twill tape (used in upholstering) onto the backs of tapestries. A strip of Velcro is then attached to the tape and another adhered to a board (shellacked so no acids can leach out) that is covered in muslin. Screw eyes are used to secure the board to the wall, at the optimum height.

## CLEANING

While fabric protectors such as Blue Magic® Tectron® may solve many of the problems associated with soiling, fading and humidity, periodic cleaning will still be needed. Some pieces can be carefully vacuumed, with a mesh screening placed over the work to minimize fibers being either disturbed or extricated from the piece. Dry cleaning, though, by anyone other than a well-versed conservator, can be dangerous business; textile conservators around the country specialize in cleaning fragile artworks.

When appropriately cared for, contemporary fiber art will endure long after its creation. Good care from the beginning will guarantee that the best of our textile treasures will be passed on within the family for future generations to enjoy.

## OVERCOMING GLARE

Artwork that is covered with glass or plexiglass can reflect light. The potential for glare can be determined even before the artwork is hung as long as you know where lights will be placed in relation to the art. The angle of light reflecting off the glass or plexi always equals the angle of the light hitting the surface.

Here are some solutions to the problem of glare:

- Add parabolic louvers to light fixtures to provide a 45° shielding angle.
- Set the ceiling lights at a sharper angle: move the lights closer to the wall where the art is displayed.
- Use floor canisters that shine light upward onto the art.
- Display the artwork unframed or have it framed without glass.

# DOREEN BECK

100 WEST 57 STREET, #12C ■ NEW YORK, NY 10019 ■ TEL/FAX 212-541-5066
E-MAIL DORBEC@JUNO.COM

210

Top left: *Blur 3*, 42" × 50". Top right: *Childhood Memories*, 44" × 54".
Bottom left: *Dining*, 56" × 44". Bottom right: *Band*, 62" × 47".

# LINDA FILBY-FISHER, QUILT ARTIST

LINDA FILBY-FISHER ■ 6401 WEST 67TH STREET ■ OVERLAND PARK, KS 66202 ■ TEL 913-722-2608
FAX 913-722-1594 ■ WWW.SAQA.COM ■ WWW.GUILD.COM

Top left: *Rising*, from the *Celebration of Life* series, international and hand-painted fabrics, photo transfers, embroidered text and fetishes, 59.25"L × 47.75"W, reversible.
Top right: *Origin*, from the *Celebration of Life* series, international and hand-painted fabrics, embroidered text and fetishes, 74.5"L × 52"W, reversible.
Bottom: *Becoming*, from the *Celebration of Life* series, layered appliqué, silk and metallic threads and embroidered legend, 49.5"L × 76.5"W, reversible. Photographs: Eric Berndt.

# RESOURCES

# THE CUSTOM DESIGN CENTER
## A Project of GUILD.com

A commissioned work of art is a uniquely individual way to celebrate a family milestone, fill an unusual space or make everyday objects artful. This book gives you the essential tools to make that happen: photographs showing a range of products, media and art forms, and contact information so that you can connect directly with the artists whose work you want to own. For many *Artful Home* users, the path to custom-designed artworks is just this simple.

However, you may want to make use of another service available through the GUILD.com website. The GUILD Custom Design Center enables you to broadcast a description of your dream project to suitable artists via the Internet. Interested artists submit proposals free of charge, and you are under no financial obligation until you decide to proceed with a project.

GUILD.com

## GUILD Custom Design

A handcrafted cradle for a first child? A portrait of a beloved grandparent? Whatever the project, the GUILD Custom Design Center can help make it a success.

## www.guild.com/cdc

What kinds of projects pass through the Custom Design Center? Here are some examples:

- A portrait for a California bedroom
- Bar stools for a New York apartment
- Ceramic tiles for an Oklahoma kitchen
- Wall sconces for a California walkway and garden
- An art quilt for a Canadian home

Visit the GUILD Custom Design Center at www.guild.com/cdc, or call 877-344-8453 to discuss your idea with one of GUILD's Design Consultants. They can recommend candidates for a specific job, assess the qualifications of individual artists or help draft a letter of agreement.

# ARTIST INFORMATION

**MARY LOU ALBERETTI**
Ceramic Tiles & Wall Reliefs
Page 146

Mary Lou Alberetti's hand-carved ceramic reliefs, inspired by the artist's studies in Italy, include images of architectural details for public, corporate or residential spaces throughout the United States. Sizes range from 12" x 12" x 12" to 72" x 20" x 4". Commissions: Cultural Commission, City of New Haven, CT. Collections: HBO World Headquarters, New York, NY; Reese, Lower Patrick & Scott, Ltd., Architects, Lancaster, PA; Fuller Museum of Art, Brockton, MA; Mint Museum of Art, Charlotte, NC. Awards: Master craftsperson, honorary life-time member, Society of Connecticut Crafts. Publications: *Architectural Ceramics; Sculptural Clay.* Alberetti's work has also been featured in previous GUILD sourcebooks.

**DANA LYNNE ANDERSEN**
Paintings
Pages 68, 85

Contemporary works of enduring beauty. Museum-quality original fine art and archival giclee reproductions for home and corporate interiors. Vibrant and luminous, masterful in painterly refinement, Dana Lynne Andersen's work conveys a quality of presence and spirit that touches the heart and uplifts the mind. Andersen's large-scale originals, up to 8' x 25', have received wide acclaim for their inspiring vision in both sacred and civic public arenas. Mid- and smaller-sized paintings in a thematic series are also perfect for hotel and office suite projects. Designers especially appreciate the *Feng Shui* series, which renders the elements with an appealing twenty-first century resonance.

**DAVID PAUL BACHARACH**
Metal
Pages 155, 158-159

David Paul Bacharach is a self-taught metalsmith who has been creating decorative and functional, hand-woven copper sculptures (colored with traditional patinas and glazes) for over 30 years. Working with individuals, corporations, museum curators and the trade, he crafts each wall-mounted, tabletop or free-standing sculpture with the client's spatial and design requirements in mind. Sculptures can be fabricated for interior or exterior installation. Collections include: American Craft Museum, New York, NY; Craft and Folk Art Museum, Los Angeles, CA; United States Embassy, Singapore; The White House, Washington, D.C.; U.S. Treasury, New Carrolton, MD; Fidelity Investments, Boston, MA; Monsanto Corporation, Washington D.C.; and numerous private collections.

**ALLAN BRUCE ZEE**
**FINE ART PHOTOGRAPHY**
Photographs
Page 115

For 33 years, a unique vision, an extraordinary range of imagery and impeccable printing technique have contributed to the enthusiastic response to Allan Bruce Zee's photography. His prints have been purchased for private residences, offices and prominent corporate and public collections on six continents. Imagery includes interpretive landscapes, abstract textures, "rustscapes," oriental and architectural motifs and international settings (Europe, Mexico, Bali, Tahiti and South Africa). His work is included in the collections of IBM, AT&T, Merrill Lynch, Sloan Kettering Hospitals, American Express, World Bank and Ansel Adams. Print sizes range from 10" x 14" up to 40" x 60", are signed and numbered and priced from $250 to $1500. Slide, color copy or electronic portfolios are available upon request.

**JUDITH ANTON**
Paintings
Page 79

Translucently rich and delicately textured surfaces burst with color and movement in Judith Anton's dye-painted works on canvas and cotton. Anton is the recipient of NDEA and Ford grants. Clients include private and corporate collectors such as Southern California Edison and Imagica Media Inc., Japan. Due to the high demand for Anton's original dye-painted works, three are now available as limited-edition giclee prints, individually signed and numbered. These are printed on acid-free watercolor paper using archival inks and are the perfect size for home and office. Prices range from $450 to $575 for prints and from $1,000 to $7,500 for original dye paintings. Please go to www.antonartgallery.com to view complete works by the artist. Publications: *National Geographic, Architectural Digest,* and *American Crafts* magazines.

**HYE SUN BAIK**
Mixed & Other Media
Pages 161, 181-182

Originally from Korea, Hye Sun Baik is a national award-winning mixed media on handmade paper artist. Baik has created significant commissions for major corporations, government and public institutions, including the World Bank, Delta International Hotel, Samsung Corporation and the Canadian National Center for the Arts. Her work is highly textured and tactile. She begins by making her canvas using traditional Korean mulberry paper. She builds her canvas using innovative casting, painting, printing and embossing methods. People viewing Baik's work often find hidden signs, symbols or patterns that they personally connect to themselves in a way that transcends their culture or spiritual orientation. The artist now lives in Chicago, where she has set up a studio and created a gallery for her work. Prices range from $900-$15,000.

**RICHARD ALTMAN**
Mixed & Other Media
Page 179

Contemporary style, vivid colors, texture and dramatic design are the hallmarks of Richard Altman's glass art. Applications of the artwork include wall panels, skylights, room dividers, wall sconces and sculptural elements. The glass can be mounted on walls, supported with custom metal stands for floor and table display, or integrated into unique metal frameworks for very large-scale installations. Stunning visual effects are created using combinations of glass particles, poured glass shapes and kiln-forming techniques. Altman's work is well suited for custom residential projects or high-tech corporate environments and commercial projects including retail, restaurants and resorts.

**ARTPLANE.com**
Prints
Pages 97, 102-103

ArtPlane.com features an online collection of limited-edition prints. Produced in collaboration with the artists, these archival prints are of the highest reproduction quiality and are available in limited, signed editions. ArtPlane caters to individual collectors, interior designers and corporate clients, offering a vibrant collection of engaging, comtemporary work by internationally recognized artists. Prints are available unframed, framed or museum-finished on custom hardwood panels. To find out more about framing options and to view the entire collection, please visit www.artplane.com. You can contact ArtPlane directly by calling toll-free, 877-473-7000, Monday through Friday, 9 a.m. to 5 p.m., Pacific time. Our mailing address is: Artplane, P.O. Box 548, Lagunitas, CA 94938.

**LISA BAILEY**
Ceramic Tiles & Wall Reliefs
Page 150

Lisa Bailey's ceramic wall sculptures have a dynamic visual presence that express the energies of the heart, inspiring and uplifting all who view them. Mandalas—ancient ritualistic formulas used for elevating one's consciousness—are a source of inspiration for Bailey's compositions. Currently focused on the archetypes of Greek goddesses, she builds large-scale, multi-sectioned mandalas that imbue and emanate the intangible qualities of each goddess through the tangible means of visual art. Bailey attends graduate school while selling her work through regional galleries and completing commissions for the Cultural Council. Her work is appropriate for home, corporate, indoor and outdoor settings. She is happy to do work that has an alternative conceptual impetus, keeping in mind that aesthetics are the enduring signature of her heart.

216

# ARTIST INFORMATION

## KRYSTALL BARNES
Paintings
Page 86

Krystall Barnes' paintings are completed without mixing colors on the palette, as is typically done with watercolor. Instead, she layers on pure color—red, yellow or blue—until the desired intensity and color is achieved. Her paintings reflect her love and respect for nature and also represent her struggle to accept the duality of life: positive coming from negative, beauty from ugliness and pain. "It's a Zen thing," she says. Her works are found in collections around the U.S., including California, Ohio, Texas and Oregon. Her commissions include a 21-piece project painted for the Deaconess-Billings Clinic Health Care System in Montana.

## LYNN BASA
Tapestry, Fiber & Paper
Page 191

Lynn Basa's work has been shown at the Louvre and the Smithsonian and has been featured in an ad for Absolut Vodka, but her favorite venues are the homes and public spaces of her commissioning patrons. She thinks of her work as symbolic portraits, each one as unique as the people and places that engage her. Now, with the *Argyle* series, two of which are pictured in this publication, she has produced limited-edition tapestries available for direct purchase. Two additional series, *The Haven Triptych* and *Harbor*, are also available. Basa's silk and wool rugs and tapestries are hand-knotted in Nepal by a team of artisans with whom she has worked for the past 20 years.

## HEATHER BAUSE
Paintings
Page 64

Heather Bause received a B.F.A. in painting and art history from the University of Houston in 1997. Her work has been exhibited in several group shows in both Houston and Austin, TX. Her current focus has been painting famous women actresses from the 1930-1950s. With an interest in nostalgic and classic images, Bause makes these lifelike paintings in greater-than-life-size proportions. Working in oils on canvas, painting only in black and white, she further pays homage to the nostalgic origins of her subjects.

## DOREEN BECK
Art Quilts
Page 210

Doreen Beck, in collaboration with her illustrator-cartoonist husband Dink Siegel, has given a contemporary, sometimes humorous and often recognizably New York look to old craft techniques, especially appliqué, piecing, and layering. Her most recent art quilts, inspired by her husband's digital paintings, are more abstract and painterly. They are easily hung with a rod attached to a fabric sleeve. The quilts can be particularly effective when they are hung against a wall painted in an appropriate solid tone. Prices are available upon request. Beck's work has been featured in *Creative Quilting Magazine*, Sept-Oct, 1990, and in previous GUILD sourcebooks. "What delightful work you are doing . . . . Your pictorial representations are imaginative and wonderfully capricious." Ursula E. McCracken, Director, The Textile Museum, Washington DC.

## RITA BLITT
Paintings
Pages 66-67

Rita Blitt's creative journey has encompassed many mediums and processes, from the discovery that her drawings could become sculpture, up to 60 feet tall, to the realization that her painted lines can flow powerfully from both hands at once. Her works have been documented in the award-winning book, *Rita Blitt: The Passionate Gesture*, 2000; at www.ritablitt.com; and video, *dancing hands: Visual Arts of Rita Blitt*. She has exhibited and is collected internationally. Recent installation sites include the Gold Coast Sculpture Park, Surfer's Paradise, Australia and Brandeis University in Waltham, MA. Her gestural oil and acrylic paintings for the wall range from 22" x 30" to mural-sized works on canvas.

## ERNEST BRAUN
Photographs
Page 114

For more than 30 years, Ernest Braun has been a dedicated advocate of the natural world, exploring deep inside nature's beauty. His awe-inspiring, impressionistic photographs, many of them intimate close-ups eliciting great feeling, probe the wonders of mountain meadows, stream banks, shorelines and tidepools. To view more of Braun's most requested photographs, nature clasps, landscapes, flowers, seascapes and tidelines, visit his online portfolio at www.ernestbraun.com. Braun's work has been published in the following books: *Living Water, Tideline, Exploring Pacific Coast Tidepools, Grand Canyon of the Living Colorado, Our San Francisco, Portrait of San Francisco – Oakland Bay Area.*

## BOB BROWN
Paintings
Page 22

Bob Brown's colorful paintings highlight an area by bringing the bright outdoors to the inside. The thick texture, created with durable acrylic paint and a painting knife, provides an intriguing surface. Subjects are representational and mostly landscapes. Unframed paintings range from 16" x 20" to 36" x 48". A brochure is available. Collections: Prince Albert, Monte Carlo, Monaco; McGraw Hill Companies, New York. Exhibitions: In galleries and public spaces in the United States, Monaco and France. Brown's work has also been featured in previous GUILD sourcebooks.

## MICHAEL BROYLES
Photographs
Page 134

Michael Broyles' works portray ordinary scenes that have been transformed into striking works of art. He employs attention to setting, color and precise detail to create beautiful images in an exciting new medium. Broyles transfigures simple flowers or landscapes into powerful compositions; he is an artist truly capable of capturing the extraordinary. After a distinguished career as a chaplain with the United States Army, Broyles now shares his creativity and artistic works with the public. In addition to creating and exhibiting his original works of art, he enjoys sharing his knowledge of digital art with his students at the University of Tennessee, where he teaches digital photography through the Professional Development Program.

## FRAN BULL
Prints
Pages 101, 110

In this group of etchings, Fran Bull explores the language of human gesture, the unspoken sentences woven in and through movement that occurs between human beings. Bull speculates on the implications of arms touching, embracing, reaching, enfolding. Like a choreographer, she delves into the meanings implicit in figures juxtaposed. The etching process provides an opportunity for Bull to work spontaneously, improvisationally, and to express a wide range of ideas and concerns. The work ranges in price from $500 for a drawing on paper to $4,000 for an etching to $30,000 for a work on canvas. Recent projects include an exhibition of opera portraits at the Karpeles Museum in South Carolina, a portrait commission, a solo exhibition in Kansas City and ongoing work with printmaking in Spain.

# ARTIST INFORMATION

## MYRA BURG
Tapestry, Fiber & Paper
Pages 104-105, 195

Myra Burg's installations are primarily made from wrapped fiber, often combined with burnished metals, which are inspired by anything from clients' thoughts and needs to the colors of an autumn leaf, reflections in a pool of water or the patina colors of aging metal. Completed works, custom "quiet oboes" and site-specific architectural installations are also available. Size range: table top to airplane hangar for freestanding, wall mounted and aerial constructions with collaborations welcome. Prices range from $150-$30,000. Recent projects include: Universal Japan, Travelocity, Caribe Hilton in Puerto Rico, exhibitions in the Los Angeles County Museum of Art, Orange County Museum of Art and private residences in 42 of 50 states, Japan, England, France, Israel, Australia and New Zealand.

## BARBARA CADE
Tapestry, Fiber & Paper
Page 190

Collectible rocks, luscious vegetation, textured trees and dramatic skies: two- and three-dimensional sculptural landscape elements inspired by your geographic location, maybe using your favorite photograph. Use elements together or individually. Barbara Cade continues to be inspired by themes in nature, translating her photographs into tapestries of woven and felted wool, often incorporating other fiber techniques. Commissions include: The Kraft Center, 1997, Paramus, NJ. Collections: Weyerhaeuser Company, Tacoma, WA; Tacoma Art Museum, Tacoma, WA. Exhibitions: *Reality Check*, Ohio Craft Museum, 2001, Columbus, OH. Her work has been published in previous GUILD sourcebooks.

## CLARK & HALL
Murals & Painted Finishes
Pages 137, 143

Clark & Hall Studios is a full service decorative painting company. For seven years, its partners Barbara L. Clark and Donald J. Hall have painted skillful and imaginative interior paint techniques in homes and restaurants. They design their painted finishes to be appropriate for a space's architecture as well as its furnishings. Many of the paint finishes offered by Clark & Hall were invented for specific projects. No technique is too subtle or extravagant for their team to accomplish. Faux Bois is a company specialty. They install authentic Italian plasters and French Lime paints. Clark is now painting murals on canvas. Her realistic painting style and strong composition skills create art that is an architectural as well as artistic addition to every space. Their customers agree, Clark & Hall's attention to detail is amazing. Literature is available.

## DAN BURKHOLDER
Photographs
Pages 116-117, 127

Dan Burkholder is a digital-imaging pioneer whose photography melds his unique vision with mastery of both the traditional and electronic darkrooms. His beautiful handmade platinum prints are included in many collections. Burkholder's pigment over platinum prints are the first to combine digitally applied color pigments with the hand-coated platinum process. The final archival print captures the beauty of the two processes with a fresh sensitivity that is both innovative and anchored in the traditional photographic disciplines of craft and beauty. Burkholder's landmark book, *Making Digital Negatives for Contact Printing*, has become a standard reference in the fine art field. Burkholder received his B.A. and M.A. in photography from the Brooks Institute of Photography in Santa Barbara, CA.

## PAT CASHIN
Paintings
Page 52

Pat Cashin's museum-quality paintings offer beauty and inspiring vision. Large in scale and saturated in color, her works create a spiritual quality that is universal and uplifting. Cashin received her M.A. from Wayne State University in Detroit, Michigan, after studying painting at Fontainebleau School of Fine Arts in France. Her work has received numerous awards and has been exhibited in galleries and museums throughout the United States, including the Cincinnati Art Museum, The Ringling Museum of Art and The University of Michigan. Her work is found in private, public and corporate collections, including those of the University of Colorado, Brenau University, Lankford & Associates, Diatech Diamond Corporation and Teco Electric Company. She uses acrylic paint on canvas, wood, paper, screens and freestanding structures. Prices range from $4,000 to $1,200.

## WILL CONNOR
Photographs
Pages 113, 121

Will Connor's photographs are about nature, beauty and the magical relationship between the camera lens and the human imagination. He uses a large-format camera and prints on Fuji Crystal Archive photographic paper. The Crystal Archive prints (tested to remain color stable for 70 years), are luminous with brilliant color and are very sharp at any size. Prints are available from 8" x 10" to 48" x 96". Connor's photographs hang in hundreds of private and corporate collections internationally. An extensive selection can be viewed at www.WillConnor.com.

## BRIDGET BUSUTIL
Paintings
Page 35

Busutil's favorite mediums are encaustics and oils. Encaustics give her the feeling of being part sculptor and part chemist. The encaustic process of applying wax is challenging as it settles immediately, though the surface can be scratched, marked or burnt, allowing different layers to appear. The wax texturizes and shimmers, turning realistic works into dreamier pieces. Busutil loves pure color and has developed a technique using pure pigments mixed with a glazing medium. It is a long process, but the result is well worth it: the paintings glow, the light affecting one or several layers. Having lived in Vietnam and Africa until the age of 21, Busutil has been strongly affected by the purity and intensity of color in her environment. "Color is always my starting point," Busutil says, "It feels like starting a poem."

## JERRI CHRISTIAN
Paintings
Page 55

Jerri Christian's imaginative creations are inviting, compelling, mysterious and, at times, whimsical. The images offer glimpses of a personal language expressed in symbol, intriguing and curious, opulent and elemental, vibrant and subtle, bold and quiet. Threads of metallics are interwoven with richly colored multi-layered surfaces. An appreciation of words, geometry, poetry, exquisitely drawn line work, architecture, the colors of the Mexican landscape, the restraint of Asian art and the originality of personal symbols and deeply meaningful content result in images of iconic elegance. Publications: *International Artist*, June/July 2002; *International Artist*, June/July 2001; *Watermedia Focus*, Issue 21, 2000.

## DONNA CORLESS
Prints
Page 131

"My work is inspired by my worldwide travels and includes architectural, floral, tropical and seascape settings." In the collection featured in this publication, Donna Corless has captured Europe and the Caribbean with a focus on Italy and the Bahamas. Each piece is set in or around the water. The artistic media, which she calls digital watercolor, represents the digital manipulation of photographs that she has captured. She turns the presentation of the work into her interpretation of what the subject would look like as a watercolor painting, with an impressionistic appeal. Largely self-taught, she creates her fine art using a Minolta SLR camera to capture her subjects and prints limited-edition giclee art prints.

# ARTIST INFORMATION

## MICHELLE T. COURIER
Paintings
Page 23

Trained as a fine artist, Michelle Courier earned her B.F.A. in 1987 from the University of Michigan. The focus of her work is the landscape, both natural and urban. Michelle has worked with many decorators and galleries to create paintings for corporate and individual clients. She welcomes commissioned work in a variety of sizes and subject matters. Contact the artist for more information and prices. Collections include: Dow Chemical, Midland, MI; Delta College, University Center, MI; Arts Midland, Midland, MI; Upjohn Pharmaceutical, Battle Creek, MI; Outdoor Experience, Sandpoint, ID; First of America Bank, Rock Island, IL; Second National Bank, Saginaw, MI; Saginaw township building, MI; Keswick Manor, Bay City, MI; and private collections throughout the United States.

## EDWARD SPAULDING DeVOE
Paintings
Page 24

Edward Spaulding DeVoe exhibits throughout the United States and abroad and is recognized for his unique ability to "create modern paintings with the qualities of Renaissance masters." He is the recipient of numerous awards, including Best in Show and the President's Award from the National Arts Club. Last year his work was featured at the United Nations Ambassador's Ball and was auctioned by Christie's in support of the World Trade Center Relief Fund. He is currently at work on a series of 8' × 10' paintings depicting ancient mythological figures. Prices available upon request; commissions welcomed.

## EILEEN DOUGHTY
Art Quilts
Page 212

The tactile nature of quilts is explored and celebrated in the art of Eileen Doughty. She incorporates unique fabric manipulation methods with a variety of nontraditional materials. Details are added with "thread painting" and surface design techniques such as dyeing, painting, discharging and stamping. Doughty often portrays nature themes in her work. One of her favorite subjects is the positive and negative interactions we have with our environment. She has been creating distinctive fiber art for public, corporate and private clients since 1991. Recent commissions include: the White House ornament collection; the Utah Arts Council; and the City of Greeley, CO (gifted to the city of Moriya, Japan). Doughty has exhibited in various venues across the United States. Her work has been featured in previous GUILD sourcebooks.

## TERESA COX
Paintings
Page 78

Teresa Cox is a painter whose work is strongly influenced by nature's rhythm, originality, order, beauty and adaptiveness. Through amplified color, movement and strong form, she explores the relationship of nature's magnificence to the human spirit. Cox works on stretched canvas and heavy cotton rag papers with acrylic paint and oil pastels. Her work typically ranges in price from $900-$15,000. Collections include: U.S. Bank, Los Angeles, CA; U.S. Senator Mark Dayton, Washington, DC; Money Corporation, St. Paul, MN; Lutheran Brotherhood, Minneapolis, MN; Baker Management Corporation, Minneapolis, MN; and many private collections. Exhibitions include: solo exhibit, 2003, Concordia College, St. Paul, MN; Blanden Memorial Art Museum, 2001, Fort Dodge, IA; and a group exhibition, 1998, St. Paul Companies, MN.

## JAMES F. DICKE II
Photographs
Page 135

James Dicke's process employs mixed-media oil on canvas. He seeks to build on the development of art in America over the last century with images that are abstract and representational. He strives to engage the viewer in his art and in the varying levels of meaning and information contained therein. If the art lover views Dicke's work as a beautiful example "of nature" and finds in it emotional components of our time, then the artist has reached his goal. His work is in the permanent collections of NASA, Washington, DC; Eli Wilner, New York, NY; and the National Museum of American Art, Washington, DC. Recent exhibitions include: 57 North Fine Art Gallery, 2001, Washington DC; Cincinnati Art Galleries, 2001, OH; and Ralls Collection, 1999, Washington, DC. Dicke was a National Academy of Design honoree in 1999.

## JEFF EASLEY
Mixed & Other Media
Page 171

Award-winning designer and artisan Jeff Easley creates wall sculptures and studio furniture, combining his high standards of craftsmanship with refined designs and the natural beauty of wood. Dimension requirements, wood preferences and design options may be discussed for your projects. Other designs are available upon request. Comments from clients include: "Installation was a breeze. We have enjoyed having a piece of your art in our home and know that we will continue to enjoy it in the years ahead." "We will always value and appreciate your magnificent artwork in our home." "Thank you for such beautiful works. We are so pleased to have them enhance the comfort of our home." "I feel very fortunate to have found you and your work."

## DANIEL LANG STUDIO
Paintings
Pages 29, 234

"Daniel Lang remains what he has always been, a painter of landscape and a romantic. Beyond all the apparent formal concerns of the painter—the deceptive simplicity of approach, the immaculate surface of the paint, the careful, structured composition—his essential preoccupation lies with the emotional charge, physical and visual, which is to say, the poetry of his subject. As always with Daniel Lang, we find ourselves thinking of the tradition that runs from the romantic through symbolism to the metaphysical—of de Chirico for the feverish, distorting clarity with which he invests his dream world; of Hopper and the calm and quiet of his desolation; of Friedrich standing at the cliff's edge, gazing into the infinite. This is indeed the stuff of the romantics and metaphysicals." William Packer, art critic for the *Financial Times*, London, October 1997.

## SUZANNE DONAZETTI
Metal
Page 163

Suzanne Donazetti paints on copper with metallic leaf, inks, acrylics and pigments. She weaves the painted copper into tapestries, framed pieces and folding screens. Donazetti's work is included in corporate, public and private collections and is represented by Expressions in Fine Art, Santa Fe, NM. A folding screen is featured in *Color on Metal: 50 Artists Share Insights and Techniques* by Tim McCreight and Nicole Bsullak, Guild Publishing, 2001. Donazetti has won a grant for artistic excellence from the Maryland State Arts Council. You can view her work on www.freefalldesigns.com or www.expressionsinfineart.com.

## CLAIRE EVANS
Paintings
Page 25

Claire Evans paints oil and watercolor landscapes true to the spirit of each place, with careful attention to the special light of each location. Her work is informed by nineteenth-century traditional painters such as Innes, Bierstadt and Moran. For more than 25 years, she has created well-crafted, commissioned paintings for corporate and private collectors. Evans is also well-known for her fine portraits of people of all ages. Her prices range from $1,000 to $12,000.

219

# ARTIST INFORMATION

## ROB EVANS
Paintings
Pages 40-41

Rob Evans received a B.F.A. from Syracuse University in 1981. His paintings have been featured in numerous books, newspapers and magazines. Solo and group exhibitions include: Tretyakov Museum, Moscow; Delaware Center for the Contemporary Arts; the National Science Foundation; and an international exhibition of American drawings organized by the Smithsonian Institution. Museum collections include: Corcoran Gallery of Art, Washington, D.C.; Portland Art Museum, OR; and the James A. Michener Art Museum, Doylestown, PA. Prices for original paintings range from $1,500 to $35,000. For more information about the artist and his available work, please visit www.robevansart.com. Print prices range from $200 to $750.

## SHELLEY FEINERMAN
Paintings
Page 90

Shelley Feinerman's paintings are essences gleaned from the keen observation of the artist. Her representational paintings are set apart by her open enjoyment of the imaginary and the real, where color and texture transform information into poetic visions. Feinerman has exhibited nationally. Her body of work includes still lifes, landscapes, murals and portraits. A complete exhibition list and commission list, as well as slides and pricing, are available from the artist upon request. Collections: Rene B. Timpone Collection, Publisher, New Jersey Goodlife; Bellevue Hospital, New York, NY. Publications: *American Artist* magazine, feature article: "Still Life: The Real and the Imaginary;" *New Jersey Goodlife,* cover. Artist in residence: Wave Hill, New York, N.Y.

## TOM FERDERBAR
Photographs
Pages 118-119

Tom Ferderbar's style of photography has been influenced by Ansel Adams and Edward Weston, both originators of the "Group f/64," whose members strongly believed in the concept of great definition and extreme depth of focus in their photographs. Hence, his work exhibits a wealth of fine detail, as well as great tonal range. The color photograph featured in this publication is one of a series on the old "Mother Road," Route 66, which Ferderbar began shooting in 1947. The black-and-whites are from a series done in Yosemite National Park and the surrounding vicinity. His work appears in the Ansel and Virginia Adams collection at the Center for Creative Photography, University of Arizona, Tucson; and the Milwaukee Art Museum, WI.

## MIKE FERGUSON
Paintings
Page 28

For centuries artists have painted the world around them. Mike Ferguson is compelled to follow this tradition as well. Using various mediums both in his home studio and in the field, he brings to life a thoughtful and vibrant interpretation of the landscape. Ferguson's approach to painting is basically representational. The reality of the scene is readily apparent; a fracturing of shape and eruption of color occur upon closer inspection. Over the past 20 years, collectors from around the world have purchased Mike Ferguson's work. His most recent commission was a three-panel, 15-foot mural for Pierce Commercial Bank in Tacoma, WA. His work can be found in the collections of the U.S. Embassy, Jakarta, Indonesia; Frye Art Museum, Seattle, WA; FAA, Portland, OR; The Boeing Company, Seattle, WA; and U.S. National Bank, Portland, OR.

## PATRICIA GEORGE
Paintings
Page 49

Patricia George creates paintings depicting Europe and Asia. She wants the viewers of her art to experience the past enchantment of these far-off lands. George's commissioned works hang in corporate and residential environments around the world, including Australia, France, the Cayman Islands and the United States. Her latest listings are included in *2000 Outstanding Artists of the 20th Century, Who's Who in American Art,* and *One Thousand Great Americans.* Among her numerous awards, George has been the recipient of the Grand Award, Festival of Paris, France; the Grand Cordon of the Templars, Museum of Sapporo, Japan; and the Special Award from the Sorbonne, Paris, France. Prices range from $2,000 to $20,000.

## JOHN PETER GLOVER
Prints
Page 106

John Peter Glover's digital works usually begin as graphite and ink drawings. The work is scanned into his Mac system work environment, primarily using Adobe Photoshop. He then manipulates his own drawings in either one of two fundamental ways. In the first approach, the drawing gets a treatment of color. Particular attention is paid to getting maximum quality at a high resolution, given the final paper size of the limited edition. In the second approach, Glover uses multiple layers of his drawings and then recomposes and stacks the images until the final effect is achieved. Out of necessity, he emphasizes that the final work is digital but not computer-generated. The end result is a unique art form that often mystifies the viewer. Price range: $600-$2,000 for limited-edition prints and $4,000-$8,000 for acrylic or oil paintings.

## GARY D. GRAY
Paintings
Page 48

Gary Gray is fascinated by the forces and rhythms that underlie the natural world; he seeks to suggest them in his realistic paintings. The marine landscape is one of his favorite subjects, providing opportunities to explore dramatic forms and compositions in his work and to hint at the pull of powerful emotion beneath surface appearance. Gray is both a fine artist and a professional illustrator. He works in a range of mediums, including watercolor, oil, mixed media, pastel, charcoal, acrylic and pen and ink. He has been featured in one-man shows, and his work is displayed in private homes as well as corporate and public buildings. Prices generally range from $250 to $5,000.

## L.P. GREGORY
Mixed & Other Media
Page 170

L.P. Gregory is a classically trained sculptor who tests the boundaries of relief by drawing on the unique potential of mixed media. As the repeat director of the board for the La Scuola Classical Sculpture School, she keeps one eye on the masters and the other on the present. L.P. Gregory's work makes use of a variety of materials and processes. Many pieces incorporate raku-fired ceramic, with shades ranging from subtle to dynamic. To expand her palette she often adds metals, such as copper, brass and steel, each of which has its own distinct energy. These combinations provide vast potential for unique colors, textures and feelings. Her work, figurative, environmental and abstract, is represented by galleries across the U.S. Prices range from $300 to $3,000 and up.

## JUDY GRIFFITHS
Paintings
Page 27

Judy Griffiths has been an artist for more than 35 years. "The Arts of the Wild name came about because I started out painting wildlife. I decided that my work still hinges on a wild note." Griffiths likes to work with brilliant colors, though many of her pieces are created in moderate tones to accommodate her clients' tastes. Her work includes a variety of subject matters: landscapes, wildlife, florals and still lifes. She works in acrylics, colored pencil and mixed media. Exhibits include: the Butler Institute of American Art, Grange Insurance and Motorists Insurance Headquarters, Trotters Association and many charitable organizations. Collections include: First Federal Bank, Forum Health, Northside Hospital, St. Joseph's Hospital, Bral Corporation, and Buckeye Oil. Her work is found throughout the U.S., as well as the Cayman Islands and Chile.

# ARTIST INFORMATION

**LARRY HALVORSEN**
Ceramic Tiles & Wall Reliefs
Page 151

Larry Halvorsen is a self-taught potter with 25 years experience working with clay. He distributes his productions, commissions and one-of-a-kind work to shops and galleries nationwide. For the last 15 years, he has been exploring and refining the sgraffito carving technique, which has become his signature style. Combining his interests in primitive art, ancient tools and natural forms with a lifelong love of pattern, Halvorsen creates an ever-evolving body of work. Recently one of the focuses has been work for the wall. Using many small components, a large area can be treated. The *Wall Balls* are available using as few as ten components. The components of the *Waves* installation are priced individually. General price range is $10-$3,000.

**MICHELE HARDY**
Art Quilts
Pages 6, 199, 207

Michele Hardy's colorful, energetic art shows a strong sense of color and form. Her art incorporates elements of collage, surface design, quilting and embroidery. In her personalized approach to images in textile assemblage, she juxtaposes large blocks of color with areas of intricate stitched detail. Hardy has received numerous awards, including several Best of Show. Her works are continually featured in national exhibits and in private collections throughout the U.S. The notion of looking out or looking in and seeing a fragment of our world is the current theme in Hardy's art, explored in several series of nature-based abstractions. A lifelong love of geology and nature has been the inspiration for this work, supplying the artist with an unlimited palette of color and texture.

**RENEE HARRIS**
Tapestry, Fiber & Paper
Pages 183-184

The creative process has taken Renee Harris from illustrating with conventional tools to discovering the infinite possibilities of drawing with fiber. Combining the ancient process of felt-making with embroidery, she is able to create colorful landscapes, birds and mixed-narrative imagery. After making the felt fabric from dyed wool, Harris enhances the rich, textural surfaces of the felts with hand embroidery. The pieces are then prepared for framing. Harris exhibits her work nationally through shows, including the Smithsonian Craft Show and the Philadelphia Museum of Art Craft Show. She has created commissioned work for private and corporate interiors and is happy to send more information to interested clients upon request.

**WILLIAM HARSH**
Paintings
Page 73

"From imagination and memory, I draw in thick oil paint, constructing forms to expose the emotive power of physical, tactile imagery. Through many re-configurations of what first emerges on canvas, intensities of color and movement arise. Jury-rigged assemblies, sometimes fortress-like in appearance, get built up and 'set' in ambiguous spaces. Mix-ups in 'representation' occur. If all goes well, space becomes alive in its compression, ordinary objects become mutable, and unnameable forms adopt the authority of 'thingness'. Estrangement compels the surprise necessary to finish a picture. For me, the whole ensemble becomes a curiosity, the way driftwood piled high on a beach or junk piled up in a studio corner can suggest a drama. A finished picture must feel at least as real as an unexpected or dismantled monument."

**CAROLYN HARTMAN**
Paintings
Page 87

"I love fantasy . . . departing from reality." With a B.A. degree in fine art from the University of Maryland, Carolyn Hartman explores transparent watercolor and collage. Her paintings have appeared in over 100 exhibits in the mid-Atlantic area. She offers museum-quality artwork that restores a sense of balance and calmness. Sunlight is a key subject matter. Using new technology, she creates each original giclee by combining two paintings into one image with transparent layers of vibrant colors and shapes. Each is extensively enhanced by additional hand work. Magic happens when one water lily becomes the reflection of another or sunlight dances over leaves on a stream. Truly stunning and imaginative, her paintings give us a fresh look at nature.

**YOSHI HAYASHI**
Paintings
Page 31

Yoshi Hayashi was born in Japan and learned the rigorous techniques of Japanese lacquer art from his father. Hayashi carries the spirit, history and inspiration of this process with him today as he reinterprets the ancient lacquer traditions for his screens and wall panels. Hayashi's designs range from delicate, traditional seventeenth-century Japanese lacquer art themes to bold and contemporary geometric designs. By skillfully applying metallic leaf and bronzing powders, he adds both illumination and contrast to the network of color, pattern and texture. Recent commissions include works for private residents in the United States and Canada.

221

**JUDY HEIMANN**
Mixed & Other Media
Page 176

Judy Heimann has been working with wood for 25 years. She cuts out shapes on the band saw, assembles them onto a plywood board, gessoes several layers and then paints the images with many layers of paint. For the past three years, she has been interpreting the paintings of Fragonard, both comically and satirically. Heimann's work has been commissioned in many public and private collections. She has also received many grants and awards for her work and has been involved in many one-person shows, including the New York Arts Council and the Maryland State Arts Council, as well as shows in New York, California and Maryland. Prices range from $3,500-$15,000.

**STEVE HEIMANN**
Paintings
Pages 42, 235

Like icons in their simplicity, Heimann's works employ few elements. He creates images that seek to engage the viewer in feeling resonance, much the same way religious icons seek to elicit that response in believers. Heimann's distinctive style is featured in corporate collections and extends to an international audience through numerous commissions for postage stamps. Countries that have commissioned stamps include the British Virgin Islands, Grenada, Sierra Leone, Uganda, Tanzania, Dominica and Antigua/Barbuda. In 1999, seven paintings were featured in "Extreme Homes," a production of the Home and Garden Network. Collections include: Ciba-Geigy Corporation, Florham Park, NJ; and SmithKline Beecham, Parsippany, NJ. A catalog is available upon request.

**MARILYN HENRION**
Art Quilts
Pages 186, 204-205

Whether exploring the visual aspects of music or the metaphor of poetry, the art quilts of Marilyn Henrion vibrate with the lush intensity of a Matisse painting, the complexity of an Indian miniature, the mystery of a Russian icon or the elegance of a Japanese kesa (the robes worn by monks), just a few of the many sources that inspire the artist. Celebrating textiles as her medium of choice, she employs a wide range of materials—including silks from India and Chinese brocades, metallics and exotic cotton prints—animating their surfaces with meticulous hand quilting. Her works are included in important museum, corporate and private collections, including the American Craft Museum, U.S. Ambassadors' residences in Guatemala and Morocco, Lucent Technologies, Avaya Communications and Kaiser Permanente.

# ARTIST INFORMATION

## HOME ART OF ROSEBUD STUDIOS
Murals & Painted Finishes
Page 139

Home Art of Rosebud Studios specializes in paintings and mosaics that make a home unique. Wendy Grossman creates murals, faux treatments, folding screens, mosaic installations and furniture—sometimes combining mosaic treatments and hand painting. Her commissions include public and private clients. Using her love for research and her computer skills, Grossman is able to create unique and in-depth detail that can leave the viewer in awe. Grossman has more than 28 years of experience as a painter, mosaic artist and teacher. She has taught at the School of Visual Arts and the Pratt Institute—both in New York. Her work can be seen in nurseries, entranceways, waiting rooms, living rooms, kitchens, bathrooms and patios. Her prices begin at $1,500. The artist will gladly work on site.

## JUNO-SKY-STUDIO.COM
Mixed & Other Media
Pages 167, 169

Embracing a variety of materials and innovative techniques has enabled Juno Sky to create unique, mixed-media works of rich color, sensual surface and emotive content. Layering media such as handmade papers, acrylic, gold leaf and fabric gives the works a sense of opulence and an engaging presence. A study of many cultures and an "inherent pleasure in making things" reference all of her works. Collections: the Toledo Museum of Art; Mazza Museum of International Art; United States Customs House; Hyatt Regency Hotels; Thermos Corporation; Marathon Oil Company; SAS Institute; Honda Peace Collection; Long Term Credit of Japan. Available works and direct sales at www.JunoSkyStudio.com. Commissions welcome. Price range: $250-$15,000.

## SUE KEANE
Ceramic Tiles & Wall Reliefs
Page 154

Ceramic artist Sue Keane molds, bends and folds clay to form abstract wall or freestanding works. Each sensitive design is a one-of-a-kind creation. These clay pieces may also incorporate wood, metallic lusters, paint, glass and light to complete the artistic statement. The artist holds degrees from the Parsons School of Design, New York, NY, and from Otis College of Art and Design, Los Angeles, CA. Commissions are welcomed for private residences, corporate environments and public spaces. Slides of current works are available upon request. Exhibitions include: Raiford Gallery, Roswell, GA; Gallery Eight, La Jolla, CA; TAG-Artist Gallery, Santa Monica, CA; and Roche-Bobois, Los Angeles, CA. Recent projects include: A Community of Angels, public art project, Los Angeles, CA.

## MARCIA JESTAEDT
Ceramic Tiles & Wall Reliefs
Page 147

Marcia Jestaedt has been working with clay since 1970 and raku firing since 1972. Her work is characterized by rich, lustrous glazes and designs that are inspired by the Orient. This work consists mostly of hand-formed tiles, which are etched with geometric and floral images, then glazed in a painterly manner. Jestaedt is a graduate of the University of Maryland, where she majored in studio art and taught for a number of years. Her work has been exhibited in galleries and shows throughout the country, including the Smithsonian Institution. She has received numerous grants and awards and has been featured in *Handbuilt Ceramics* and *Surface Decoration*, both published by Lark Books, and in *Ceramics Monthly*. Her prices range from $1,250 to $3,600.

## KARL DEMPWOLF STUDIO/GALLERY
Paintings
Page 26

Karl Dempwolf's work has been influenced by several early California impressionists, including Wendt, Rose, Puthuff and Payne. Their art has had a profound effect on him and has given him the inspiration to pursue his craft. Dempwolf's goal is to make his paintings come alive—a process that takes time and patience and cannot be rushed. He begins all his paintings *en plein air* usually by creating a small sketch of an exhilarating landscape or coastal scene. He finishes his work by applying heavy impasto paint, which is an integral part of his artistic technique. His desire is not to copy a scene, as a photograph would, but to instill in the viewer a sense of the beauty of nature. If you have access to the Internet, you can watch him at work online at www.netmonet.com.

## CHRISTINE KEFER
Tapestry, Fiber & Paper
Page 196

Christine Kefer has been designing and weaving for 25 years and has worked with many traditional and non-traditional techniques. Her focus for most of the last 15 years has been commissioned tapestries and rugs. She enjoys research in historic textiles and graphic designs of the past century. Each work is created with the client's needs, location and architectural space in mind. Her framed wall pieces usually include layered fabric (which is hand-dyed or felted), as well as handwoven bands of silk and antique buttons and beads. Please contact studio for slides, pricing and additional information.

## JULIANN JONES
Paintings
Page 92

Juliann Jones' work has recognizable subjects, which she explores with great interest and intimacy. She likes to work with a wide variety of subjects. Though the themes of her pieces are important, the paint itself is more important in her work; the raw beauty of the paint and the spontaneity of the act of painting drives her through each new exploration. Currently she is working on dividing surfaces into many small paintings in order to explore a single theme many times within one piece. She paints in casein on canvas or wood. (Casein is a milk-based, environmentally friendly permanent paint.) She finds this medium intensely colorful; the translucency allows her to layer the paint to create interesting depth and unusual images. Jones works from her gallery in Livingston, Montana.

## KAUFMANN STUDIOS
Tapestry, Fiber & Paper
Page 188

Sarah Kaufmann's handwoven wall pieces combine a love of drawing and painting with a love of pattern. Hand-painted warps (the vertical threads) create a complex color composition. Lifting threads one at a time from left to right, bottom to top, she creates patterns that are textural, figurative and evocative of script, language, landscape and architecture. The final piece is endlessly fascinating, meditative, vibrant and luxurious. These pieces add elegance to any home, office or place of worship. Kaufmann's work has been collected by many private parties and universities. You can see her works at American Craft Council craft shows and top retail craft shows across the country. Publications include: *Surface Design Journal, Shuttle Spindle Dyepot*, and *Fiber Arts 6*, a Lark publication.

## KELLY FITZGERALD PHOTOGRAPHY
Photographs
Page 124

"I love traveling to different parts of the globe and documenting images from my photographic adventures." Kelly Fitzgerald captures the images, faces and landscapes of our ever-changing world. She has an excellent reputation for producing uniquely creative and quality images within the field of black-and-white photography. Fitzgerald has received top honors in the *Photographer's Forum* magazine and Canon Photography Contest Series and has been featured every year in the *Best of Photography Annual* since 1998. Her photographs have appeared in numerous exhibits in various art galleries around the world. This past year her work was exhibited alongside photographers Linda McCartney and Cecil Beaton. Fitzgerald makes her gelatin silver prints with only the finest museum-quality materials available.

222

# ARTIST INFORMATION

## BRIAN T. KERSHISNIK
Paintings
Pages 21, 61-63

In his paintings, Brian Kershisnik aspires to a certain disciplined relinquishing of control, a venture to tell the story that he wants to tell without denying the story that wishes to be told. The process is filled with negotiations and reconciliations between intention, necessity and accident. The result is a very personal body of work that often strikes chords in us, even those chords that the artist did not necessarily intend to sound. Kershisnik is not irreverent about his own exposure or ours, but in his quiet, beautiful and often humorous narrative paintings, he invites us to contemplate peculiar questions and peculiar beauty.

## KOTIKREATIONS
Mixed & Other Media
Page 178

In 1987 the Cleveland Institute of Art graduated one of its celebrated students, Cindi Kotik. She not only attended each year on full scholarship, but also completed a five-year program with honors in four years. Since then her work has been commissioned from Miami to Cleveland by private collectors. Current sculpture compositions utilize hand-brushed aluminum, cut and polished glass elements (which are often sandblasted for texture) and pure pigment dyeing. The result: three-dimensional layers of shape, color and texture that create a kaleidoscope of visual effects. Prices currently range from $2,800 to $12,400 for private commissioned pieces, as well as those displayed in both corporate and private galleries.

## MARLENE LENKER
Paintings
Pages 34, 234

Marlene Lenker is a mixed-media layerist and colorist, painting on canvas and paper in transparent and opaque layers. Her brushstrokes and marks are unique, intuitive expressions of energy and spirit. Her monotypes and collages are evocative abstract layers. Collections: American Airlines, Lever Bros., Arthur Young, PepsiCo, Kidder Peabody, Union Carbide, Pfizer, Warner-Lambert, Vista Hotels, Horcht, CIBA, Merrill Lynch, Hoffman-LaRoche. Publications: *Bridging Time and Space*, 1999; *Layering*, 1991; *Who's Who in America; Who's Who of American Artists; Who's Who of Women Artists; Who's Who of World Women*. Her work has been featured in previous GUILD sourcebooks and is available for sale on www.guild.com.

## HELEN KLEBESADEL
Paintings
Page 51

"My paintings are a tribute to the women in my family who presented their creative voices to the world through their needles and cloth." Helen Klebesadel's watercolor images are drawn from a combination of observed reality and imagination. Starting with complete pencil drawings, she uses multiple washes to achieve the rich colors and subtle renderings that give her works their realistic forms. The painted quilts presented in Klebesadel's series, *Everyday Use*, celebrate a traditional art form closely tied to the history of women. The paintings evoke the symbolic, historical and emotional meaning associated with quilts. They remind us of their makers' ability to combine creativity with care. Painting prices range from $4,000 to $15,000. Limited-edition giclee prints are available from $600 to $1,200.

## KOZAR FINE ART
Prints
Page 111

Steven Kozar passionately portrays the landscape with stunning craftsmanship and heartfelt vision. His paintings depict real places, primarily near his home in rural Wisconsin. His painting tools are not unusual: oil or watercolor applied with a paintbrush. Although his work is sometimes mistaken for photography, Kozar seeks to go beyond mere accuracy to reveal the sublime quality of the landscape. Painting full-time for over 15 years, Kozar has over 175 original paintings in various collections, including the McDonald's Corporation, Dean Foods, Zurich Kemper and Merrill Lynch. Original paintings can be difficult to obtain. Archival-quality giclee prints are available in small editions. Kozar is involved in every step of the printmaking process, including ownership of the digital printing equipment. Prints are signed, numbered and titled by the artist.

## LINDA LEVITON
Metal
Pages 156-157

Linda Leviton creates modular wall sculpture that evokes the color and texture of nature. Her designs can be hung to form one large piece or mounted as smaller separate units, creating ease and flexibility for large installations or changing interior spaces. Using etching, dyes, patinas and paint, Leviton can texture and color metal to form subtle or vibrantly colored designs. Her techniques come from many disciplines, including blacksmithing, sheet metal construction, welding, silversmithing and printmaking. Recent projects: Profiled on HGTV's "Modern Masters." Commissions: Northwest Airlines, Detroit, MI; Longmont Clinics, CO; WICHE Inc., Boulder, CO; State of Ohio, Columbus. Awards: Cheongju International Craft Biennale, Korea; Ohio State Fair Arts Council Award, 2001. Publications: *Color on Metal*, 2001; Niche magazine, Autumn 2001.

## NANCY SMITH KLOS
Tapestry, Fiber & Paper
Pages 148, 187

For Nancy Smith Klos, weaving is a spiritual meditation and a way of living. The trademark of her artistic work lies in the multiple fibers she chooses from hand-dyed and spun materials, which are mixed with commercial yarns. Nancy Smith Klos earned her B.A. in fine art, art history and french from Connecticut College in 1981. She studied Fiber Arts for five years at the Oregon College of Art and Craft in Portland. Klos began weaving tapestries in 1990 and has been commissioned to weave for residential, corporate and liturgical settings for over 12 years. Klos' work has been published in *Fiberarts* magazine, January 1997, as well as *Handwoven, Surface Design Journal* and *Ornament*. In 2000 Klos Studios was featured on HGTV's "Modern Masters" and Oregon Public Broadcasting's "Oregon Art Beat" in the premier season.

## KERRI LAWNSBY
Paintings
Page 84

Working in soft pastels on paper and oil on canvas, Kerri Lawnsby reveals the inner luminosity of the natural world. Compositions of flowers and trees convey the essence of the subject, whether the glorious shimmering light from a gingko tree in autumn or the tender blossoms from a hydrangea. Lawnsby also paints landscapes on location to portray the magic of places such as Yosemite, Hawaii or Banff, Canada. Please visit the artist's website for a comprehensive view of her work. Lawnsby enjoys sharing her love of the natural world through art and has connected with art lovers at art shows in northern California. The artist welcomes commissions and the opportunity to help people heighten the ambiance of their homes through fine art.

## LINDA FILBY-FISHER, QUILT ARTIST
Art Quilts
Page 211

Linda Filby-Fisher's art quilts, composed of international fabrics, text, mixed media and embellishments, are created using traditional and unique processes. The results are works of detailed design, visual impact and distinct meaning. Each piece, which is often double sided, includes an embroidered legend, thereby grounding the quilt in history and meaning. The artist's work can be found nationally, and commissions are welcome. Slides and resumé are available upon request.

## MICHELLE LINDBLOM
Paintings
Page 69

Michelle Lindblom's work is a challenging and psychological examination of her internal conflicts, thoughts and perceptions. These internal dialogues have their basis in the spontaneous reactions and personal relationships she experiences daily. This is where her most passionate and mystifying dialogues exist. Her work has become the visually tangible result of these examinations and ultimate revelations. Michelle received her undergraduate degree from the University of New Orleans and her M.F.A. from the University of North Dakota. Besides working as a professional artist, she teaches full-time at Bismarck State College in the Visual Arts department and directs the campus galleries. Her work has been exhibited in the U.S., England and Norway and has received numerous awards. Prices range from $650-$2,500.

## THOMAS MANN
Metal
Pages 164-165

Thomas Mann, known for assemblage techniques and the use of found objects and alternative materials, has now invented the "tech-tile" system. Surface patterns and thematic designs are applied to aluminum, brass and steel tiles employing sandblasting, painting, drawing, incising and grinding techniques. The system is mounted on plywood panels per design specs for lobbies, kitchens, etc. Available in standard or custom forms. Interior use only. Price range: $1,400 and up. Collections include: Renwick Museum, Washington DC; Wustum Museum, Racine, WI; AT&T Corporate Headquarters, Dallas, TX; American Craft Museum, New York, NY; City of New Orleans, LA, Berman Park Public Art Sculpture; MTV's "The Real World," New Orleans, LA. Publications include: *Hand and Home*, 1994; *One of a Kind: Contemporary American Craft Art*; and *Thomas Mann: Metal Artist*, 2001.

## GLORIA MATUSZEWSKI
Paintings
Page 91

Gloria Matuszewski paints the isolated rose or chair or person. From many layers of texture, we are invited to behold the depth and majesty of the singular object as a unique, wondrous metaphor for the self. Matuszewski has exhibited throughout the country and has won awards in many competitions, including the Award of Excellence at the California State Fair and the Tempe Public Library Competition Purchase Award, AZ. Her work is included in many corporate and private collections, including the Kaiser Hospital collection, the David and Lucille Packard Foundation, the Ebert Holding Company, the Janet Trefethan collection, the Jessie and Laurent Boucher collection and the Art in Embassies program. Commissions are welcomed; giclee prints are readily available.

## ELIZABETH MacDONALD
Ceramic Tiles & Wall Reliefs
Pages 145, 152-153

Elizabeth MacDonald produces tile paintings by layering ceramic powders on thin pieces of textured clay that have been torn into squares. The resulting surfaces suggest the patinas of age. The compositions are suitable for either in- or out-of-doors, and they take the form of freestanding columns, wall panels or architectural installations. Commissions include: Conrad International Hotel, Hong Kong; St. Luke's Hospital, Denver, CO; ITT Hartford, for the City of Hartford, CT; Department of Environmental Protection, Hartford, CT (Percent for Art); Milliken, Spartanburg, SC; University of Maryland Medical Center; U.S. Trust, Stamford, CT; Chubb and Sons; Pitney Bowes; Aetna Life Insurance Company; Miles Pharmaceutical; IBM; and the Mayo Clinic, Phoenix, AZ. Her work has been featured in previous GUILD sourcebooks.

## DAVID J. MARKS
Metal
Page 166

David Marks' work expresses a sense of time and mystery. The patina finish that is a trademark of his work is a hybrid he has developed since the late 1980s. It combines painting, gilding (metal leafing), chemical patinas and lacquering techniques. The complex layers result in a quality that gives the appearance of a faux petrified stone. He uses the lathe, in combination with his fully equipped woodworking studio, to create his sculptures. His inspiration is derived from a fusion of styles, including ancient Egyptian, African, Art Nouveau, Art Deco and Asian. Common to all of his designs, however, is the attention he pays to fine detail.

## PAVLOS MAYAKIS
Tapestry, Fiber & Paper
Page 189

Weaver and textile artist Pavlos Mayakis constructs one-of-a-kind, handwoven, multi-functional art pieces. They are beautiful for wall art or impressive as eye-catching throws or blankets. Producing rich colors and "striking that important balance between elements" in a controlled, yet somewhat spontaneous manner, comes naturally to him. His work appears in galleries, schools and private collections throughout the United States. Mayakis welcomes collaborations with architects and interior designers. He has been featured in the 2002-2003 edition of *New Art International*. Awards include a Mendocino College full-time faculty scholarship and the 2001 Mendocino College Foundation Scholarship of Promise.

## GREGORI MAIOFIS
Paintings
Page 43

Gregori Maiofis was born in St. Petersburg, Russia, in 1970. His artistic legacy is traced to his grandfather, a highly regarded Soviet architect, and his father, a well-known Russian book illustrator. From 1987-1990, Maiofis studied at the Repin Fine Arts Academy in St. Petersburg, and in 1991 he moved with his family to the U.S. Over the last few years, Maiofis has been living in Los Angeles, California and in St. Petersburg, Russia. In his work, Maiofis utilizes historical forms, materials, techniques and references and arranges these elements uniquely to create his own combinations. Twelve Russian museums and state galleries have Maiofis' work in their collections. His book, *Archeology*, is also available for purchase.

## THOMAS MASARYK
Murals & Painted Finishes
Pages 18, 138

Thomas Masaryk is uniquely gifted in his ability to combine his natural passion for painting and loving approach to the creative process with his meticulous style and technical knowledge. An experienced painter of illusion, he brings his artistry and master craftsmanship to the home and commercial field. The artist's work has been featured in individual and group exhibitions, as well as numerous publications in the United States and overseas. He has been a special guest on "Live in Style," WVIP Broadcasting Corporation, and has given professional seminars and demonstrations in the Connecticut, New York, Boston and Philadelphia areas.

## NATHAN McCREERY
Photographs
Page 120

Nathan McCreery began his photography career while in art school. "My major was commercial art with an emphasis in graphic design. As part of my course of study, I was required to take a course in photography. When that first image appeared, as if by magic, I was hooked. From that moment on, I knew my destiny was set. I would make photographs . . . ." Nathan currently owns and operates a photographic studio in Clovis, New Mexico. He is a guest lecturer in art at Eastern New Mexico University in Portales, New Mexico. He lives with his wife, Virginia, and one dog, a Border collie named T-Max. His photographic work is found in many collections, both corporate and personal.

224

# ARTIST INFORMATION

## CALLAHAN McDONOUGH
Paintings
Pages 76-77

An Atlanta artist of 28 years, Callahan McDonough combines symbolic aspects of myth and spirituality with personal narrative. Her artwork has been exhibited in galleries nationally and featured in numerous publications. "The departure point for my work comes from myself, my relationships and my surroundings, but the layers of meaning that surface are always a bit of a surprise to me. I fantasize about a time when the artist and community were connected, a time when all that we celebrated and mourned was expressed in the arts." McDonough's art is inspired by collaboration with her clients—the vision they have for their lives and their environment.

## AMOS MILLER
Paintings
Page 65

Amos Miller's work exhibits brash spontaneity and verve; its sweeping linear brushstrokes and vivid color are indicative of Neo-Fauvism. His compositions of striving figures occupy stark environments with explosive tension, challenging and confronting while eliciting empathy. Commissions are welcome. Recent commissions include private collectors in Miami, FL, 2000; Atlanta, GA, 2000; Cleveland, OH, 1994; and Ashville, NC, 1990. His work can be found in the collections of the Constitutional Court of South Africa, Johannesburg; The Masur Museum of Art, Monroe, LA; Progressive Corporation, Cleveland, OH; and private collections throughout the United States. Miller was awarded Best of Show in 2001 at the 28th Annual Juried Competition of the Masur Museum of Art in Monroe, Louisiana.

## DANA MONTLACK
Photographs
Page 133

Dana Montlack holds a B.F.A. in sculpture from the University of California at Santa Cruz and an M.F.A. in mixed media from the Otis College of Art and Design in Los Angeles. Her work has been exhibited in galleries and museums nationwide, including the Museum of Art, Downtown Los Angeles Conceptual Evolution, Alexandria Museum of Art, LA; Albright-Knox Art Museum and CEPA Gallery, Buffalo, NY; the California Center for the Arts, Escondido, CA; Monique Goldstrom Gallery, New York, NY; Sylvia White Gallery, Los Angeles, CA; and Flux Gallery, San Diego, CA. Additionally, her work is featured in such private collections as Nokia, San Diego, CA; City National Bank, Manhattan Beach, CA; Scripps Memorial Hospital, San Diego, CA; National University, La Jolla, CA and Crown Plaza Hotel, Atlanta, GA.

## SUSAN McGEHEE
Metal
Page 160

Susan McGehee produces two bodies of work: woven metal weavings and sculptural wire kimonos. Applying traditional textile techniques, she weaves wires and metals into striking forms that seem to float on the wall. The kimonos are created from bronze or stainless steel screening, then embellished with scraps of wire from the weavings and recycled electronic remnants. Even though the pieces use late twentieth-century recycled materials, they have a look and feel of previous centuries. These lightweight, easily installed and maintained pieces complement both residential and commercial settings. McGehee's work has been featured in previous GUILD sourcebooks.

## DAVID MILTON
Paintings
Page 72

David Milton's abstract expressions resonate with the vibrant colors and rhythms of his native South Africa. His art is about capturing the essence of the emotional elements of life, increasing our knowledge of their strengths and meanings. An intuitive use of color gives visual expression to emotion. The use of line creates movement and depth, propelling perception beyond the two-dimensional canvas. Blending, layering and texturing create a multi-dimensionality. David Milton's varied styles, along with his collaborative experience, facilitate working with individuals on customized projects. His paintings are in private collections from California to the Caribbean. He accepts commissions in a broad range of sizes. A portfolio of paintings and sculpture is available upon request. Current paintings range from 14" x 16" to 67" x 102".

## LEN MORRIS
Photographs
Page 136

Len Morris invites you to celebrate the hidden beauty of those objects that are a part of our everyday lives but are often regarded as utilitarian or insignificant. These objects—whether a discarded piece of paper, a dried flower or leaf—are markers of our experiences and are often tossed aside after our conditioned perception of their value has been realized. Morris' photographs of these everyday objects reveal an extraordinary beauty in what may have been considered the ordinary. Corporate and private collectors around the world, including the Boca Raton Museum; the Miyako Osaka Hotel, Japan; and WNYC Radio, New York, NY, have enthusiastically embraced his work. Please visit www.lenmorris.net.

## GEORGE THOMAS MENDEL
Photographs
Page 122

George Thomas Mendel, a location/freelance and fine art photographer, has been working with the medium for more than 20 years. In this time, he has produced a variety of portfolios, which include architecture, waterscapes and humanitarian projects. Primarily working in black-and-white photography as an art form, limited-edition prints are produced by way of traditional fiber-based gelatin silver (cold or warm tone per request). His creative use of light and composition is matched by his master craftsmanship in the darkroom, where he produces the highest level of quality and archival stability. You may view project portfolios on his website gallery, and commissioned project and documentation services are available by request. Publications: *Beautiful Things*, 2000. Mendel's work has also been featured in previous GUILD sourcebooks.

## JULIA MITCHELL
Tapestry, Fiber & Paper
Page 185

For 25 years Julia Mitchell has designed and woven site-specific tapestries for residential and corporate spaces in the United States and abroad. She works in close collaboration with her clients to produce arresting natural images, which are said to reveal the mystery and spirit of her subjects and draw the viewer into a quieter place. The tapestries are meticulously woven of wool, silk and linen, employing traditional and innovative techniques. Following the great tradition of Medieval and Renaissance tapestry, her work conveys an illusion of movement, delicacy, light and shadow within a highly durable and long-lasting construction. Résumé available upon request.

## MIRANDA MOSS
Paintings
Page 54

"In life, a lot of things go on under the surface, worlds of things are hidden . . . until you have the insight to see them. These hidden dimensions fascinate me, and I like to paint around this theme." Large, bold and expressionistic, Miranda Moss' canvases are richly layered with suggestions of animals, personal and cultural icons, landscapes and figures. Some images are overt and some are hidden through positive-negative juxtapositions. The longer you look, the more you see. Moss received a B.F.A. from the Maryland Institute of Art and has taught at the Minneapolis College of Art and Design. Her work can be seen in her studio/gallery, and prices range from $600 for prints to $15,000 for original paintings. She also accepts commissioned work.

# ARTIST INFORMATION

## LORETTA MOSSMAN
Prints
Page 98

Loretta Mossman has expanded her artistic vocabulary by exploring new materials and processes, to which she brings her own personal content. Inherent elements in the media allow her a range of expression. Subtleties and ambiguities within her images become apparent and articulate her reality. "I use symbols to access what lies within me," she says. "I express my views through metaphor, visual suggestions, textures and tonal sensuality." Recent work includes lithographs, etchings, woodcuts, multi-media paintings and drawings. Mossman continues to design and produce unique wool rugs and tapestries with the weavers of Teotitlan del Valle, Mexico. These works vary in pricing according to complexity and color. Mossman's work is displayed in public, corporate and private collections.

## DEBRA NICHOLAS
Paintings
Pages 16-17, 57

Debra Nicholas creates large-scale portraits of families in their everyday surroundings. With a jewel-like brightness and superbly detailed depictions, her paintings present a heightened and magical reality. Nicholas' ability to meld competing patterns into visually unified settings springs from her earlier career designing fabrics for Dior, Lagerfeld, Knoll, Macy's, Marimekko and Saks Fifth Avenue, among others. Nicholas has lectured and taught at the Smithsonian Institution, the Baltimore Museum of Art and American University. She has been a Yaddo Fellow, was awarded the Norman Robbins Traveling Fellowship for Museum Study and designed the modern textile and jewellery collections at the Museum of Ancient Greek and Cycladic Art in Athens.

## EDY PICKENS
Paintings
Page 36

Edy Pickens received a B.A. in studio art from Hollins University and an M.F.A. in painting from Indiana University. Her work has been exhibited in numerous national and international juried competitions. Her paintings have been featured in film and television productions, including "Judging Amy" on CBS. Awards include the Francis Neiderer Scholarship from Hollins University and a fellowship to study in Florence, Italy, from Indiana University. Pickens has been commissioned for projects in private residences and public spaces. Currently, she teaches art at the Brentwood School and the Brentwood Art Center in Los Angeles, CA. Pickens finds inspiration in settings that feature intense color or a profound sensation of drama. Her work ranges in price from $250 to $3,000.

## CHARLES MUNCH
Paintings
Pages 44-45, 88

In the rugged hill country of southwestern Wisconsin, Charles Munch sketches boldly simplified landscapes populated with animals and people. He floods these large drawings with rich, luminous color, bringing the images to life. The finished paintings are like dreams that linger, inspiring endless contemplation. Munch's semi-abstract forms harmonize with most architectural styles. His largest paintings have the character of murals and may be installed as such. Prices range from $1,000 (16" x 20") to $10,000 (48" x 72") and up. His work is found in private, corporate and museum collections. He has exhibited from Seattle to New York and is represented by the Tory Folliard Gallery, Milwaukee, WI; the Grace Chosy Gallery, Madison, WI; and the Perimeter Gallery, Chicago, IL.

## MODESTO PADILLA
Prints
Page 100

"I follow my passion for art and travel and portray Europe's architecture through pen and inks," says Modesto Padilla. An architect for more than 20 years, Padilla's artwork focuses primarily on architectural subjects. He works in pen and inks, primarily in black and white, though sometimes he uses liquid acrylic to create beautiful works in color. Padilla feels that pen and ink is a dying art form and wishes to continue this age-old craft using his training and Rapidograph pens. He loves to present realistic detail in his drawings. Modesto credits his wife and creative partner, Donna Corless, for her photographs, from which his drawings are produced.

## DOUGLAS W. RANDALL
Prints
Page 99

Douglas W. Randall graduated from the Pennsylvania Academy of the Fine Arts with a degree in sculpture. His sculpture has been widely shown and acclaimed. He is now releasing his works on paper. Randall carefully crafts prints with consideration for every square millimeter. Each image is printed on heavy-weight matte archival paper with archival pigments. His newest series, *Images from the Body*, is as stunning as his sculpture. Prices reflect a new series offering, limited to 40 signed and numbered prints. At this time, they sell unmounted for $300. Size can sometimes be changed to fit your needs. More examples of Randall's work can be seen on his website at: www.dwr2.com.

## MARY BATES NEUBAUER
Prints
Page 107

"I am enchanted by the natural world. I create luminous surfaces, which lend qualities of inner life and animation to my artwork, revealing its natural spirituality and tactile beauty. My most recent images resemble mysterious, flower-like creatures, sensitive and colorful." Mary Bates Neubauer has shown her digital prints and cast metal sculptures nationally and internationally. Her work is in a number of public and private collections. Recent exhibitions and awards: Bentley Gallery, Scottsdale, AZ; Tucson Museum of Art; Graphic Art Biennial, Gyor, Hungary; Grounds for Sculpture, Mercerville, NJ; Chuck Levitan Gallery, New York, NY; California Center for the Arts, Valencia; Ford Fellowship; Fulbright Fellowship. Selected commissions: Tucson Pima Arts Council; Ora Valley, AZ, Arts Council; Loveland, CO, Arts Council.

## LESTER C. PANCOAST
Paintings
Page 94

Lester Pancoast's watercolors are inspired by his tropical surroundings and by his subjects, which include palms, water reflections and plant forms. His paintings range from highly detailed, botanical studies to the almost abstract. His images are strong; the work is usually full of light and transparent color. Pancoast has won Best in Show and all other award levels from the Miami Watercolor Society. He shows annually at the Kampong in Coconut Grove, Florida, and is represented in collections on both coasts of the U.S., as well as Japan, Canada, France and Mexico. In addition to the originals, Pancoast's work is also available in digital projections on paper, up to 1.25 original size or on canvas with a minimum short dimension of 48".

## PHYLISS RAY
Paintings
Page 46

Phyllis Ray's artmaking process is greatly intuitive. Using the medium of oilstick, she creates layer after layer of paint, then scrapes down again and again to reveal the underpainted colors and ghost forms. The process is one of building up and scraping down and is guided by a search for the right feeling. Recurring subjects include empty interior spaces and chairs, which often appear empty, but are occupied by unseen people. The chair form offers volume, as well as an emotional vehicle. Her paintings range in price from $450 to $2,500. She has participated in numerous group shows and four individual shows. Her work is represented by the Seattle Art Museum Rental/Sales Gallery, WA; RiverSea Gallery, Astoria, OR; Campiche Gallery, Long Beach, WA; and Corporate Arts West, Bellevue, WA.

# ARTIST INFORMATION

## ROY RITOLA
Photographs
Page 132

Roy Ritola is a professional graphic designer. He creates his artwork through the lens of a camera using both traditional and digital techniques. Often mistaken for paintings, his images are usually quite graphic, if not abstract, in style. Reproductions are created digitally as either Indigo prints in open editions or as a giclee on quality watercolor papers in limited editions. All prints utilize the latest technology, the finest papers and archival pigment-based inks. Ritola's limited-edition prints have been collected by numerous corporate organizations as well as private collectors. His work appears in the following publications: *Graphis Photo Annual,* 1991; and *Leica Magazine.*

## KIM RITTER
Art Quilts
Pages 206, 234

Kim Ritter's newest body of work features wild horses and wild women. *Spirit Horses,* a series of silk-screened quilts, explores her lifelong love of horses. Her interest in the horse is influenced by her childhood in Oklahoma and an inspiring trip to the Uffington White Horse, a thousand-year-old abstract chalk carving of a horse in rural England. Ritter's horses are imaginary spirits of strength and freedom. The women in her quilt series, *Attitudes,* share these same spirited qualities.

## CHRISTINA ROE
Tapestry, Fiber & Paper
Page 197

Christina Roe combines traditional and abstract decorative motifs with original surface finishes and textures in papier-mâché and hand-cast wall sculptures. The paper castings usually begin with a clay original, from which a mold is made and then cast using a paper pulp, which she recycles herself. Using cut fragments of these casts, she assembles designs for her wall reliefs like a mosaic, gluing them to a backing to create a unified appearance. The final piece is then painted with many layers of color and may be cast again. Richly colored and textured, her multilayered relief surfaces are both durable and lightweight. Wires attached to the back enable them to be hung unframed. Prices range from $500-$5,000.

## ANTHONY ROSS
Paintings
Page 47

Anthony Ross's *Road/Signs* series uses acrylic on canvas to capture images from America's roads, the asphalt arteries that flow through our lives. This series comes from the artist's many road trips across America and is part of his desire to capture the beautiful images that are often ignored in our hurry to "get there." Many of the images are in danger of being lost to history or are neglected as a product of a bygone era. Prices range from $95-$15,000. Galleries: Art Encounter, Las Vegas, NV; Legacy Arts, Santa Ana, CA; Gallery of Art, Antiquities and Sculpture, Las Vegas, NV; Tangram Gallery, Newport Beach, CA; F.Y.B. Gallery, Long Beach, CA. Collections: Global Icons, Hollywood, CA; Newport Generations, Newport Beach, CA; Paul, Hastings, Janofsky and Walker, Newport Beach, CA; and various private collections.

## BEATRICIA SAGAR
Paintings
Page 70

In 1998 Sagar started working on paintings influenced by totems and scrolls, which are vertical in form. Image builds upon image, color and texture build up and are sometimes taken away as they engage the eye in a journey reflecting time, breath and abstract connections. She focuses intensely on each painting while working on it, but has come to realize that a new and engaging dynamic, similar to a filmstrip, is created by viewing them as a group of two, three or more. An unplanned tempo or beat is established; the chaos of the multiple image forms a flowing unity, a rhythm of its own. The mystical nature informs the original order with new and surprising results. Her work is created in mixed media.

## PAGE SAMIS-HILL
Paintings
Page 93

Page Samis-Hill is a signature artist with the Pastel Society of Canada. She is proud to represent her country in many exhibits in the United States. Samis-Hill paints the beauty of fruits and flowers using pastels on a sanded surface. Her paintings are reproduced as giclee prints in assorted sizes. Awards: Signature member of the Pastel Society of Canada, Ottawa, 2000; member of the Pastel Society of America, New York, 2001; member of Degas Pastel Society, Louisiana, 2002. Exhibitions: Accepted into the Pastel Society of North Florida Seventh Biennial National Exhibition, *All Pastel,* in Fort Walton Beach, Florida; winner of American Artist magazine award, 2002.

## JOAN SKOGSBERG SANDERS
Paintings
Page 60

Joan Skogsberg Sanders' art is transcultural and universal. In her series, *Moroccoscape,* she melds the exotic with the familiar into dreamlike images in her own distinctive style. She received her formal training at California State University-Long Beach, the Art Center College of Design in Pasadena and the University of Oregon. Recently interviewed on international television, Sanders has received numerous awards for her art and has exhibited widely in the United States and abroad. Her media includes acrylic, ink, glazes, crayons, pencil and photomontage. Her preferred surface is high-quality glossy printers' proof sheets. Originals are available, as well as giclee prints. Each giclee is signed and has a certificate of authenticity. Giclees allow for custom sizes and can be printed on heavy watercolor paper or canvas.

## KAREN SCHARER
Paintings
Page 71

Karen Scharer's expressive contemporary paintings combine bold color and strong design to convey moods ranging from dramatic to contemplative. Working primarily in acrylic, she uses layering techniques to produce pieces that radiate light, often creating the impression of stained glass. Whether examined closely or enjoyed from across the room, her work draws the viewer in with rich texture and use of line and movement, enlivening the imagination and inviting the viewer to become part of the creative process. Since 1987 Scharer has produced works on paper, board and canvas, ranging in size from miniature to 3' x 7'. Selected images are available as limited-edition giclee reproductions. Scharer's work is currently held in hundreds of private and corporate collections. Commissions are welcome.

## BARBARA J. SCHNEIDER
Art Quilts
Page 203

Barbara Schneider creates art quilts and art cloth hangings with rich, complex surfaces. The painted, dyed and embellished pieces are characterized by their visual impact from a distance and their tactile quality at close range. Her recent series include: *Reflections:* art quilts interpreting reflection and shadow imagery; *After Images:* whole cloth art quilts dye cast from vintage pressed tin; and *After Effects:* art cloth created from tin and other surface design techniques. Exhibitions and awards: International Quilt Festival, 2002; Quilt National, 2001; Art Quilts at the Sedgwick, 2002; American Quilt Society, 2001; Museum of American Quilter's Society: *New Quilts from an Old Favorite,* 2002; World Quilt and Textile Exhibit, 2002. Publications: *Quilt National,* 2001; *Tumbling Blocks: New Quilts from Old Favorites,* 2002; *Color Play,* 2000.

# ARTIST INFORMATION

## RHONA L.K. SCHONWALD
Paintings
Page 83

Life's milestones, miracles, adventures and triumphs are reflected in the award-winning creations of Rhona Schonwald. Relationships among color in her paintings and forms in her sculpture evoke thought, sensuality and joy. Her paintings celebrate the interaction of color with drama and delicacy. Sculptures flow and undulate, illuminating nature's rocks, root systems and shriveled leaves. Rhona Schonwald's art unleashes emotion. Whether viewing her sculptures or paintings, patrons experience exhilaration, inspiration and a sense of peacefulness. Schonwald paints and sculpts because she loves the process, an adventure of the mind expressed through material. When this adventure comes to an end for the artist, another one begins for the viewer.

## SUSAN SCULLEY
Paintings
Pages 37, 236

Susan Sculley creates paintings that have the appearance of landscapes suffused with light. Stunning in both contemporary and traditional settings, her compositions of color and elusive form capture the essence of the peace and beauty one experiences when communing with nature. Creating paintings that engage a particular environment is what she finds most rewarding. Clients will often choose to design their space using her paintings as a focal point. Sculley's work is shown in galleries and through art consultants; she has pieces in numerous corporate and private collections. A partial list of corporate collectors includes: Commonwealth Edison Corporate Headquarters, Chicago, IL; Amoco Corporation, Chicago, IL; Hartford Insurance Company, Chicago, IL and the Apostolic Church, Chicago, IL.

## SHELBY GLASS STUDIO
Ceramic Tiles & Wall Reliefs
Page 149

California artist Nancy Shelby brings nearly 30 years of glass experience to her mosaic studio. Winner of the Corning Museum's New Glass Review for her mosaic work, she continues to delight her clients with remarkable glass mosaics that excite, stimulate and satisfy the imagination. She presents a wonderful variety of whimsical, representational and abstract designs using many different types of glass tesserae. From small mirrors to large wall pieces, her work can be found in many private collections and galleries. Commissions are welcomed. Please contact Shelby for more information.

## MADELAINE SHELLABY
Prints
Page 112

Madelaine Shellaby extends the tradition of botanical prints and still lifes through digital means. She frequently invents plants by combining disparate materials. Her still life work includes a mix of scanned natural materials, symbolic objects and photographic images. Her archival ink jet prints are produced in limited editions of ten. Shellaby has received artist fellowships from the New Jersey State Council on the Arts and has been a fellow at the Virginia Center for the Creative Arts. She has exhibited in museums and galleries in California, Louisiana, New Jersey, New York and Pennsylvania, and her work is found in public and private collections in the U.S. and abroad. Shellaby received B.A. and M.A. degrees in humanities and painting from Scripps College and the University of California-Berkeley.

## KATHARINA SHORT
Paintings
Page 56

Katharina Short lives and works in Santa Cruz, California. She is self-taught and considers nature, both human and physical, her primary inspiration. Her love of gardening has given her paintings an obvious color infusion; often the whimsical characters in her paintings wear the bright tones of flowers. Short is an award-winning artist who has been featured on "Detours," a short documentary about Santa Cruz artists. Her awards include Best Visual Artist, 2001, Santa Cruz County, CA; Best of Show, 2000, Carmel Art and Garden Show, CA; Best of Show, 2000, Bargetto Art and Wine Festival, Soquel, CA. She has sold over 300 original paintings and works regularly on a commission basis with clients.

## MARTHA SIELMAN
Art Quilts
Page 202

Martha Sielman really enjoys the commission process. She is exhilarated by the challenge of creating an art quilt that both she and the client love. When making art quilts on commission for individuals and business clients, Sielman first listens carefully to a client's story. The story may be of the sea, or of a daydream or of jazz drumming, but it is personal and unique to each art quilt's owner. Sielman's palette includes her own hand-dyed and hand-painted fabrics. Her quilts are pieced, appliquéd and quilted on the sewing machine, with some details added by hand. She gives each quilt a fascinating dimensional quality through the use of free machine quilting and embellishments of beads, lace and found objects.

## BJORN SJOGREN
Prints
Page 109

"The power of simplicity"—a comment made by a viewer of Bjorn Sjogren's art at an exhibition in New York—is maybe the best way to describe the way he works. The titles of Sjogren's pieces create a sense of identity for his work and may be determined months after the artwork has been created. He works in gouache, tempera and with photo and computer graphics. You will find his work in Scandinavia, Germany, Russia and the United States. Bjorn Sjogren used the pseudonym "B. Padrick" early in his career, from 1987-1990. He moved from Sweden to Wisconsin in the fall of 2001.

## AMANDA SMITH
Photographs
Page 125

Amanda Smith has developed a beautiful portfolio depicting country and western lifestyles, from the windmills of yesterday to the cowboy way of life, which still exists today. She captures each photograph with emotion and creativity and with an intensity that is unique and fresh. Smith captures her subjects with the kind of emotion that makes you feel as if you were there. She began covering professional rodeo in 1995. Her rodeo photographs are exhibited in several southern California restaurants and bars. Smith's photographs are appreciated in corporate and residential settings and have become increasingly popular with private and corporate collectors including: the American Heart Association Annual Silent Auction, 2002; and the International Photography Exhibition, 2001.

## COLETTE ODYA SMITH
Paintings
Page 89

Colette Odya Smith creates intimate landscapes, full of mystery and delight, rich in subtle colors and textures. Her work is aesthetically sound, as well as strong in thoughtful content and associative power. It provides a beautiful source for sustained reflection that wears well over time. Soft pastels are thickly layered over watercolors in a working process she describes as meditative. "It is like falling in love, when I attempt to discover all I can about the beloved." Exhibitions and awards: Purchase Award, 2002, Wichita Center for the Arts, KS; Charles Allis Art Museum, 2002, 2001 and 1998, Milwaukee, WI; Anderson Art Center, 1996-2001, Kenosha, WI; and the Purchase Award, 2000, Pastel Society of America, New York. Publications: *Pastel Artist International* cover, 2002, and *The Pastel Journal*, 2000-2002.

# ARTIST INFORMATION

## MICHAEL A. SMITH
Photographs
Page 129

For over 35 years, Michael A. Smith's distinctive vision has resulted in international recognition, including: three books, one of which was awarded the prestigious *Le Grand Prix du Livre* at the International Festival of Photography in Arles, France; over 100 museum collections in the United States, Europe and Asia, including MOMA and the Metropolitan Museum of Art in New York, NY; the Art Institute of Chicago, IL; Bibliothèque Nationale, Paris, France; Stedelijk Museum, Amsterdam, the Netherlands; Victoria and Albert Museum, London, England; and the National Museum of Modern Art, Kyoto, Japan. Smith works with large view cameras: 8"x10", 8"x 20" and 18"x 22". Thousands of exquisite black and white prints are available as contact prints and some as giant enlargements up to 6' long. Selected commissions accepted.

## ALLAN STEPHENSON
Paintings
Page 32

Allan Stephenson is originally from England; and his native country has influenced his ideas on painting. He is a traditionalist, applying himself to the craft of perfecting techniques established by past masters. The landscape is also a traditional subject matter, and Stephenson approaches it as a journal of the places he has traveled. He believes there is a language in the natural world, and he is always looking for that certain combination of elements that speak to him. In looking for poetry in the forms of nature, he hopes he can remind the viewer of the beauty and meaning that surrounds us. His work is found in many corporate and private collections and is represented by several galleries nationwide.

## JUDITH VANACORE
Paintings
Page 95

With vivid color and a direct approach, Judith Vanacore primarily paints street-scene landscapes, using simplified forms and bold coloration with directional strokes to create a sense of energy. Working entirely in soft pastel on sanded paper, Vanacore tries to capture the beauty of the locale by creating brilliantly colored, light-filled impressions. She is a member of the Pastel Society of America, the American Artist Professional League and the Catherine Lorillard Wolfe Art Club. Exhibitions and awards include: Brevard Museum of Art and Science, Hilton Head Art League, Vero Beach Museum of Art, Salmagundi Club, Atlantic Center for the Arts, Pastel Society of America, American Artist Professional League and the Catherine Lorillard Wolfe Art Club. Publications include *The Best of Pastel 2*, 1999, Rockport Publications and *Pastel Artist International* magazine.

## ARDITH STAROSTKA
Paintings
Pages 17, 59

Ardith Starostka has been noted as "... a rising star in the firmament of American Portraiture." (*Artist's Magazine*, April 2001). She is a fine artist who specializes in realistically rendered portraiture and figurative paintings in oils, pastels and graphite. Starostka accepts commissions and will travel to accommodate her clients. Her formal training has included the study of all aspects of art, thus she is able to combine animals, objects and landscapes into her work. National and international awards include: Best Portfolio & Certificate of Merit Award, 2002, Portrait Society of America (PSA); Best Portfolio, 2001, PSA; Top 10 Honor Award, 2000, PSA; and numerous others. Commissions: the White House, the Blair House, Wright Brothers Museum, Cessna Aircraft, Inc., Creighton University and several private commissions.

## NAOMI TAGINI
Mixed and Other Media
Page 177

Naomi Tagini creates moveable blocks of color appropriate for positioning practically anywhere in an environment—down a hallway, up a staircase or around a corner. She creates her graphic art for the wall using several coats of paint that are brushed, rolled or sprayed on; she frequently applies a crackle finish at the end of her design process. Each completed piece proves that color, texture, clean lines and asymmetry can all be achieved through the versatility of wood. Tagini's work is created in pieces that are meant to be interchangeable. She wants the owner to have fun with the work—rearrange it on a whim and participate with it. Larger format work and custom colors available.

## SHERYL VANDERPOL
Murals & Painted Finishes
Pages 11, 144

Sheryl VanderPol is your "Untapped Resource" for custom artwork. Working in your choice of commercial ceramic or porcelain, inspiration and collaboration between the client and studio results in custom hand-painted masterpieces on tiles and porcelain sinks, fired to a beautiful permanency. Untapped Resource's skills expand beyond ceramic and porcelain, with projects including wall murals and trompe l'oeil. VanderPol's work is promoted in over 25 showrooms throughout the nation, has been included in countless award-winning commissioned works in homes and commercial properties and is shown in many top publications.

## PAM STEELE
Mixed & Other Media
Page 168

Pam Steele is internationally known for her large-scale metal and enameled glass wall pieces, which have been commissioned for numerous private and public collections. Her experimental techniques in enameling, combined with unique metal patinas, make her pieces both painterly and sculptural. Her pieces allude to landscape imagery, but emit a technological and architectural presence. The circles and triangles she creates have an elegant, spiritual quality. Education: M.F.A., Cranbrook Academy of Art; B.F.A., Syracuse University. Collections: IBM Corporation, Hyatt Hotels, Lucent Technologies, Kaiser Health Foundation, Wang Corporation, Steelcase, Inc., Aetna Insurance, Northwestern Bank, St. Peters Church. Publications: *Enamels, Enameling, Enamelists, Who's Who in the East* and *Artforum* magazine. Price range: $500-$25,000.

## ALICE VAN LEUNEN
Mixed & Other Media/Tapestry, Fiber & Paper
Pages 180, 198

Alice Van Leunen's artworks explore pattern, texture and reflection. Her approach is light-hearted. Many of the artworks make musical or literary allusions and feature calligraphic marks and symbols. Works range in size from small, intimate pieces to major architectural installations. Commissions are welcome. Commissions: Mulia Bank Complex, Djakarta, Indonesia; National High Magnetic Field Laboratory, Tallahassee, FL (with Walter Gordinier); Fairview Auditorium, Fairview, OK; Kaiser Medical Services, San Diego, CA; Kodiak Auditorium, Kodiak, AK; Playboy Towers, Chicago, IL. Collections: Atlantic County Office Building, Atlantic City, NJ; General Motors, New York, NY; City Light Collection, Seattle, WA; Calvin Klein Cosmetics, Wayne, NJ. Awards: Oregon Individual Artist Fellowship, 1993. Van Leunen's work is featured in previous GUILD sourcebooks.

## HELEN VAUGHN
Paintings
Pages 16, 33

Helen Vaughn specializes in representational pastel and oil paintings of landscapes, figures and still lifes. Her beautiful works boast rich, velvety textures and vivid colors wrapped in carefully arranged compositions. As a painter, Vaughn is continually fascinated by the properties of color, light and shadow as they affect both the image and her own sense of time, place and inner harmony. While this fascination influences both the visual elements of her work and her own needs as an artist, the paintings stand or fall on their own. Her work, included in museum, corporate and private collections, has won many awards and has been widely exhibited in solo and group exhibitions. Publications: *Pastel Artist International*, May/June, 2002; *American Artist*, November, 1998.

229

# ARTIST INFORMATION

## MEINY VERMAAS-VAN DER HEIDE
Art Quilts
Page 201

Meiny Vermaas-van der Heide's quilts are known for their strong graphics, minimalist appeal and the "color magic" of visual illusions. Machine piecing and quilting hand-dyed and commercial cottons, she considers her works to be "contemporary classics." Washing and preshrinking the work is part of her construction process in order to create the desired wrinkled heirloom appearance. Her work has been published and exhibited worldwide and is found in residential, corporate and public art collections. Her work has been featured in previous GUILD sourcebooks. Commissions, exhibition opportunities and studio visits are welcome. Resumé, slides and prices available upon request. Prices begin at $200 per square foot. Completed works are available.

## CHERYL WARRICK
Paintings
Pages 96, 213

Cheryl Warrick is a Boston-based painter best known for her richly colored, quilt-like paintings that explore the journey of wisdom. She incorporates folk wisdom, proverbs, symbols and landscapes. Her work asks the viewer to open doors to find visual relationships in the work and quietly discover their meaning. Her work can be found in the collections of the Boston Public Library, Boston, MA; Museum of Fine Arts, Boston, MA; Philadelphia Free Library, Philadelphia, PA; Rhode Island School of Design Museum of Art, Providence, RI; Rose Art Museum, Waltham, MA; Harpo Productions, Chicago, IL; Fidelity Investments, Boston, MA; Embassy Suites Hotel, Philadelphia, PA; and Lucent Technologies, New York, NY.

## WOODLAND STUDIOS
Photographs
Page 130

Woodland Studios creates custom originals of nature, homes, gardens, family, pets and more. The art begins with a photograph, which is digitally manipulated using computer graphics, output as a giclee print on archival materials, and then over-painted using a variety of natural mediums. Each one is painted on an artist proof of the original digital image. The work is a collaboration of artists, as well as digital and natural mediums. For 20 years Gary Walker and Cindy Lou, working together as creative directors on global accounts, have become well known for their high-tech, creative abilities. Now they've focused their talents in a new direction: creating digital abstractions of what people love most. Prices range from $175-$2,500 based on size and available photography.

## PAUL VINCENT
Paintings
Page 53

Paul Vincent has developed his own technique for combining realist painting with weaving. Multiple watercolor paintings of the same subject are cut into strips then woven into a single piece. The resulting paper weaving offers a complex mix of color, pattern, texture and weave. Working from photographs, Vincent seeks to portray the individuality and character of his subjects while transforming them into sumptuous works of art. He accepts portrait commissions. Prices begin at $3,000. Collections: Alumax Corporation, Atlanta, GA; Banker's First, Augusta, GA; Eastman Chemical, Kingsport, TN; Springs Industries, New York, NY; University of Virginia-Wise; Meadowview Convention Center, Kingsport, TN; Johnson City Public Library, TN; Southwest Virginia Higher Education Center, Abingdon.

## ZACH WEINBERG
Metal
Page 162

Zach Weinberg has been creating art from metal for 15 years. His artwork is purely intuition, surfacing from his soul. Dedicated to the exploration of the creative process, Weinberg has developed a unique style that is truly his own. His sculptures are portals that are intended to bring the viewer to places beyond the familiar. Weinberg enjoys creating both fine art and functional art, from garden gates and furniture to 20-foot-tall site-specific sculpture. He feels no art project is too big or too small. Custom work for custom places is his specialty, and he welcomes both indoor and outdoor commissions for private homes, as well as public and corporate spaces. Prices begin at $1,500 and installation is available.

## BARBARA ZINKEL
Prints
Page 108

Barbara Zinkel is known for her dramatic use of color in her limited-edition silkscreen prints and in her professionally hand-tufted and hand-carved custom wool rugs for residential and corporate interiors. Zinkel's work has been featured in decorators' show houses in Detroit and Columbus, on several television sets, and in the *Detroit News* (1994), *Hour Detroit* magazine (1999), and *Better Homes and Gardens Decorating* magazine (1987). While featured in various collections in the Netherlands, Hong Kong, Venezuela and Spain, Zinkel's domestic collection placements include General Motors, Daimler Chrysler Corporation Headquarters, Ford, Dupont, Steelcase, CBS, Chase Manhattan Bank, Texas Instruments, Honeywell, Ericcson and Verisign.

## STEVE WALKER
Paintings
Page 75

"Art is an oasis. It offers us a place to quench our thirst for the reflection and contemplation of the common questions of mankind and the mysteries of human existence." A Chicago native, Steve has worked in a variety of media for the past 20 years. His latest acrylic works have the same color punch as his earlier works but now explore the new themes of human relationships and communication. By using distinct line, primary color and simple form, he leads the viewer through some familiar settings and cerebral interactions that do not answer questions, but instead lead us to ask new ones. Exhibitions and commissions include: the Art Institute of Chicago, Michael Reese Medical Center, Campanile Gallery, Talman Home Savings, Loyola University Medical Center and Anthony Michael Interiors.

## ERIN WILSON
Art Quilts
Page 200

As a modern quilt artist, Erin Wilson creates work that is alive, deep and colorful. With a palette of hand-dyed cotton broadcloth, she combines intricate color schemes with simple geometric shapes to produce quilts that feel balanced and full of motion. Her process is fast paced and instinctual. While there is a purpose and ordered sense of design in each piece, it is this intuitive spontaneity that pushes the work to such vibrancy.

230

# A LIST OF FAVORITE GALLERIES

Each year, the publisher of *AmericanStyle* and *Niche* magazines asks artists to name favorite galleries.
The following list is based on responses from a poll of more than 26,000 artists in North America.

Thanks to the Rosen Group for permission to reprint the list. To order subscriptions to *Niche* or *AmericanStyle,* call 800-272-3893.

A Mano Gallery
128 S Main Street
New Hope, PA 18938
215-862-5122

Abacus
44 Exchange Street
Portland, ME 04101
207-772-4880

Accipiter
2046 Clark Avenue
Raleigh, NC 27605
919-755-9309

Agora Arts
104 East Water Street #1
Decorah, IA 52101
563-382-9584

American Artisan
4231 Harding Road
Nashville, TN 37205
615-298-4691

American Craft Gallery
163 South Street
Morristown, NJ 07960
973-538-6720

An American Craftsman
1866 Route 284, PO Box 480
Slate Hill, NY 10973
845-355-2400

Animazing Gallery
461 Broome Street
New York, NY 10013
212-226-7374

Annapolis Pottery
40 State Circle
Annapolis, MD 21401
410-268-6153

ArtCraft Collection
8600 Foundry Street
Savage, MD 20763
410-880-4863

Artful Hand Gallery
36 Copley Place
Boston, MA 02116
617-262-9601

Artique
161 Lexington Green Circle
Lexington, KY 40503
859-272-8802

Artisan Center
2757 East 3rd Avenue
Denver, CO 80206
303-333-1201

Artisans Gallery
Box 133 Shop #35
Peddlers Village
Lahaska, PA 18931
215-794-3112

Arts & Artisans Ltd
36 South Wabash Suite # 604
Chicago, IL 60603
312-855-9220

Arts Company
125 North Townville Street
Seneca, SC 29678
864-882-0840

As Kindred Spirits
1611 Rockville Pike 1206
Rockville, MD 20852
301-984-0102

Bluestem Missouri Crafts
13 South Ninth Street
Columbia, MO 65201
573-442-0211

BNOX Iron & Gold
404 First Street
PO Box 156
Pepin, WI 54759
715-442-2201

Browning Artworks Ltd
Highway 12
PO Box 275
Frisco, NC 27936-0275
252-995-5538

By Hand South
112 East Ponce de Leon Avenue
Decatur, GA 30030
404-378-0118

Cambridge Artist Cooperative
59A Church Street
Cambridge, MA 02138
617-868-5966

Campbell Pottery Store
25579 Plank Road, PO Box 246
Cambridge Springs, PA 16403
814-734-8800

Capitol Craftsman
16 North Main Street
Concord, NH 03301
603-224-6166

CBL Fine Art
459 Pleasant Valley Way
West Orange, NJ 07052
973-736-7776

Citywoods
651 Central Avenue
Highland Park, IL 60035
847-432-9393

Clarksville Pottery Galleries
4001 N Lamar Blvd #200
Austin, TX 78756
512-454-8930

Clay Pot
162 7th Avenue
Brooklyn, NY 11215
718-788-6564

Craft Company No. 6
785 University Avenue
Rochester, NY 14607
716-473-3413

Creations Fine Woodworking Gallery
451 Hockessin Corner
Hockessin, DE 19707
302-235-2310

Dashka Roth Jewelry & Judaica
332 Chartres Street
New Orleans, LA 70130
504-523-0805

Dennison-Moran Gallery
696 5th Avenue South
Naples, FL 34102
941-263-0590

Designers Studio
492 Broadway
Saratoga Springs, NY 12866
518-584-1977

Dickinson & Wait Craft Gallery
121 E German Street
PO Box 1273
Shepherdstown, WV 25443
304-876-0657

Don Drumm Studios & Gallery
457 Crouse Street
Akron, OH 44311
330-253-6268

Don Muller Gallery
40 Main Street
Northampton, MA 01060
413-586-1119

DreamWeaver
364 St. Armands Circle
Sarasota, FL 34236
941-388-1974

Dunn Mehler Gallery
337 Mirada Road
Half Moon Bay, CA 94019
650-726-7667

Earthenworks Gallery
713 First Street
PO Box 702
La Conner, WA 98257
360-466-4422

Edgecomb Potters Galleries
727 Boothbay Road
Edgecomb, ME 04556
207-882-9493

Edgewood Orchard Galleries
4140 Peninsula Players Road
Fish Creek, WI 54212
920-868-3579

Eureka Crafts
210 Walton Street
Syracuse, NY 13210
315-471-4601

Evergreen Contemporary Crafts
291 Main Street
Great Barrington, MA 01230
413-528-0511

Fabrile Gallery
224 South Michigan Avenue
Chicago, IL 60604
312-427-1510

Fire Opal
320 Harvard Street
Brookline, MA 02446
617-739-9066

Fireworks Gallery
210 First Avenue South
Seattle, WA 98104
206-682-8707

Freehand Fine Crafts
8413 West Third Street
Los Angeles, CA 90048
323-655-2607

Gallery 3-2-1
65 W State Street, Box 369
Oxford, NY 13830
607-843-9538

Gallery Of The Mountains
290 Macon Avenue, PO Box 8283
Asheville, NC 28804
828-254-2068

Gifted Hand
32 Church Street
Wellesley, MA 02482
781-235-7171

Glass Reunions of Key West
825 Duval Street
Key West, FL 33040
305-294-1720

Good Goods Gallery
106 Mason Street
Saugatuck, MI 49453
616-857-1557

Grovewood Gallery
111 Grovewood Road
Asheville, NC 28804
828-253-7651

Handworks Gallery
161 Great Road
Acton, MA 01720
978-263-1707

Hanson Galleries
800 W. Sam Houston Pkwy N. # E118
Houston, TX 77024
713-984-1242

Heart of the Home
28 South Main Street
New Hope, PA 18938
215-862-1880

Heart to Heart Gallery
921 Ridge Road
Munster, IN 46321
219-836-2300

Imagine Artwear
1124 King Street
Alexandria, VA 22314
703-548-1461

Island Style
2075 Periwinkle #16
Sanibel Island, FL 33957
941-472-6657

Kebanu
4-1354 Kuhio Highway #3
Kapaa Kauai, HI 96746
808-823-6820

Lazar's Art Gallery
2940 Woodlawn Avenue NW
Canton, OH 44708
330-477-8351

Left Bank Gallery
25 Commercial Street
PO Box 764
Wellfleet, MA 02667
508-349-9451

Limited Editions
2200 Long Beach Blvd.
Surf City, NJ 08008
609-494-0527

Log House Craft Gallery
Berea College
Berea, KY 40404
859-985-3226

Luma
1 Lake Avenue
PO Box 1439
Colorado Springs, CO 80901
719-577-5835

Mackerel Sky Gallery
217 Ann Street
East Lansing, MI 48823
517-351-2211

Mind's Eye Craft Gallery
201 South Talbot Street
PO Box 781
St. Michaels, MD 21663
410-745-2023

Moondance Gallery
603 Meadowmont Village Circle
Chapel Hill, NC 27517
919-7265-0020

Mostly Clay & Fine Crafts
227 Broad Street
Nevada City, CA 95959
530-265-3535

Mountain Laurel Crafts
1 North Washington Street
PO Box 369
Berkeley Springs, WV 25411
304-258-1919

NJM Gallery
8 Bow Street
Portsmouth, NH 03801
603-433-4120

Nan Gunnett & Co.
25 Briarcrest Square
Hershey, PA 17033
717-533-1464

Nancy Markoe Fine
American Crafts Gallery
3112 Pass A Grille Way
St. Pete Beach, FL 33706
727-360-0729

Ocean Annie's
815 A Ocean Trail
Corolla, NC 27927
252-453-4102

Patina Gallery
131 West Palace Avenue
Santa Fe, NM 87501
505-986-3432

Pismo Gallery
235 Fillmore Street
Denver, CO 80206
303-333-2879

Primavera
4 Bowen's Wharf
Newport, RI 02840
401-841-0757

Purple Sage
110 Don Gaspar
Santa Fe, NM 87501
505-984-0600

RAF
5 West York Street
Savannah, GA 31401
912-447-8807

Raiford Gallery
1169 Canton Street
Roswell, GA 30075
770-645-2050

Rasberry's Art Glass Gallery
6540 Washington Street
Yountville, CA 94599
707-944-9211

Sansar
4805 Bethesda Avenue
Bethesda, MD 20814
301-652-8676

Seekers Glass Gallery
4090 Burton Drive
PO Box 521
Cambria, CA 93428
800-841-5250

Seldom Seen
817 East Las Olas Boulevard
Ft. Lauderdale, FL 33301
954-764-5590

Selo/Shevel Gallery
301 South Main Street
Ann Arbor, MI 48104
734-761-4620

Shapiro's
185 Second Avenue North
St. Petersburg, FL 33701-0714
727-894-2111

Show of Hands
210 Clayton Street
Denver, CO 80206
303-399-0201

Signature Stores
10 Steeple Street
Box 2307
Mashpee, MA 02649
508-539-0029

Snyderman Gallery/Works Gallery
303 Cherry Street
Philadelphia, PA 19106
215-922-7775

Society of Arts and Crafts
175 Newbury Street
Boston, MA 02116
617-266-1810

Stone's Throw Gallery
1389 Beacon Street
Brookline, MA 02146
617-731-3773

Stowe Craft Gallery
55 Mountain Road
Stowe, VT 05672
802-253-4693

Studio 41
700 First Street
Benicia, CA 94510
707-745-0254

Surprises
4003 Westheimer
Houston, TX 77027
713-877-1900

Topeo Gallery
35 North Main Street
New Hope, PA 18938
215-862-2750

Vault
1339 Pacific Avenue
Santa Cruz, CA 95060
831-426-3349

Village Artisans Gallery
321 Walnut Street, PO Box 303
Boiling Springs, PA 17007
717-258-3256

Wild Goose Chase
1431 Beacon Street
Brookline, MA 02446
617-738-8020

Wood Merchant
707 South First Street
La Conner, WA 98257
360-466-4741

ZYZYX!
10301 A Old Georgetown Road
Bethesda, MD 20814
301-493-0297

# GLOSSARY OF ART TERMS

Acrylic
Marlene Lenker, *Vista V.*

Aquatint
Daniel Lang, *The Villa Road.*
Photograph: Robert Pugilsi, New York.

Batik
Kim H. Ritter, *Surface Tension,* art quilt.
Photograph: Karen Bell.

Digital Imaging
John Maggiotto, *Nine Horses.*

| | |
|---|---|
| ACRYLIC | A water-soluble paint made with pigments and synthetic resin; used as a fast-drying alternative to oil paint. |
| ALUMINUM | A lightweight, silver-colored metal used extensively in commercial applications, and occasionally by metal artists. In a process called anodizing, aluminum is given a tough porous coating that can be colored with dyes. |
| APPLIQUÉ | A technique whereby pieces of fabric are layered on top of one another and joined with decorative stitches. |
| AQUATINT | Printmaking process used to create areas of solid color, as well as gradations of white through black tones. Usually has the appearance of transparent watercolor. |
| BAS-RELIEF | Literally, "low-relief." Raised or indented sculptural patterns that remain close to the surface plane. |
| BATIK | A method of applying dye to cloth that is covered, in part, with a dye-resistant, removable substance such as wax. After dyeing, the resist is removed, and the design appears in the original color against the newly colored background. |
| BEADING | The process whereby decorative beads are sewn, glued or otherwise attached to a surface. |
| BEVELED GLASS | Plate glass that has its perimeter ground and polished at an angle. |
| BRASS | An alloy of copper and zinc. Brass is yellow in color, and though harder than either of its constituents, it is appropriately malleable for jewelry making. |
| BRONZE | Traditionally, an alloy of copper and tin widely used in casting. The term is often applied to brown-colored brasses. |
| CHASING | A technique in which steel punches are used to decorate and/or texture a metal surface. |
| CHINA PAINT | A low-temperature overglaze fired onto previously glazed and fired ceramic. |
| DICHROIC GLASS | A thin metallic coating on any type of glass. The coating is applied at a high temperature in a vacuum chamber. |
| DIE FORMING | The process of placing metal between two steel dies or stamps and squeezing them together under high pressure. This process shapes and strengthens the metal. |
| DIGITAL IMAGING | Refers to the creation, manipulation and production of images by use of computer technology, including software and printers. |
| DIPTYCH | Artwork on two panels that are hung together. Historically, a hinged, two-paneled painting or bas-relief. |
| EMBOSSING | A decorative technique in which a design is raised in relief. |
| ENAMELED GLASS | Glass decorated with particles of translucent glass or glass-like material, usually of a contrasting color, which fuses to the surface under heat. Multicolored designs can be created, as well as monochrome coatings. |
| ENAMELS | As applied to metals: a transparent or opaque glaze that melts at a lower temperature than copper, silver or gold, on which enamel is used as the decorative finish; usually fired to about 1300°F. |
| ENGRAVING | An intaglio printing process in which a design is incised into a metal plate. Characterized by sharp, clean lines and high definition. Also called line engraving. |

# GLOSSARY OF ART TERMS

**ETCHED GLASS**  Glass decorated, carved or otherwise marked by sandblasting or the use of hydrofluoric acid. The glass is partially covered with an acid-resistant wax or gum and the exposed area is etched.

**ETCHING**  A printing process in which chemical agents are used to deepen lines drawn onto a printing plate.

**FIRING**  Heating clay, glaze, enamel or other material to the temperature necessary to achieve a desired structural change. Most ceramics are fired in a kiln to temperatures ranging from 1600°F to 2300°F.

**FUSED GLASS**  Glass that has been heated in a kiln to the point where two separate pieces are permanently joined as one without losing their individual color.

**GICLEE**  French term meaning "sprayed." A process by which an image is rendered digitally by spraying a fine stream of ink onto archival art paper or canvas. Similar to an airbrush technique.

**GLAZE**  Glassy melted coating on a clay surface. Glaze has a similar oxide composition to glass, but includes a binder.

**GOUACHE**  An opaque watercolor paint, or work so produced. Gouache is applied like watercolor, but reflects light due to its chalky finish.

**HUE**  The pure state of any color.

**ILFOCHROME**  A trademarked photographic paper and the process of making prints with such paper. Ilfochrome prints are produced from slides or transparencies, not color negatives.

**IMPASTO**  A thick, uneven surface texture achieved by applying paint with a brush or palette knife.

**INCALMO**  The glassblowing technique used to create horizontal or vertical bands of color by forming and connecting cylinders of colored glass.

**INCLUSIONS**  Particles of metal, bubbles, etc., that occur naturally within glass or are added for decorative effect.

**INLAY**  A decorating technique in which an object is incised with a design, a colorant is pressed into the incisions, and the surface is then scraped to confine the colored inlay to the incisions.

**INTAGLIO**  A printmaking process in which an image is created from ink held in the incised or bitten areas of a metal plate, below the surface plane. Engraving, etching, mezzotint and aquatint are examples of the intaglio process.

**IRIDIZED GLASS**  Flat or blown glass sprayed with a vapor deposit of metal oxides for an iridescent finish. The iridized layer, which resembles an oil slick, can be selectively removed for a two-tone effect.

**IRIS PRINT**  The trademarked name for a digital print produced by an Iris Graphics inkjet printer. (See "Giclee.")

**KILN-FORMING**  A glass-forming process that utilizes a kiln to heat glass in a refractory or heat-resistant mold, slump glass over a form, or fuse two or more pieces of glass together.

**LAMINATED**  Composed of layers bonded together for strength, thickness or decorative effect.

Etching
Judith Palmer, *Cueva Pintada.*

Gouache
Steve Heimann, *The Optimist.*

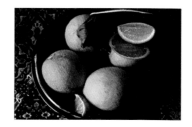

Ilfochrome
Naomi Weissman, *Meyer Lemons.*

Iris Print
Jamie Wyeth, *Fogbound Island.*
Courtesy of Artland Editions.

# GLOSSARY OF TERMS

Linocut
Lisa Kesler, *Savoy Swing-2*.
Photograph: Ken Wagner.

Lithography
Italo Scanga, *Golden Statue*.
Photograph: Greg Anderson/Jim Wildeman.
Courtesy of Tandem Press.

Pastel
Susan Sculley, *Spring Day*.
Photograph: Steve Perry.

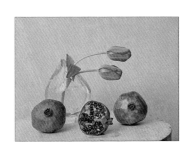

Polaroid Transfer
Libby Cullen, *Pomegranates & Tulips*.
Photograph: Libby Cullen.

| | |
|---|---|
| LEADED GLASS | Glass containing a percentage of lead oxide, which increases its density and improves its ability to refract and disperse light. Leaded glass is used for ornaments and for decorative and luxury tableware. |
| LIMITED EDITION | Artworks produced in a deliberately limited quantity. All items in the edition are identical and each one is an original work of art. The limited size of the edition enhances the value of each piece. |
| LINOCUT | A relief print process similar to woodcut. Wood blocks covered with a layer of linoleum are carved with woodcut tools, coated with ink and printed by hand or in a press. |
| LITHOGRAPHY | A planographic printmaking process based on the repellence of oil and water and characterized by soft lines and blurry shapes. |
| MARQUETRY | Decorative patterns formed when thin layers of wood (and sometimes other materials, such as ivory) are inlaid into the surface of furniture or other wood products. |
| MEZZOTINT | An intaglio printing process that produces areas of tone rather than clean lines. |
| MONOPRINT | A print produced by painting directly onto an already-etched surface and printing the image by hand onto paper. |
| MONOTYPE | A print made when an artist draws or paints on a glass or metal plate and then prints the image onto paper. |
| MOSAIC | The process of creating a design or picture with small pieces of glass, stone, terra cotta, etc. |
| OIL PAINT | A paint in which natural oil—usually linseed—is the medium that binds the pigments. |
| PALLADIUM | A photographic process in which the image is produced by palladium crystals deposited on the paper. |
| PASTEL | A crayon of ground pigment bound with gum or oil. Pastel crayons have varying ratios of pigment to chalk and gum; the more pigment, the more intense the color. |
| PATE DE VERRE | A "paste" of finely crushed glass that is mixed, heated and poured into a mold. |
| PATINA | A surface coloring, usually brown or green, produced by the oxidation of bronze, copper or other metal. Patinas occur naturally and are also produced artificially for decorative effect. |
| PHOTOETCHING | A printmaking technique in which a light-sensitive metal plate is exposed to photographic film under ultraviolet light. |
| PHOTOGRAVURE | A printing process based on the production, by photographic methods, of a plate containing small ink-receptive pits. |
| POLAROID TRANSFER | A trademarked name for the process by which an image recorded by the camera's lens is reproduced directly onto a photosensitive surface, which functions as both film and photograph. |
| PORCELAIN | A clay body that is white, strong and hard when fired. When sufficiently thin, it is also translucent. |
| PRINT | An image made from an inked surface. Prints are usually, but not always, produced in multiples. |

All glossary illustrations are from the GUILD.com website. Visit www.guild.com.

# GLOSSARY OF TERMS

RAKU — The technique of rapidly firing low-temperature ceramic ware. Raku firings were used traditionally in Japan to make bowls for tea ceremonies.

RELIEF PRINT — A process in which a print is produced from the relief carving on a metal plate or a wood or linoleum block.

REPOUSSÉ — An ancient process in which sheet metal is hammered into contours from both the front and the back.

SAND CASTING — An ancient and still widely used casting method in which moistened sand is packed against a model to make a mold—usually for metal.

SANDBLASTING — A method of etching the surface of a material by spraying it with compressed air and sand.

Sepia
Christine Rodin, *Two Pears and Cup*, photograph.

SEPIA — Warm, reddish-brown pigment produced from octopus or cuttlefish ink, used in watercolor and drawing ink. In photography, some toning processes produce a similar color in the print.

SILKSCREEN PRINTING — A printing process in which paint, ink or dye is forced through a fine screen onto the surface beneath. Different areas of the screen are blocked off with each layer of color. Also known as "serigraph."

SILVER GELATIN — A photographic process that uses silver halide crystals suspended within the photographic emulsion to produce the image. The most popular type of black-and-white photograph produced today.

Silkscreen Printing
Hunt Slonem, *Finches Black*.
Courtesy of Stewart & Stewart.

SLUMPED GLASS — Preformed flat or three-dimensional glass that is reheated and shaped in a mold.

SPALTED — Wood that contains areas of natural decay, giving it distinctive markings. Spalted wood is used for its decorative effect.

STILL LIFE — A depiction of a group of inanimate objects arranged for symbolic or aesthetic effect.

STONEWARE — A gray-, reddish- or buff-colored opaque clay body that matures (becomes nonporous) between 1900°F and 2300°F.

TERRA COTTA — Low-fired ceramic ware that is often reddish and unglazed.

TRIPTYCH — A three-paneled artwork. Historically, triptychs were hinged together so that the two side wings closed over the central panel.

Still Life
Marlies Merk Najaka, *Life*.
Photograph: Geri Bauer Photographics Inc.

TROMPE L'OEIL — Literally, "fool the eye" (French). An object or scene rendered so realistically that the viewer believes he or she is seeing the real thing.

VITREOGRAPH — A print made from a glass plate that has been prepared by sandblasting or etching.

VITREOUS — Clay fired to maturity, so that it is hard, dense and nonabsorbent.

WATERCOLOR — Watercolor paints are made with pigments dispersed in gum arabic and are characterized by luminous transparency.

WHITEWARE — A generic term for white clay bodies.

WOODCUT — A relief printing process in which a picture or design is cut in relief along the grain of a wood block.

Woodcut
Barbara Leventhal-Stern, *Games We Play*.

# GEOGRAPHIC INDEX

240

# GEOGRAPHIC INDEX

# INDEX OF ARTISTS & COMPANIES

# INDEX OF ARTISTS & COMPANIES

# INDEX OF ARTISTS & COMPANIES